Stop Motion

dedication

This book is dedicated to my mother, Francesca (1927–2006).

Stop Motion Craft skills for model animation

Second edition

Susannah Shaw

First published 2004 This edition published 2008 by Focal Press 70 Blanchard Road, Suite 402, Burlington, MA 01803

Simultaneously published in the UK by Focal Press 2 Park Square, Milton Park, Abingdon, Oxon OX14 4RN

Focal Press is an imprint of the Taylor & Francis Group, an informa business

Copyright © 2008, Susannah Shaw. Published by Taylor & Francis. All rights reserved.

The right of Susannah Shaw to be identified as the author of this work has been asserted in accordance with the Copyright, Designs and Patents Act 1988.

All rights reserved. No part of this book may be reprinted or reproduced or utilised in any form or by any electronic, mechanical, or other means, now known or hereafter invented, including photocopying and recording, or in any information storage or retrieval system, without permission in writing from the publishers.

Notices

Practitioners and researchers must always rely on their own experience and knowledge in evaluating and using any information, methods, compounds, or experiments described herein.

Product or corporate names may be trademarks or registered trademarks, and are used only for identification and explanation without intent to infringe.

Library of Congress Cataloguing in Publication Data

A catalogue record for this book is available from the Library of Congress

ISBN 13: 978-0-240-52055-1 (pbk)

Typeset by Charon Tec Ltd (A Macmillan Company), Chennai, India

contents

acknowledgements	ix
chapter 1 introduction - playing God what is stop motion? nature and caricature what this book is for	1 1 5 7
chapter 2	
getting equipped what do you need? choosing a camera lenses animation software/frame grabbers tripods lighting the animator's toolkit editing/sound glossary	8 9 12 12 15 16 18 18
chapter 3	
getting animated animating familiar objects as a first approach setting up for the first time notes on movement timing: single frame or double frame? squash and stretch the dope sheet/X-sheet planning	21 21 22 25 27 29 30 32
chapter 4	
keep it simple – developing your story idea – script – treatment planning your shots – basic film grammar/composition of shots the storyboard editing – animatics and story reels	35 35 38 43 47

chapter 5 coat-hangers for armatures – making your own model 51
coat-hangers for armatures - making your own model 5 i
character design 51 working with modelling clays 52
0 /
1. simple wire and plasticine puppet 2. days last adath adaptate for the state of
2. durable clothed puppet 65
chapter 6
model makers – the professionals 76
the maquette 77
ball-and-socket armature 78
mould making – hard and soft moulds
casting 88
coloring 93
costumes/dressing 93
model-making masterclass – ScaryCat Studio and the
Duracell bunny 95
glossary of model-making materials
chapter 7
four walls and a sky – sets and props 102
research the look
design and building of sets
interior sets 108
exterior sets 109
forced perspective 110
making props
rigging 1112
glossary of materials for sets
alamatan O
chapter 8 sound advice – the voice track 114
pre-production 115
recording dialog 110
sound breakdown 117
lip sync 119
music and effects copyright 124
chapter 9 the mechanics of movement 125
studies from observation 125
posing the model 128
· ·
weight 133 anticipation, action and reaction 134
walking and running

	contents	vii
the illusion of speed animal and bird movement		142 143
chapter 10		
animation masterclass – Teresa Drilling		147
the model on what creates a character		148 150
first position		150
the extreme downward position		153
on Vinton's		154
beginning the upward move		154
slowing down at the top of the move settling into the final position		158 162
chapter 11		
the performance		166
character animation		166 169
comedy and comic timing subtle character animation		173
Sobile character diffindition		170
chapter 12		17/
the production process lighting		176
health and safety issues		180
setting up the camera		181
shooting with a rig		184
special effects – tips and hints final checks before you hit that button		188 191
interview with Tim Allen		192
glossary		193
chapter 13		105
post-production timecode		195 195
the picture edit		196
sound		197
titles and credits		199
exporting your final film		199
chapter 14		200
getting the job – the business of animation know where you stand		200 201
different work, different studios		201
commercials		201
series		203

TV specials and features applying for jobs your showreel starting out as a runner festivals sending proposals to commissioning editors	206 209 209 210 210 211
bibliography	213
appendix 1 software and recording equipment suppliers	215
appendix 2 manufacturers and outlets	217
appendix 3 calendar of animation festivals and film festivals incorporating animation	221
appendix 4 animation courses that include or specialize in stop motion, and related organizations and websites	235
index	247

acknowledgements

Thanks to Gary Jackson and Cat Russ of ScaryCat Studio; Tony Guy; Ian Mackinnon, Peter Saunders and Christine Walker of Mackinnon & Saunders; Barry Purves; Jeff Newitt; Guionne Leroy; Timothy Hittle; Sara Mullock; Helen Nabarro at the BBC Animation Unit; Nick Hilligoss at ABC; Ange Palethorpe, Glen Holberton and Emma Bruce at Loose Moose; John Schofield at bolexbrothers; Blair Clark at Tippett Studios; Lionel Orozco of Stop Motion Works; David McCormick; Helen Garrard; Tristan Oliver; Bob Thorne at Artem; Anthony Scott; Trey Thomas; Richard Goleszowski; John Wright at John Wright Modelmaking; Miguel Grinberg (Magpie); Brigid Appleby and Mark Hall of Cosgrove Hall; Jackie Cockle; Sarah Ball; Barry Bruce at Vinton's; Nigel Cornford; James Mather; John Parsons; Brunsdon, Luis Cook, Nick Park, Sharron Traer, Dave Sproxton, Loyd Price, Gareth Owen, Dan Lane, Tom Barnes, Jan Sanger, Martin Shann, Ian Fleming and Michael Carter of Aardman Animations; Chris Webster at UWE; Rick Catizone; Chris Grace at S4C; Chris Hopewell and Ben Foley at Collision Films; Mary Murphy; Teresa Drilling; Johnny Tate; Tim Allen and Simon Jacobs.

Model making and animation sequences for Chapters 5, 6, 9 and 11 created and animated by ScaryCat Studio

Model design, sculpt and animation sequences for Chapter 10 (and cover) created and animated by Teresa Drilling

Model making for Chapters 3 and 10 by Johnny Tate

Illustrations by Tony Guy and Susannah Shaw

iztmernegbel v ombid

chapter 1

introduction - playing God

chapter summary

- what is stop motion?
- nature and caricature
- what this book is for

You want to captivate people. It doesn't come with just technique, it's about putting yourself inside that character. It's like slowing down your brain and all of a sudden you are that puppet and you move how that puppet moves.

Guionne Leroy, animator on Max & Co, Chicken Run, Toy Story

what is stop motion?

If you want to make great animation, you need to know how to control a whole world: how to make a character, how to make that character live and be happy or sad. You need to create four walls around them, a landscape, the sun and moon – a whole life for them. But it's not just playing dolls – it's more like playing God. You have to get inside that puppet and first make it live, then make it perform.

Animation is animation, whatever the medium. Whether you are drawing on paper, modelling in Plasticine, shoving a couple of matchboxes around in front of a Bolex camera or animating with a computer; to become an animator you will need to understand movement and how to create emotion. You can be a cartoonist or an artist on film, a moving image maker, and there are many beautiful and hilarious examples of this, but they do not necessarily fulfil the definition of animation that this book sets out to demonstrate. This book is written for someone wanting to take the first steps in creating three-dimensional character animation.

Methods for 2D animation have been documented for a long time. Since the formation of the Disney Studios, their vast commercial output meant they had to find ways of passing on their skills to a large body of workers who needed to know the house style. The top animators started to look at what they were doing as animators, and started to identify rules and guiding principles by which they worked. Most of these principles apply to model or puppet animation as well as – as they are derived from the scientific study of movement – the effect of gravity, friction and force on masses. One of the greatest books to read about the development of 2D animation is Ollie Johnston and Frank Thomas's *The Illusion of Life* (1997).

You will have seen computer animation that seems wooden and stiff or the characters glide and swoop about as though gravity never existed. This is simply because, in this relatively new medium, the majority of early practitioners were originally from a computing background and had learned the computing skills but not necessarily the animating skills. Director John Lasseter was a successful 2D animator before applying his skills to the computer-generated *Tin Toy, Knick Knack* and, more famously, *Toy Story* and *Monsters Inc.*, giving Pixar some of the best computer-generated characters seen so far. Not everyone can handle both skills that well. Nowadays, animators are recruited to work on computer-generated films from 2D and stop motion backgrounds, and it is recognized that training for CG character animation should follow the same traditional principles of animation.

In Europe and Asia, model animation has grown out of a tradition of storytelling, fable and legend. Most practitioners developed their own ways of working in isolation, many re-inventing the wheel, but in very few cases were methods documented, and certainly no 'principles' for model animation had been laid down in the same way as for 2D. But the basic laws of movement apply to any form of animation.

For many years Eastern Europe was the source of puppet animation; in the USA film experimentation settled more quickly to making 2D drawn animation. But in Eastern Europe there was a long tradition of puppeteering; for some, film was seen as a natural medium for the art. Puppeteers had to be able to breathe life into a jointed wooden doll in very much the same way as animators do. The design element of the puppet was very important to the story-telling process – they would need to communicate a character over a distance to the whole audience. Jiri Trnka, the Czech animator, paid homage to this tradition with his beautifully made puppet films of the 1950s and 1960s, the best known of which was an adaptation of Shakespeare's Midsummer Night's Dream (see Figure 1.1).

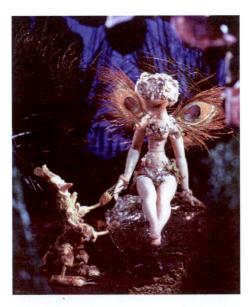

Figure 1.1 Scene from A Midsummer Night's Dream by Jiri Trnka, Czechoslovakia 1958. © Kratky Film

There are many interpretations of model animation, stop motion or 3D animation. Two Americans working in Britain, the Brothers Quay, use found objects to imbue their lyrical and sometimes nightmarish films with atmosphere, for example in *The Street of Crocodiles* and *This Unnameable Little Broom*. Their style derives from an Eastern European tradition of fairy tale and fable, and has been described as 'bringing dead matter to life'.

Jan Svankmajer, another Czech filmmaker, whose more surreal animation ranges from animating with clay to pixilation, has influenced many filmmakers, including Dave Borthwick of bolexbrothers, who directed *The Secret Adventures of Tom Thumb* as a combination of pixilated live humans acting alongside eight-inch animated puppers. Pixilation (not to be

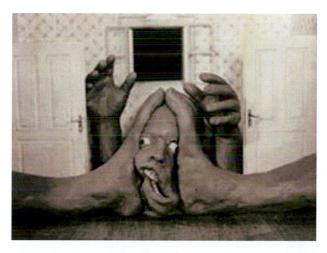

Figure 1.2 Still from Jan Svankmajer's 1989 film Darkness, Light, Darkness. Photo © Miloslav Spála

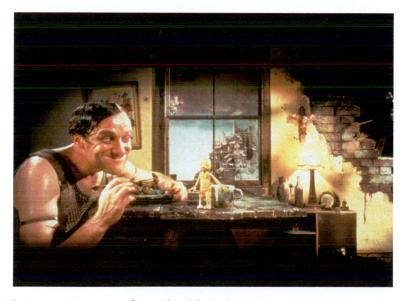

Figure 1.3 The Secret Adventures of Tom Thumb by bolexbrothers. © Manga Entertainment Ltd 2002

muddled with pixelation) is moving an object, it could be a human or a piece of furniture, frame by frame to create something that moves very differently. Further examples of good use of pixilation are Peter Gabriel's *Sledgehammer*, made at Aardman, Radiohead's *There There* made at Bristol's Collision Films, and another successful Aardman short, *Angry Kid*, but the best-known example is Norman MacLaren's *Neighbours*.

In the USA a different kind of model animation came into being with Willis O'Brien's *The Lost World*, made in 1925, and *King Kong*, made in 1933. O'Brien, and the assistant who joined him in 1948 to work on *Mighty Joe Young*, Ray Harryhausen, have probably been the greatest inspiration for today's model animators. Harryhausen's pioneering work with armatures and latex, not to mention his drawing and bronze-casting skills, laid the ground for many of the techniques still used today. His animation had a more naturalistic movement than seen before, and his animation of the skeletons in *Jason and the Argonauts* (1963) is one of his most enduring sequences studied by animators.

Harryhausen's work has influenced most of the animators mentioned in this book, among them filmmakers like Phil Tippett, who has brought his skills to bear on a whole genre of fantasy and space-legend films, like *Dragonslayer*, *Jurassic Park* and the *Star Wars* films, and who is in turn influencing the next generation of animators.

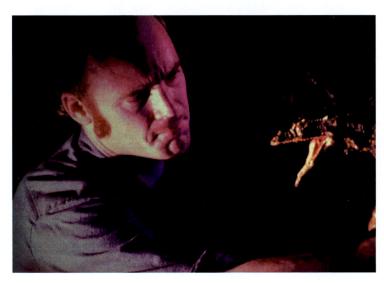

Figure 1.4 Phil Tippett animating on Dragonslayer. © Tippett Studio 1982

Several years ago the conversations in animation studios revolved around the advent of computer animation heralding the demise of model animation. Now we are seeing model animation studios embrace CGI (computer-generated imaging), sometimes due to budgetary considerations, but more often because it gives them the freedom to use many more tools and develop their ideas with fewer constraints. Skilled model animators are able to translate their work on to the computer screen, as 2D or 3D. As always, it is creativity and imagination that harness the tools to the best effect. However, some animators feel that computer animation is strangling the creative process of model animation – which is based on the tension of giving

a performance. As Guionne Leroy says at the start of this chapter 'all of a sudden you are that puppet and you move how that puppet moves ...'. This is clearly an achievement that it does not seem possible to replicate with the process of character animation on a computer. It is perhaps a harder transition for someone who has grown up with that desire to bring a 3D character to life, than a 2D animator who already works in that 'constructional' way.

nature and caricature

Why don't we just copy from live reference frame by frame? Surely it would save a lot of time and worry. Rotoscoping is used in 2D and computer animation in addition to motion capture techniques to get around some problems. This is literally copying frame by frame off live film. Rotoscoping was originally invented around 1914 by Max Fleischer for *Out of the Inkwell*; he filmed his brother dressed in a clown costume and used it as live film reference. Rotoscoping was also used extensively in Disney's *Snow White*, for instance where Snow White dances around the well singing *Some Day my Prince Will Come*. It's a technique employed to speed up the animation process, similar to motion capture in computer animation. But straight copying can look strangely lifeless because animation is an art, not just a skill. What the animator is aiming for is to create something more than mere imitation, to create a performance. Ladislas Starewitch, one of the earliest experimenters in puppet animation, astonished audiences all over Europe with his animated insects and animals in such films as *The Cameraman's Revenge* (1911), *The Tale of the Fox* (1929–30) and *The Mascot* (1933). Starewitch remembered trying to animate a frog:

I had a lot of trouble making him swim in such a way that seemed right. At first I did the movements exactly as they would have been with a real frog. But on screen it just didn't work, so I animated his movements almost caricaturally and it came out much better.

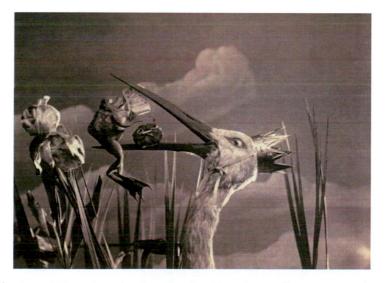

Figure 1.5 The Frogs Who Wanted a King/Frogland/Les Grenouilles qui Demandent Un Roi by Ladislas Starewitch 1927. © L.B. Martin-Starewitch

Sometimes caricature is intrinsic to the characters' design. Just like Trnka's puppets, where the static faces have a certain eloquence, Nick Park's Wallace and Gromit have an economy of design that allows a range of emotions to be described with the smallest of movements. Brow up: happiness, innocence, worry, enquiry. Brow down: suspicion, frustration, anger, mild annoyance and determination.

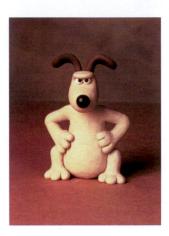

Figure 1.6 Gromit. © Aardman/W&G Ltd 1989

Extreme reactions of the 2D Who Framed Roger Rabbit? or Tex Avery (Red Hot Riding Hood) style are not normally the province of the model animator. Working with Plasticine has certain restrictions and armatures cannot be stretched to express extremes of emotion. The model animator is working in a subtler arena, where body language is employed to greater effect. This is not to say model animation precludes extremes. The use of replacements or substitutes in model animation allows plenty of 'stretch and squash'. A model is made for each different movement, so that the animator replaces a new model for each shot. When shooting on twos (two frames per move) this could mean you are using 12 different models per second of film. (Shooting on twos is explained in chapter 3, page 27.) Using this method means everything has to be very well planned in advance, but it does allow you to stretch a pose as far as you want. Replacements were originally employed by George Pal in the 1940s for films such as *Tulips will Grow* and *Home on the Range*. More recently, the original *Pingu*, the delightful series about a penguin created by Otmar Gutmann, was made with replacements – even props were repeated as replacements. Pingu was a great example of the wheel being re-invented.

I was probably more influenced by drawn cartoons: Tex Avery and Tom and Jerry stuff, rather than Trnka and George Pal. Even though you would look back on that stuff now and say 'Wow!' – I wasn't really aware of any of that as a kid. It didn't grab me as much as stretch and squash. I suppose that came from Morph [Aardman] and Disney. The performances in the drawn stuff had more life to it, rather than the wooden stuff. That's why I liked Morph so much – it felt more

flexible. It had more gags. And I suppose the style comes from just wanting to give it a sense of reality. Instead of a blob with two holes in it – you want to give it a bit more reality – or something more silly.

Jeff Newitt, Head of Character Animation on Flushed Away, director on Trainspotter and Loves Me Loves Me Not, and animated Mr and Mrs Tweedy in Chicken Run

what this book is for

This book is to help those who want to learn the hands-on, tactile craft skill of model animation (the artistry is up to you). These are just the basics – you can use the principles explained for whatever animation medium you work in. Computer technology is developing fast – even now there are experiments with sensations of weight, where the operator has a tactile sense of what they are moving. It may be that the animator can drive the technology into a medium responsive enough to be suitable for model animation, so that the animator has the same tactile control over a puppet and can derive that same sense of having given a performance, although that seems like going a long way round to achieve what we have now: hands, minds and talent.

When it's working you feel like an artist – it's great. Getting there can be very difficult because it's so time-consuming – it's such a long period of time. It's pure faith that keeps me going. I find along the way people who want to work with me, lighting people, musicians. There's a handful who have the same love of creation that jives with what I'm doing. Nobody's making any money – but we're making something beautiful, for the sake of it.

Tim Hittle, US animator, directed the Oscar-nominated short Canhead, and The Potato Hunter, animator on Monkeybone, Nightmare Before Christmas and James and the Giant Peach

chapter 2

getting equipped

what do you need? choosing a camera lenses animation software/frame grabbers tripods lighting the animator's toolkit editing/sound glossary

I started trying to tell stories when I was young at home; I wanted to tell stories in some shape or form, and I was into drawing cartoons. In our house, none of the relations had film gear or anything like that. So you try and get your head round it. 'I want to make a film ... how's it done?' How do you make a film?

I drew onto tracing paper, mounted those drawings into slides and projected them, and made a little recording to go with it. You try to make more of the story rather than think of the production values – because there aren't any production values! You just try to do an entertaining something!

Jeff Newitt, Head of Character Animation on Flushed Away, animator on Chicken Run, director on Trainspotter

what do you need?

- 1. A camera
- 2. Something to hold it steady
- 3. Something to record your animation onto.

In this time of unprecedented development in moving image production, I have endeavored to present coherent choices in this chapter, but I cannot go into enough detail to provide exactly the information you'll require as a novice. This chapter will provide some direction and information of what sort of equipment you'll need and where you can search. Basically, you just need to cover the three points above, and the choice of which format you use is down to what sort of idea you have and your budget. I have left out 'the use of film as a format' – this has now become a very specialist format, not a starter's choice. For those interested in using film they will find information in the first edition of this book. The following information is predominantly about digital formats.

As a beginner, you don't want to go out and spend your meagre funds on expensive cameras, lenses and computers. Try out animation with an inexpensive animation software and a DV camera or webcam. This will get you started, then if you get bored you won't have wasted a fortune. So if you are not bored and, on the contrary, eager to go further, read on.

choosing a camera

You will need to choose whether you are going to shoot your animation on a video camera or a stills camera. At the professional end of the scale there is High Definition Digital Video or Digital Single Lens Reflex stills cameras used for commercials and features. Obviously, the more expensive the equipment, the better the quality of the image. Cheap is fine for practising and getting your work seen if you are applying to an animation course – what people are looking for there is the quality of your animation. It helps, though, if you are looking for work, or entering your work into film festivals, that the quality looks as good as you can manage, as competition is fierce.

You must use a camera that has manual override (exposure, focus and zoom); some homevideo cameras don't have this facility. You also do need full screen resolution -640×480 – but it's really only webcams that don't give this resolution.

analog video

There may be those of you who still use an **analog** video camera. Until the advent of computer software for animation in the mid-1990s it was possible to record on to videotape. The home video camera/camcorder provided a cheap and simple-to-use option, but did not offer true single-frame capture. Once specialist animation software arrived, these cameras could be used merely as a lens feeding the images to the computer. To use this camera with your computer you will need an analog/digital converter to a **USB** or **Firewire** port, available as a card for your computer or a separate unit. When using the camera as a feed to your computer, you would not have tape loaded in the camera.

digital video

A DV camera and computer with animation software is good for learning and is the best image quality you can get on a low budget. Always check first when buying your camera that it is compatible with your software. These have to be used with a computer, as there is no single-frame capability.

DV cameras plug straight into your computer using either a USB or a Firewire connection.

Mini DV camcorders

A standard DV camcorder offers the minimum resolution needed for broadcast quality – 640×480 **pixels**. Mini DV – the name refers specifically to the size of the tape cassette – is still viable and, indeed, despite its linear format, is preferable to DVD or HDD (hard drive disk) simply because of the quality of the image. In terms of output, DV compression has a much higher data rate (one-third faster) than standard definition DVD and HDD. Film festivals will often be happy to accept Mini DV tape as its easier to capture than other formats. Even if the cameras are replaced by HDV (High Definition) they will still be able to use HD Mini DV tapes. Choose a camera with DV in and out facility (i.e. it can both input and output on DV).

While animating, use your camera simply as a lens to feed images into your computer, don't put a tape into the camera, except to record the final edited work back onto Mini DV tape. A new DV camcorder can cost anything from £100 (\$250) up to £1500 (\$3000).

HDV

High Definition Video provides a higher resolution system than standard digital video, meaning that now you can get budget camcorders with high definition as well as professional digital cameras with HD. The HD format delivers 1080v by 1920h pixels per frame, with each frame made up from approximately 2.2 million pixels.

An HD camcorder will play out onto HD MiniDV tape, or DVD and a professional one will download to digiBeta or Beta SP. An HD camcorder will set you back anything from \$1000 (£500), whereas a professional High Definition DV camera comes in at around \$60000 (£30000).

digital stills

Although a digital video camera is better designed for continuous frame storage than a stills camera, using a digital stills camera makes a lot of sense, as stop motion is essentially about taking a series of still pictures and stringing them together. Until the digital revolution this was not a realistic option, but this now presents a very different method of capturing your animation. The choices you need to make are between the point-and-shoot type camera or SLR (single lens reflex) camera. The main decision-making point is how much you are willing to pay for good resolution images. Good resolution is down to the quality of your lens and the size of the image sensor on the camera. The size of the image sensor dictates how many pixels you will have per image. You may have a large image sensor, but if you have a poor lens it will not be worthwhile. So go for the best quality lens and the most pixels – or largest image sensor you can afford.

The one problem with a stills camera is the lack of live-image feed to your computer. You will need to use another small DV cam linked to your computer to either shoot through the eyepiece of your still camera or set up alongside, in which case you'll have to allow for parallax differences. At present, with most cameras this is the best way of seeing your live image on your computer screen. Some new stills cameras have a live image on the back of the camera, like the Olympus E330, but the quality of the image is too poor to work with.

compact point and shoot

This is a consumer camera useful as an entry-level training tool, but will not give the versatility or resolution you would require on a serious or broadcast project. The image sensor is small, as is the lens, and generally cameras have autofocus. On most consumer cameras the image is compressed as a **JPEG**, which basically means the exposure, tone and color are calculated for you. Digital stills cameras do not have a live video feed to your computer, so are not compatible with frame-grabbing software. You can attach a low-resolution video camera to your computer, which could either be aimed through the viewfinder or close by your camera, so that you can use the frame grabber's various facilities. Expect to pay from £50 (\$100).

SLR (single lens reflex)

There are qualitative options regarding choice of camera, and if you are choosing to shoot on the high-end SLR (single lens reflex) camera, you need to bear in mind further options, as these will have a bearing on your computer storage capacity.

There are really two types of SLR – the semi-professional one doesn't have the huge resolution capacity that the fully pro SLR has. The pro-sumer SLR has a 7-8 MP (megapixel) sensor, and cannot be used truly manually. Consequently, this kind of camera can be bought for around £500 or \$1000.

A full SLR will give you extremely good resolution; the image sensor on a top-of-the-range SLR can give you up to 17MP. A camera can set you back around £1000 (\$2000), and that's before you start buying the separate lenses you'll need. The Canon EOS 1Ds Mk2 that was used with Nikon lenses on *Corpse Bride* would be around £5000 (\$10000).

Another benefit of using this level is the ability to completely manipulate your images.

RAW

On a professional stills camera you have the ability to use the RAW image format. This means the image is recorded and stored as the sensors see it, unprocessed. On most cameras your images will be pre-processed as JPEGs, so that you get the optimum quality. With a RAW file you can save your settings for exposure, color and tone in the file, and you are then able to convert that information to JPEG or TIFF, bearing in mind that you still need to expose it correctly in the first place. You are then able to apply these settings to your whole film. With RAW you'll get much higher resolution images so you need plenty of storage room on your hard drive.

One of the drawbacks using digital stills cameras is the resulting wear on the shutter, as the cameras haven't been designed for that workload, which may not be a problem on a one-minute short, but may present problems on much longer films. There is a wealth of information at the www.stopmoworks.com site and www.stopmotionanimation.com.

Once you have your images stored, it is more suitable to transfer your images to a photographic stills software rather than a movie editing software. For an excellent description of how this is best achieved, have a look at Phil Dale's website, www.phildale.net/digitalstills. html. Phil was head animator on *The Periwig Maker* and also worked on *Corpse Bride*.

webcam

This is a low-cost, low-resolution solution, using the USB connection to the computer. Webcams provide a simple and very affordable way to get into stop motion and get a feel for it, doing some basic animation tests. The optical quality, however, is too poor to consider for any serious projects.

lenses

The huge difference in price between professional and consumer digital cameras is created in the most part by the size of the image sensor and the quality of the lens. You have to remember that to get the best quality out of your recorded image, the lens is the most vital component – as everything from the lens onwards degrades the image. Go for the best quality lens you can afford.

Digital camcorders and point-and-shoot stills cameras have their own zoom lenses, which are going to work automatically, with no manual control. One important thing to check is that you have an 'optical' zoom rather than a 'digital' zoom – a digital zoom will simply enlarge the picture, reducing the quality. Interchangeable lenses are available for the SLR cameras. For a 'pro-sumer' SLR camera with a big lens and small sensor, the standard, or as close to normal eye perspective, is afforded by a 35 mm lens. For a professional digital SLR, the normal focal length is 50 mm, with a wide angle at 28 mm. Second-hand lenses for old-style 35 mm film still cameras will still fit many of the new digital stills cameras. So you can look for a set of lenses that will give you top quality from wide angle to close-up.

Zoom lenses may afford you all the sizes of shot you'll need on one lens, but your optical quality is compromised by the extra glass needed to make that happen. Also, with a zoom lens the widest aperture you'll get is generally f2.8, whereas a prime lens has a fixed focal length, so you have to change lenses if you want to go wider or go in tighter. **Prime lenses** have better optical quality and can open up as wide as f1.2. This becomes important if you are working in low light conditions.

To get a closer-focused shot than you can with a standard lens, you can use a **diopter**. These are supplementary lenses, useful on miniature sets that come ranging from a $\frac{1}{4}$ diopter to a +2 diopter, depending on how much magnification you need. Alternatively, you can use extension tubes that fit between the camera body and the lens to focus closer.

animation software/frame grabbers

Up until the 1980s animators worked 'blind', not being able to see the results of their handiwork until the film came back from the labs the next day or perhaps a week later. Inevitably, this caused stress and sleepless nights, but that was how it was, and many traditional animators would say it gave them an edge that's been lost now that you can check every frame. Barry Bruce, Creative Director at Vinton's, the US studio famous for Claymation®, maintains it has slowed animation up. Working blind, he says, gives you a flow and a more instinctive feel for the animation that is unique to model animators. There's no denying that, for the less than super-skilled animators, frame grabbing, or frame capture software is a godsend.

It allows you to capture your animation, with a camera feeding images frame by frame, into a computer. You review your frame before 'grabbing' it and if you are satisfied with it, you can store it and compare it to your live image. This way, you can see how your animation is progressing frame by frame. You should be able to overlay your live image over your stored image, and see exactly how far to move limbs, drapery and hairs. You can go backwards and forwards frame by frame, or set up a loop, to show the animation in real time up to your current 'live' image.

In the late 1980s in the UK, animators were using tape-based video assist systems with single-frame facility. The PVR (Perception Video Recorder) made by the Canadian company Digital Processing Systems was a device for computer graphic artists to render onto and play back their animation in real time without the need for an expensive tape-based system. Cosgrove Hall and Aardman Animations had both waited many years for animator-friendly software. David Sproxton, director of Aardman Animations, remembers:

We saw it at the Cardiff Animation Festival, around 1990/1. As it recorded video on a frame-by-frame basis it seemed ideal for our needs. We had extensive faxes going back and forth to Canada describing our needs. Eventually, they sent a guy over to talk to us and things started to happen. The 'Animate' system was really the culmination of our requests and others over the course of several years.

This software helped create a revolution in animation by helping to make the model animation process more accessible, allowing a craft that was previously available only to enthusiasts with a big bank balance or a hefty arts/film council grant to be accessed by anyone, even children starting in primary education.

One of the first affordable softwares was Stop Motion Pro, an Australian software that allowed the animator total control of every frame, being able to flip between the previously shot frame and the 'live' frame (waiting to be shot). It also enabled superimposing or onion skinning both the previous and the live frame, and the ability to delete frames if necessary. Now there are educational and broadcast-quality animation softwares available to download for both Mac and PC with licences available for as little as £20 (\$40). For some good reviews of the different softwares available for Mac or PC, have a look at www.stopmotionworks.com.

Some animation frame capture software will work only with DV camcorders with a Firewire connection, and others will work only with analog camcorders (USB or **S-Video** connections). You will also need a compatible video capture card. Some animation video capture software may allow you to go through the USB connection and may not require a video capture card (again, it depends on the frame capture software). Video capture cards are getting cheaper all the time, but sometimes have the benefit of being sold along with a software package, so it depends on your dealer and some informed negotiation.

The features you should have with your animation software are:

Live overlay or frame toggling – this feature allows you to flick between your live image
and your previously shot frame. You can set it to blink between the frames and a variety
of speeds to see how you are progressing on the next shot.

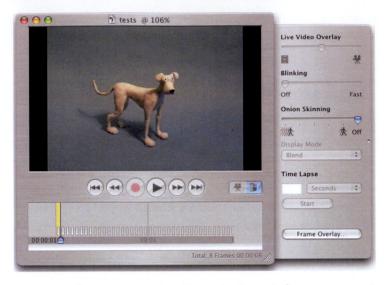

Figure 2.1 Stop motion software screen, iStopMotion by Boinx Software, istopmotion.com. Dog model courtesy of Johnny Tate

Onion skinning – this shows you a 'ghost' image of your current live position. This feature allows you to see how far you have moved in your current animation, take your model off the set to work on and replace it to match the image, and, crucially if there is any set shift or you have knocked anything, it allows you to match to your frame.

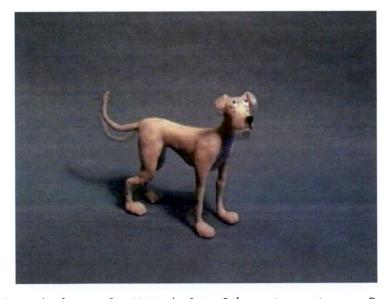

Figure 2.2 Onion skin feature. iStopMotion by Boinx Software, istopmotion.com. Dog model courtesy of Johnny Tate

The frames you have shot are numbered below the screen and you can scrub back and forth between frames using your mouse. This software, used in conjunction with an edit software like iMovie, Adobe Premiere or Final Cut, makes the technical process very quick, I wouldn't go so far as to say foolproof.

To get right away from the nightmare of which animation software or video capture card to choose, there is the extremely straightforward **LunchBox**. This is the simplest set-up of all and is a great learning tool. It has many of the same features as the computer software. Simply plug your video camera and monitor into this stand-alone animation system. It is a hardware device used to create and test animation, without the aid of a computer. It is digital in that all the video is digitized. However, it only has analog input and output. Many animators find this a very friendly way to work.

The LunchBox Sync model 3000P (PAL) model for European use can store at least 612 minutes of animation, although you can get an extra storage facility that allows you to store 18 times that amount. There is an NTSC version for use in the USA. The new LunchBox DV supports digital cameras as well as having several improvements on the 3000 model. The website listed in appendix 1 gives more information on this product.

Figure 2.3 LunchBox Sync. Courtesy of Howard Mozeico. © Animation Toolworks

tripods

You need something solid on which to put your camera: a **tripod**. And no matter in which format you shoot, your tripod has got to be rock steady. It can, of course, have its feet glued into place with a glue gun, but if the legs are flimsy it'll let you down. You need a tripod with, at the very least, a head that you can pan and tilt, and that locks off firmly. Most domestic video tripods come with their **heads** attached. But if you were to find an old wooden tripod there are a variety of different heads for different sensitivities of movement. The **friction head**, the simplest form of pan and tilt movement, is designed for live filming and cannot be reliably used for controlled camera moves. It's perfect for 'locked-off' shots. The **fluid head** is also used for 'live' filming, as it has a cushioned, smooth movement that is not particularly helpful for animation. The **geared head** is far more expensive, but gives

you a *controllable*, smooth movement. This suggests that trying to create camera moves using the ordinary heads is not going to be easy, which is why the professionals use immense computer-controlled robot arms for **motion control**. Because it is preferable, when making your first films, to concentrate on the animation rather than trying to create flashy camera moves, a locked-off friction head is the best bet.

If you have to do a camera move, a Manfrotto geared head (second-hand approx. £150 (\$300)), on a sturdy tripod, gives you more control over your camera movements. There are far bigger, heavier heads which would only be used professionally: the Worral head, Moy head, etc. Nowadays, the heads will be motorized for motion control, but it is possible to do your moves by hand, with a taped pointer on the head and marked tape on the track.

A **tracker bed** that can take the geared or other tripod head will enable smoother tracking. This is a small track to put alongside your set on which you can manually move your camera very small increments per frame. This kind of specialized equipment is hard to find second-hand and will be expensive, but an animation studio that has updated to more sophisticated motion control may be able to lend one. Camera moves on a professional shoot are generally done on a computerized system that allows full motion control.

lighting

Available light (as opposed to created light) is not an option with animation – daylight conditions will change dramatically while you are filming and affect your image greatly. So you need to create an artificially lit set.

The simplest form of low-cost lighting would be with articulated desk or Anglepoise lamps, so long as they can be locked off tightly and don't 'drift' during your shot. This sort of domestic **tungsten** lighting will not create enough light for anything other than a very basic learning set-up. If the light is too low this will reduce your depth of field (the area of your set that is in focus), which presents problems keeping everything in focus if things are moving around the set.

So you may want to experiment with other types of lighting. Another low-cost form to try out is the fluorescent light tube. You can get daylight or tungsten-balanced tubes that'll give you a good overall light, as well as keeping your set cooler than with conventional lighting. It's a good idea to keep your working conditions cool, to avoid soft Plasticine and frayed nerves. Fluorescent lighting can give your film a green cast, but color correction filters are available for this, either to put in front of your camera lens or in your post-production software.

For other low-cost lighting options, **photofloods** and **mini-spots** are available from photographic shops. **Halogen** lamps in the range of 150–300 W (known as 'garage' lamps) are available from most DIY stores and are useful for a wide throw of light. For lighting smaller areas or a smaller set, mini reflector 12 V (50 W) halogen lights can be used with a transformer and a dimmer, again available from DIY stores. You can also get 6 V (30 W) spots that can throw a narrow beam, useful for back lighting or rim lighting (see chapter 12 – the production process).

It may be worth investing in a couple of domestic or display lighting tracks that will allow a certain amount of flexibility and keep the lighting out of the way.

A wide range of lighting is available from film and theatre lighting distributors. Ask if there's any ex-demonstration lighting; sometimes they sell on ex-hire stock. You could invest in a kit of lights: four 150W lights with stands and accessories could set you back around £2000 (\$4000).

Hiring lighting is a possibility, but in hiring any equipment for animation, the length of the shoot is a strong consideration.

Figure 2.4 Arrisun. Image courtesy of ArriGB Ltd

A 200 W Arrisun **PAR** is an example of the sort of light you might use on an animation set and would give a good throw of light as your main, or key, light. It uses an **HMI** bulb and can be focused through a set of lenses. Lights like this can be hired from places like Lee Lighting in the UK, a company that is used by filmmakers. Normally, this would cost around £50 a day or £250 a week to hire, but for an animation shoot one would expect a reduction and any company would negotiate a price with you.

health and safety

Filming on a normal domestic electric circuit you cannot use more than 3100 W. Although it is unlikely you would use this wattage for a small animation set, you do need to know your maximum use, otherwise you are in danger of blowing the circuit by adding more and more lights. Theatrical or film lighting has more controllability in that you can focus the beam, and they also have attachments, making it easier to add filters or diffusers.

For little practical lights to use on the set, you can use torch bulbs and Christmas tree bulbs.

New on the scene is **LED** lighting – low on energy, this comes with a variety of color temperatures, which don't change on dimming. At present, they are new to film and therefore pretty expensive but, because of their low energy consumption, may be worth looking into.

Sheets of white polystyrene or styrofoam board, or white card, are useful as 'fill'. Placed opposite the lights, they are used to take away the black shadows created by strong lighting.

You can find stands and special grips that will hold large sheets of polystyrene or board at lighting hire companies

the animator's toolkit

Apart from modelling tools, which are always a personal choice, you will need a comprehensive toolkit including G-clamps, to hold your world together, every kind of pliers, screwdrivers, but probably the most useful piece of equipment for the new animator is a stopwatch. Timing, the basis of all animation, takes practice. Imagine or observe the move, practise the move yourself, timing your speed; break the move down into actions and then time those actions. The more you do it, the less you will need to rely on the stopwatch.

A hand-drill will be required for creating holes on your set for positioning the puppet's tiedowns – these are bolts or pins fixed to the puppets' feet which fit into pre-drilled holes in the set, and can be fixed by a wing nut from below the set, and will stop your puppet falling over. This is not essential, but it's used extensively in professional animation.

You will also need a mirror to look at yourself, study how you move and look at your expressions. Always have a small mirror on your set – or a large mirror somewhere that you can study yourself in.

Another useful piece of kit is a hot glue gun. It's a reliable and handy way of fixing things down. It is important that nothing moves in each shot, or the story's credibility is blown. The glue gun shouldn't be used on a good floor or table surface for obvious reasons. Alternatively, there is always 'gaffer' tape or duct tape, for use instead of a glue gun; it's tough and very sticky, useful for taping down cables that clutter the floor.

Keep wet wipes on hand to keep your hands clean. They should be lanolin-free and as non-fibrous as possible – the best type in the UK are Boots' own brand. They are also wonderful for cleaning pen marks off a monitor.

editing/sound

A number of editing and sound packages are available. Final Cut Pro (Mac) is a semi-professional editing package that's becoming very popular and, considering it is relatively cheap, is being used more and more by professionals, as editors find they can work from their home computers. A sophisticated post-production package is After Effects made by Adobe, and a popular and well-used product is Adobe Premiere. But there is a large choice of editing software available and it's a question of choosing what you're happiest with, within your budget.

Editing your digital stills is easier using photographic software and transferring them as batches of sequential images. For an excellent description of how this is best achieved, have a look at Phil Dale's website.

recording sound

Whatever you record on, as with a camera lens, the important part is the microphone, as that sources the material. You can get a decent dynamic microphone for as little as £10 (\$20). Top of the range would be a Neumann U87 at around £1900 (\$3800). For more information and advice on sound recording, a good website is www.shure.com.

Dialog needs to be recorded before animation if it is to be synched up with mouth movements, as you will work out your timings to your dialog track (see chapter 8 – sound advice). You can record your sound onto a Minidisc or DAT recorder, or into an audio interface, which should have a minimum of two mic inputs.

To break down your voice track to facilitate lip sync, you can get specific software designed for animators, like *Magpie* from www.thirdwishsoftware.com/magpie or J-Lip-Sync. You can then see your soundtrack displayed in a wave form – a visual translation of the sound – allowing you to identify every accent down to a quarter frame. This allows you to break your dialog down into phonetic sounds so that you can work out your mouth shapes. These softwares also display a bank of mouth shapes as a guide.

Other than dialog, the music, atmosphere and sound effects can be created and added in the edit. You can design the soundtrack to your film using sound editing software such as (professional) Pro Tools or Cool Edit. You can add sound effects, atmospheres and music from library discs, but again, it is going to be a more individual project if you create the soundtrack as much as possible yourself.

The prices mentioned in this chapter are only an approximate guide; they should be checked before any purchase. You would probably do best to look further on the suggested websites listed in appendix 1.

One thing to remember while getting yourself equipped – try not to get too bogged down by technical considerations; remember to be inventive with your problem solving, like Jeff Newitt's quote at the start of this chapter.

glossary

analog (UK analogue): in this case, tape-based, but generally signals that are recorded in analog format are modulated, i.e. their information is contained in amplitude or amount of signal. Digital, conversely, is either on or off, and amplitude is identified in a different way (source: www.qeiicc.co.uk).

dope sheet/X-sheets or bar charts: dope sheets and bar charts are marked up paper pads used in the planning of animation. The dope sheet helps plan the specific timings of action, dialog, music, sound effects and camera instructions. They are used in conjunction with the storyboard to map out and plan animation sequences in terms of storytelling, filmmaking, cinematography and narrative. Bar charts are more specifically just for dialog. In the USA and in computer animation these are called X-sheets or exposure sheets.

Firewire: a very fast external bus computer connection. A single port can be used to connect up 63 external devices.

gaffer tape: wide, tough and very sticky fabric-backed tape available from electrical suppliers; also known as duct tape.

HMI bulb (Hydrargyrum Medium arc Iodide): a flicker-free light source recommended for digital cameras that require long periods of exposure.

JPEG: method of photographic compression. Stands for Joint Photographic Expert Group, who set the standard.

LED (Light-Emitting Diode): A relatively new form of lighting, at present being investigated for use in filming, but still expensive.

mini-spots: small lamps with a reflector, creating a narrow, focused beam up to 200 W.

PAR light: Parabolic Aluminized Reflector with a lens and a reflector.

photofloods: tungsten bulbs used in photography ranging from 250 to 500 W.

pixel: a single point of a digital image. The greater the number of pixels per inch, the greater the resolution.

registration: as the film is passing through the camera, it stops in front of the gate, is held steady (in registration) while being exposed and is then pulled down. If the film moves in the gate at all, the image will jump about so much, or be blurred, that it renders the film impossible to watch.

single frame: film is exposed at normal running speeds of between 18 frames (8 mm) and 24 frames (16 and 35 mm) per second. Video records at 25 fps (USA 30 fps). Single frame means exposing one frame of film at a time. Video actually records two 'fields' for every frame.

S-Video: S-VHS – Super VHS connector.

telecine: film labs' term for transferring film to video or digital format.

U-Matic: an old tape-based video system.

USB (Universal Serial Bus): an external computer connection.

chapter 3

getting animated

chapter summary

- animating familiar objects as a first approach
- setting up for the first time
- notes on movement
- timing: single frame or double frame?
- squash and stretch
- the dope sheet/X-sheet
- planning

I began making films as a teen on my own in the late seventies. I never attended any kind of film school. I worked in Super 8 and managed over the years to make a series of short, rough and cheap films. Learning to pull off good animation was my main motivation. I soon came to realize that it was important to make a complete film, not just a string of pointless animation tests that no one would want to watch. Then the clay characters became actors telling a story and it all was much more interesting.

Tim Hittle, animator on Monkeybone and The Incredibles

animating familiar objects as a first approach

Your ultimate aim may be to make a story in which your characters are the actors. If you start from the very beginning thinking about giving a performance, even the exercises suggested in this chapter will become imbued with life. It is the key to character animation and will take the dryness out of any practice work that you do. The exercises included all have a practical basis, but in order to keep them interesting, think about giving the piece of Plasticine, or matchbox, that little bit of character that will bring it to life.

This chapter doesn't give those character animation tips, you will progress on to that later. My suggestion is that if you begin by thinking of exercises in terms of performance, you will get there quicker.

First of all, before you attempt something more elaborate, pick some everyday objects and try to breathe a little life into them. Don't give yourself extra work such as rigging to stop something falling over, or having to articulate 'limbs' that flop around and need stiffening, or overcomplicate things by building sets and constructing armatures. Inanimate objects are a good way of learning about animation and character. Take a matchbox and try to imagine it as a dog or a car and then start giving it dog/car characteristics. For instance, the dog wants you to throw a ball for it. So it's panting, wagging its tail and jumping up and down. It quickly becomes apparent that it's quite hard to do this or to make your matchbox look like anything at all, let alone a panting terrier. And yet, while you're practising – and this doesn't have to be filmed at this stage – what you are doing is imagining all the movements this dog is making, you are thinking about the timing of the movements and you are taking the first crucial steps in the process.

If you can start to get some recognizable 'doggy' movements out of this matchbox you'll have some understanding of the *performance* of animation, then think how much easier it will be when you are using a toy dog, or even an articulated puppet dog!

setting up for the first time

I am going to assume that you are using a computer with animation software and a digital camera, and help you get set up for the first time to do some exercises. As these are just exercises you won't need elaborate lighting, just some desk lamps to bring up the general light levels. Use a flat table with a board clamped at 90° to the back, then you can drape some plain paper from the top of the back board to cover your table, so there's a smooth background with a curve. This gives you a set-up that will be suitable for some later exercises.

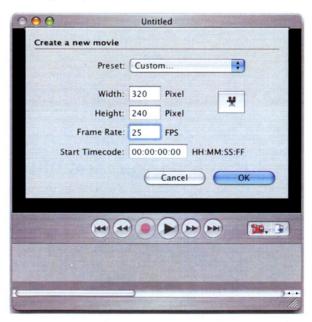

Figure 3.1 Opening screen for stop motion software, iStopMotion by Boinx Software, istopmotion.com

Then set your lights and camera. The DV camera can be plugged into the mains (so you don't run out of power at an annoying time) and will have a lead out to the computer (DV to Firewire). If you are using a digital stills camera make sure it's got a compatible setting: some need to be set in 'PTP' mode, others in Playback setting; the camera should have instructions. The camera needs to be on a tripod that is fixed in position, so that you can't knock it over. Anything that is not being animated also needs to be firmly fixed in position.

Place the computer in a position that you can easily see the screen. Take a bit of time rationalizing cables, so you're not tripping up or having to lean over cabling – and switch on.

To start with, you have to make a couple of decisions telling your computer how you will be working. For instance, the 'preset' information menu can come from your camera, so click on the camera icon. The resolution of your film is dictated by the pixel size you choose – start with a small size, you don't need to consider resolution at this stage. Your frame rate at 25 frames per second is standard for animation. The timecode will start at your first frame.

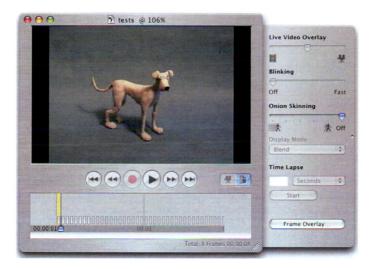

Figure 3.2 iStopMotion by Boinx Software, istopmotion.com. Courtesy of Boinx iStop Motion

This what the screen would look like. This image has an **aspect ratio** of 4:3. The aspect ratio is the width of the displayed image divided by its height. The two popular aspect ratios are 4:3 (1.33:1) for the television screen and 16:9 (1.78:1) for high definition television and European digital television.

There are guides on the screen to help you see how much of your picture may be lost if transferred to TV. The outside line shows the 'picture safe' guideline – keep your composition

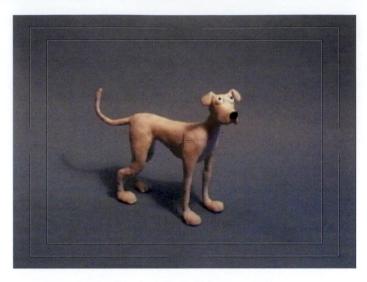

Figure 3.3 Screen display with 'picture safe' and 'title safe' guidelines. iStopMotion by Boinx Software, istopmotion.com. Courtesy of Boinx iStop Motion

within this guideline. The inside line shows 'title safe' – this gives you a guideline that your titles should not stray outside. These guidelines appear if you click 'frame overlay'.

Check your composition – that you have enough frame space for the action you are attempting – you don't want to have to re-frame in the middle of a shot.

Once you have your frame and the camera is focused, you can start by taking your first frame. It helps sometimes just to shoot some still frames at the beginning of a shot to give your eye a bit of a run-up when you are looking back at a movement. A one-second hold is enough.

exercise 1: easing in and out

An essential first step in animating movement is to understand that a movement will start slowly, then accelerate to a constant speed, then, unless forced to a stop by something unexpected, will ease to a stop. To do these exercises you'll either need to adjust your camera so that it is angled at 90° to your table top, or place a board at an angle on your table top, that the camera can film at 90°.

 Measure out 25 evenly spaced marks in a straight line approximately in the middle of your screen. Using a coin (if you are on the angled board you'll need to fix your coin in some way), just move it straight across your screen in 24 evenly spaced moves: one second.

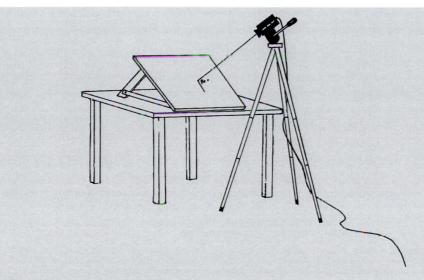

Figure 3.4 Animation exercise set-up.

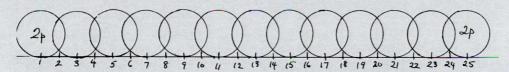

Figure 3.5 Moving coin.

2. Try easing it in with smaller moves for the first few frames, increasing till at eight frames you are travelling roughly the same distance between frames as the previous exercise. Then at 13 frames start to decrease your moves. Try different speeds of cushioning in and out and see what different effects this has on the action. Give the coin a two-second move, i.e. 50 frames.

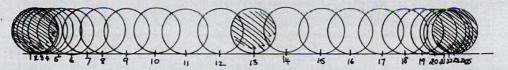

Figure 3.6 Moving coin: easing in and out.

notes on movement

The bouncing ball is often given as a starting point in animation training because it is a simple way of looking at movement and the forces that make things move. It brings together

many of the principles of animation in one simple exercise and is all based on physics – Newton's three laws of motion – which, if you really want to know, are that:

- An object at rest remains at rest until acted upon by a force; an object in motion continues
 moving in a straight line at constant velocity until acted upon by a force.
- Acceleration of an object is directly proportional to the force acting on the object and inversely proportional to its mass.
- For every action there is an equal and opposite reaction.

It's not necessary to understand these laws in depth, but when you start looking at things falling, or balls bouncing and hitting walls, or a car skidding around a corner, you start thinking about gravity and friction acting upon things, and then you are beginning to understand movement.

As an animator you need to:

- 1. Give weight to inanimate objects you need to consider how long it will take for a rock or a leaf to fall.
- 2. Give weight and movement to a living creature you want the audience to believe your puppet is a living, breathing, thinking entity in its own right, so it should have a 'life force' of its own.

By getting right back to the basics of movement, you can learn how to give weight, thought and vitality to your puppets. If a ball is thrown into the air, the force throwing it is the person, the force causing it to slow and drop to the ground is gravity. The heavier the object, the more force is needed to move it, so when animating a heavy object, you would start it off slower than a light object.

A movement builds up speed and then slows down again to a stop, unless it is interrupted. If you lift your hand, the movement will start slowly, then slow down again before stopping.

If you roll a ball along the ground, unless it bumps into something, it will eventually slow down and stop. The force that puts it into motion is you, the forces that slow it down are gravity and friction (the surface of the ground). A sense of weight is created by how much time you give a movement: very simply, a creature that moves slowly seems heavier – a dinosaur, an elephant or a giant lumbers slowly along. A creature that moves quickly seems lighter – a scurrying mouse or a scuttling insect. The quicker a creature can gather speed, the lighter or younger it is; the slower, the heavier or older. For example, a heavy person will take longer to get up from a chair than a light person, but not necessarily be slower to sit down again, as gravity is helping them.

If you were to animate a ball being dropped to the ground, the movements would be close together for the first few frames and then, on each successive frame, the movements would get wider apart because the ball is accelerating until it reaches a constant speed. As the ball is not going to slow up before hitting the ground, there would be no decrease in increments.

There are situations, as in Disney's Fantasia, where a hippo floats on a fountain of bubbles or an elephant gets trapped inside a floating bubble. You may not want things to move realistically, but understanding the rules gives your animation credibility and, having demonstrated that you understand them, you'll get a bigger audience reaction when you break them.

timing: single frame or double frame?

The first principle of animation is based on persistence of vision: the way your eye joins up consecutive still images to make a moving image, and the amount of difference from one image to the next that the eye will tolerate and translate as a fluid movement. Film and video is projected at 24 (film) or 25 (TV) frames per second (fps). These speeds were arrived at as being an optimum number of images per second for the eye to perceive smooth movement. In the UK, Europe and Australia, wherever the mains frequency is 50Hz, video playback is at 25 frames per second. In the USA and Japan, where the mains frequency is 60Hz, video plays back at 30 frames per second. The playback speed for computers is variable: digital formats such as Mpeg, the highest quality digital files, will play at 30 fps but Quicktime will play at 10–15 fps, Quicktime 3 at 15 fps and RealMedia plays at 3–6 fps. This would require a different approach and, generally, in this book I am basing the animation on 24/25 frames per second.

However, this does not necessarily mean that in animation you have to produce 24 or 25 different movements per second in order to create an acceptable flow of movement. You learn to calculate whether you can convey convincing movement by changing the move every two frames, more or less.

Should you work in single or double frames? Ones or twos? It depends on the movement. Single frame is when you move on every frame, so there are 24/25 different shots per second. This creates a very fluid, smooth movement, useful for hand gestures or a flag waving. If you are shooting a very fast action it might require shooting on ones. Shooting on twos is quite acceptable and in fact the animators at Aardman tend to favor twos to keep a lively sense of action. Nick Park prefers working fast and not getting bogged down by too much technique: 'I don't notice technical smoothness – that doesn't interest me – that can work against a character sometimes.' However, that would not stop him using single framing in certain situations. For instance, if you are filming someone running across the screen in six frames, very fast, you will need to shoot on singles, or the movement won't even register with the viewer.

Look at the coin exercise again at one frame per move, then see the difference when you change that to two frames for each move – you'll see the single frame looks smoother.

When you are studying the timing of a movement you first of all break it down into seconds, then you break it down into frames. Use a stopwatch to help get used to timing. Get used to counting seconds, half seconds and so on, tapping out the rhythms, so that when you make a hand gesture, or bounce a ball off the floor, count out the move.

Anthony Scott, who animated Jack in Nightmare Before Christmas, suggests:

Say 'one-thousand-one' as you're acting out your motion. Then use this to figure out frame count:

one = six frames one-thou = 12 frames one-thousand = 18 frames one-thousand-one = 24 frames. I use it all the time, it's a built-in stopwatch.

As you get to understand animation, you learn that to hold for longer can convey certain movements or emotions or, if you are filming a fast action, it may be you need to shoot it one frame per move.

exercise 2: the bouncing ball

A useful exercise when starting out is the bouncing ball, useful because you learn a variety of basic skills in a relatively simple exercise. You are learning first about timing and, second, about using timing to create an illusion of weight.

You can use the same set-up here as for the coin exercise. For the ball you could use either a coin held in place or a flat Plasticine disc that you can shape to make it squash and stretch (next exercise). Make some spares.

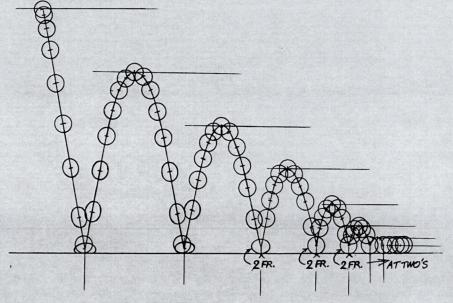

Figure 3.7 Bouncing ball parabola (ping-pong ball). Illustration by Tony Guy

The shape a ball makes in the air is a smooth parabolic curve, or arc. The ball slows down at the top of the arc, so the moves will be closer at the top. You can plan this shape on your background or on your screen with a marker and give the ball a trajectory to follow, marking the increases and decreases in the speed of its movement.

The accent is at the points where the ball hits the ground; the spacing of the ball as it moves through the air will give the smooth, naturalistic movement (Figure 3.7).

Mark out where you think the ball will hit the ground first and in the following bounces. The bounces will get smaller and closer together as the ball loses energy.

squash and stretch

If you were to exaggerate the shape of the ball by flattening it as it hits the surface and elongating it as it comes away from the surface, you are employing one of the first tricks that start giving weight and movement in animation. Experiment with different amounts of stretch and squash. You could give it a sense of speed by elongating it on the fall or after the bounce of the arc. Or you can create more impact when the ball hits the ground, as if it's been thrown down, by elongating the ball at the frame before contact with the ground. It's easy to overuse the effect and end up with your ball looking as though it's made of soft putty, rather than rubber. The right amount will add life and spring to your ball.

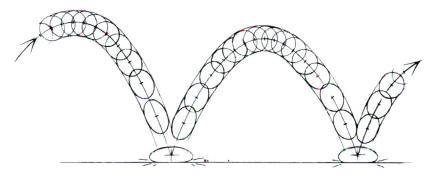

Figure 3.8 Bouncing ball parabola with exaggerated squash and stretch. Illustration by Tony Guy

Try out a variety of balls. Knowing that a ball will bounce in relationship to the force applied to it and the surface it is hitting, here are some examples of the type of bounce you would expect when different forces apply. Draw your arc onto your surface as a guide, and mark off the 'increments' or measurements. Play back what you've shot and study it for timing.

A ping-pong ball is light and therefore has very little resistance, and, when dropped, can go on bouncing for some time. It is rigid and would have no squash and stretch. It will come out of a bounce very quickly. Shoot this on singles; try it with two frames on the ground so that the contact will register.

A football would be heavier and therefore have more resistance. If it is just dropped it will not bounce as high as a ping-pong ball or a tennis ball. A football is designed to be kicked. A foot kicking a football will slow up momentarily on contact as the force is transferred to the football – the football will squash a little in taking the force of the kick and then be flung into a parabola.

A really heavy object will take more force to start it moving. To lift a cannon-ball into the air takes a powerful ignition, then once it is airborne, the momentum of that force is lost against the constant force of gravity, and the cannon-ball falls to earth. It will have a little bounce, rather like a bowling ball. Figure 3.9 illustrates the effect that the force has on the cannon as well (it's not necessary to create a cannon for the experiment).

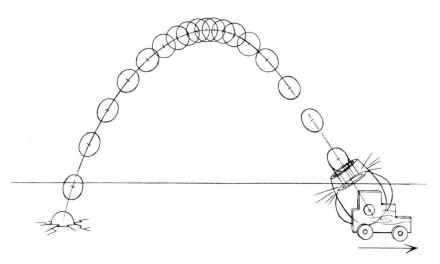

Figure 3.9 Cannon firing ball. Illustration by Tony Guy

Using the Plasticine, make a square shape. Then animate that in the same way as the bouncing ball. Drop it in from the top of frame and decide how it's going to bounce when it hits the floor.

air resistance

A balloon has very little resistance and is susceptible to a small force: the flick of a finger or a puff of wind. Air resistance will keep the balloon up in the air. Falling leaves are slowed up on their descent to earth by air resistance, but the fine edge of the leaf will cut into that resistance, causing an erratic zig-zag descent.

the dope sheet/X-sheet

Breaking down a movement is the first stage in planning. You can use a dope sheet or X-sheet (see Figure 3.11a) to express your movement in a very visual way. These are designed for

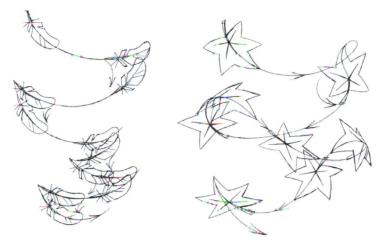

Figure 3.10 Falling leaf or feather – use the line of the leaf stem, or the feather quill, to plan your line of descent. Illustration by Tony Guy

Figure 3.11 (a) Dope sheet. Courtesy of Chromacolour International Ltd. (b) Bar chart used for sound breakdown. Example courtesy of HOT Animation. © HIT Entertainment PLC and Keith Chapman

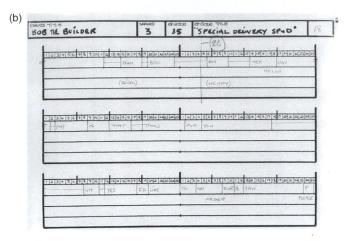

Figure 3.11 continued

2D animators, but are used by 3D animators to chart timings, actions and camera moves. The sheet is divided up so that you can break your movement and dialog down to 25 frames per second, as well as adding in any camera instructions you need. There are also bar charts (Figure 3.11b) which you can use; these concentrate more on sound, but you can mark out action on them as well.

Dope sheets and bar charts are available from animation suppliers (see appendix 1). Apart from helping you, this is a great way to communicate if other people are going to be helping you to animate.

planning

To be really emphatic about the animation, it's hard to describe, but if a fist is slamming into something – like a table – you **don't** want to slow down. As the fist gets nearer to the point of contact, the increments get bigger and bigger until it slams into the table. Plan ahead well so that you're not left with a small increment when you hit the table. Plasticine is perfect for this. You can sculpt it and press it right into the table so that absolutely no light shows through, whereas a latex fist will leave a little space, a little light – it's almost impossible to get it truly flat.

Pete Lord, Aardman Animations, director Adam, War Story, The Adventures of Morph, Chicken Run

If you were doing 2D animation you would probably plan every movement and divide it up into 'key' positions, and then plan all the in-between drawings. For obvious reasons, model animators don't work this way. You start at the beginning and carry on going until you've finished. But you can plan out where you need to be on your set.

UK animation director Barry Purves used a good exercise with matchboxes when he was teaching trainees at Cosgrove Hall Films in Manchester. The matchboxes were dodgem cars.

Two dodgem cars are destined to collide. So the animator has to make sure that the movement is planned so that the collision happens at the right speed. If this shot wasn't planned, the cars could end up chasing each other round in circles, and just missing – a frustrating experience!

exercise 3: dodgem cars

This is a good basic exercise in timing and planning:

Both cars start at the same time from standstill from different parts of the set. They
need to build up speed then the speed will level out.

Decide what direction they are travelling in and what their route will be. You can make little invisible marks on your tabletop, marking each movement out, or put the marks on paper that you can lay down between each frame.

3. One car could take a wiggly route, the other could move in a smooth arc, but they both need to collide in, say, five seconds.

4. Work out where the cars are going to bump into each other.

5. There is no slowing down of the speed before they collide, so there is quite an impact. This causes both cars to react by bouncing back (action and reaction). So the increments (measurements) should look as shown in Figure 3.12.

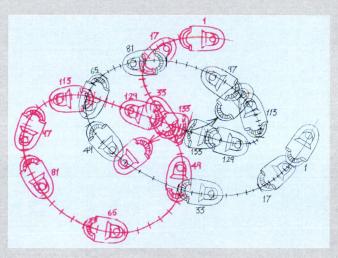

Figure 3.12 Planning a move. Illustration by Tony Guy

As the car builds up speed, the increments start small and increase, and similarly the increments would become smaller and smaller if the car were slowing down to a stop, except in this case there is no slowing down: it has collided with another object.

Another thing to take into account setting up this exercise is that you are not working on the two-dimensional plane you were using for the balloon and ball exercises. Now you have two objects in a three-dimensional world. You will need to give yourself enough light to keep both 'dodgem' cars in focus. Check the focus of the cars at their furthest apart positions by zooming your camera in to each one. Give yourself enough light to reduce the difference in focus between the two objects (for more information about lighting, focus and depth of field, see chapter 11).

the old ones are the best

Try these exercises: the bouncing ball, matchbox/dodgem cars. All these exercises have been tried before by animators and the smart ones will refer back to them over the years. They will be well received on a showreel, because they show you have wrestled with some of the crucial principles of animation. But try to think of better ones, and create some of your own, no more than 10 seconds long. And a word of warning – it's easy to get caught up with exercises, especially now that equipment is so much cheaper and it costs nothing other than your precious time to go over and over your animation to improve it. These exercises are valuable but don't let them inhibit you in your progress as an animator. It's quite a good idea to do an exercise once, then again to correct it – but then move straight on to another using what you've learned. Otherwise you can get bogged down in detail, which can get frustrating and hold you back. Animation is a slow process – you need to let your instincts help you where you can and not get caught up too much in the mechanics.

I always admired Pete Lord's work – with Morph and the early stuff with Vision On [BBC children's program initially for deaf children, which contained Aardman's seminal character 'Morph']. I loved the ideas – the little sketches, Plasticine characters. They would only last about a minute. There'd be somebody hoovering [vacuuming] up and they would hoover up everything in the room. They would eventually hoover up themselves. Just starting in one place and seeing where they ended up – without a script. I think I like animation where you are still aware of the medium it's made in.

Nick Park

chapter 4

keep it simple - developing your story

chapter summary

- idea script treatment
- planning your shots basic film grammar/ composition of shots
- the storyboard
- editing animatics and story reels

It's normal for people to want to make something elaborate. I'd say – keep it really simple. Work within the resources you have and keep things as simple and intimate as possible – concentrate on giving a performance. Begin by giving an inanimate object some character. Even if it's only a 10-second piece that expresses a simple idea, it's going to mean so much more than if you say: 'I've got this amazing storyboard' or 'I started making this model but ...' – where's the film?

leff Newitt

idea – script – treatment

It's much easier to keep it simple when you have a really good idea. Sometimes the idea is great, but you can't think of the best way of expressing it. There are many different planning stages you can go through to give an idea a really good working over – then you will know after a while whether it's the business. If you are trying to sell your idea, you will need to go through quite a few drafts before presenting it to a commissioning editor, and probably several after that stage as well! Always try to go with your instincts.

The first stage in developing your **idea** is to write a **script** and from then work out a **treatment**, where you need to start planning the look of the film, the design of the characters and, just as importantly, the sound for your film. Animation is a very different process from other filmmaking activities, the main differences being that the voice track is recorded first and that

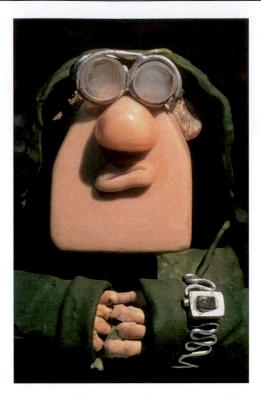

Figure 4.1 Trainspotter, directed by Jeff Newitt and Neville Astley. Courtesy of Hellzapoppin' Pictures Ltd

most of the editing is done in the planning stages. Each stage you go through helps you to visualize more precisely how it is going to work. I recommend that you do go through each of these planning stages with your idea. It can seem painfully slow – but it is always worth it.

No amount of set dressing and character design will make up for a weak plot. Unless you are very happy with your script, it's not worth going to the trouble of building elaborate sets or the expense of model making. But if you have an idea really worth developing, then you need to plan properly.

the script

This is a cue for another book – scriptwriting is a craft in its own right. The main thing to remember is that you must *entertain*. And that doesn't mean you have to be funny. Entertaining people is making sure that they have really engaged with your idea – and they get some emotion from it. If your ideas are too obscure you will diminish your audience. This is not to say that you should create a film purely to please people, but if your idea has clarity and focus, it can be weird but still entertaining. One of the clues that you're on to a good thing, apart from the obvious laughter or tears, is when people feel the hairs go up on the back of their necks. Then you know you've got them. However, you need to sustain that interest from beginning to end of your production, and that is where an experienced editor can help you.

There are many film styles your idea may fit into, or you may be creating something different. Film styles have always developed and changed, and some of the early techniques for narrative film have been challenged by filmmakers such as Buñuel, Hitchcock and Tarantino. Narrative filmmaking has also been influenced by documentaries and commercials, and probably most dramatically first by music videos – which veer away from narrative style to a more sensory style – and second the internet, which has challenged conventional filmmaking by allowing access to anyone with a camera.

find a good editor

Running your ideas past an editor at the planning stage (someone with experience of editing dramas, especially shorts) will help you. Editors are skilled in knowing what works and what doesn't, filmically. You probably know something of this yourself if you go and see a lot of movies (as you should do if you are planning to make one). When you come out of the cinema, ask yourself if you liked the film: if you did, why did you like it? What made it good – what made it bad? Were you gripped from the first scene? Did your attention wander? It may have been a great idea but somehow the tension got lost and you started to think about other things. Editing can make or break a film. The editor is usually someone other than the director. If the director is editing their own film, it's easy for them to get carried away by their own ideas and not always be aware of the impact they will have on an audience. So show your script to an editor and then later, when you have a storyboard, have that properly edited too. Editors tend to specialize in different types of work – documentary, feature, commercial – so someone with experience of cutting short films would be the best bet.

Give your characters a history. This will help your animation later, and help them develop as real characters for your audience. Giving them a history also helps in the writing. Nick Park commented on writing Wallace and Gromit scripts:

Now that they exist, it's much easier to write them, not just for me but because we feel like we all know them, so we know what they would do and wouldn't do. If you put them into any situation, they sort of start to write their own story, because of how they would react to that situation. It takes a little finding out. But that's what I find is a good way to write the story, to ask 'What do the characters want?' at any part in the story. Once you know what they want, you know what they will do. Otherwise you have them doing things that are just off the wall, not really motivated.

You've got to have a good idea to start with. Just recently, I've been trying to think up new ideas for future Wallace and Gromit films – you can think of new characters that might come in, but these are more superficial, less important elements. What works is to think on the level of 'What's their dilemma? What's their problem?' rather than think what new character you could bring in. There's nothing worse than thinking 'Oh – you could have an anteater in the next one. Hmmm ... what story could an anteater get up to?' That's difficult because that's starting with a blank piece of paper. It's better to think, 'What problem do they have where an anteater could intervene? Or mess things up! What's their issue? How does the anteater make it more complex? How does an anteater invade that situation?'

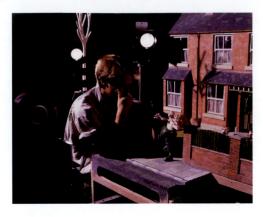

Figure 4.2 Nick Park. © Aardman/W&G Ltd 1993

treatment

The treatment puts your script into a visual format, so that you are describing what is happening as each scene unfolds: 'Fade up on a dingy rooftop, view of distant cityscape, gray, overcast sky and the sound of distant traffic. Three pigeons peck about and preen on the roof ledge. Sound of old voice croaking a song off-camera. Old lady enters camera right, shuffling along, carrying washing basket ...' This is a real mental exercise and helps to order your thoughts.

planning your shots - basic film grammar/composition of shots

When you have a script you need to really start putting your characters in context. In order to storyboard your film, you have to first make some visualizations: drawings of what the scenes will look like; the world your characters inhabit. Not only do you need to make your characters believable to an audience, you need to make their world credible. This is not as difficult as it sounds, it is simply a matter of planning each stage and thinking it through – always with your audience in mind.

aspect ratio

Your screen size will affect the composition of your shots. These are the ratios that describe your screen size. Different aspect ratios have been developed for TV (4:3) and European digital TV and HDTV (16:9). You can set up your aspect ratio on your animation software screen.

plan

A bit more detailed, – a plan drawing (as seen from above): where are they, where are they moving to? Plot out all the character moves on a plan. Then you can start marking camera angles. Imagine yourself as the camera. What are you seeing? What do you want to see/need to see? This can develop into a 3D cardboard mock-up, which will develop later into your set: The more you can work through in the planning stage, the better your story will become. You will sift out unnecessary information and keep the ideas that make the story flow.

film grammar

In order for your story to work, you need a sense of how your images will relate to each other to tell the story, and how the audience will see them on screen. This is called 'film grammar'. When first starting out with a script, it's easy to get absorbed in detail and not look at the bigger picture. Watching other films will start to give you a feel for film grammar. The action should flow from one shot to the next; if the action suddenly changes direction, without any visual clues, the audience can be momentarily disoriented, long enough to break their concentration.

Watching other people's work has inspired me along the way. Bob Godfrey's Roobarb and Custard was a big influence on me. That disregard for technical slickness. It's all about execution of ideas and humour and freshness and making that whole approach attractive in itself – the wobbly lines – and in fact he even used his own voice – a very handmade approach, getting close to the medium.

Nick Park

how to angle your shots and give them continuity

First of all it is important to establish what is going on for the viewer. The **establishing shot** is generally a wide shot giving a geographical location, such as a wide shot of a room or a landscape. The viewer can then be taken into the action. Without the establishing shot, the viewer doesn't know where they are. The director knows, because it's in their head all the time. That is what you, as director, need to remember at all times: how is the audience seeing it?

A shot is made up of several elements. One of these is **composition**: this has developed into a convention through fine art, photography and film. The more you've been exposed to, the more you will recognize what makes 'good' composition. Essentially, composing your frame is you showing the audience what you want to show them. If the location is a bedroom, it's up to you what part of that room we see – whether we look in from the hallway, giving a sense of depth, or secrecy (Figure 4.3A), or whether we are right there, in the room with the action (Figure 4.3B).

Figure 4.3 (A) Bedroom from hallway. (B) Bedroom interior. Illustration by Tony Guy

camera angle

It is conventional to change the camera angle when you change a shot; if you don't change the angle sufficiently it can look like a 'jump' cut.

A jump cut describes a cut that can confuse or surprise the viewer: it may not be enough of a difference from the previous shot, and therefore look like a bit of the film has dropped out. Traditional camera practice states that you shouldn't have less than 30° between two consecutive shots of the same action. However, there are always exceptions to the rule. A situation might arise when you need to shock the viewer – as in a series of quick shots getting closer to the subject. An extreme camera angle means something more dramatic to the audience. A low angle makes the character seem bigger, possibly more threatening, whereas looking down on a character makes them seem smaller and less significant. So camera angles bring a lot to the story.

motivation

What is the motivation to cut to another angle or to cut to another shot? A movement is a motivation to change; it doesn't need to be a large movement, but the viewer is drawn to the movement. If it is the character's eyes looking to the left, we want to see what they are looking at. So the next shot would logically be what they are looking at (see Figure 4.4).

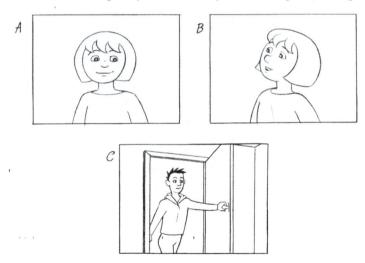

Figure 4.4 (A) M/S character looking forward. (B) M/S character looks to the left. (C) W/A shot – new character enters from the left. Illustration by Tony Guy

We might want to speed the action along. A shot of someone walking from A to B may be unnecessary and boring, as well as providing a massive amount of animation on the actual walk, so think of angles that can provide the information of the character moving from A to B without spelling it out.

continuity

It is important that one shot flows into the next without jumping, and this is helped by the action continuing in the same direction. For instance, if the characters are seen leaving left of

stage in one shot and entering the next shot, it is important that they are walking in the same direction for continuity, so they would enter to the right of the stage.

You want to make sure the audience know, even if it is off screen, where the door is, or where the other people are in relationship to the character that's in shot.

crossing the line

This is one of the basic rules that even professionals get wrong, regularly. It is about knowing how characters relate to each other and how the viewer sees them, and the confusion of putting a 3D world onto a 2D screen. If you imagine a conventional set with two characters

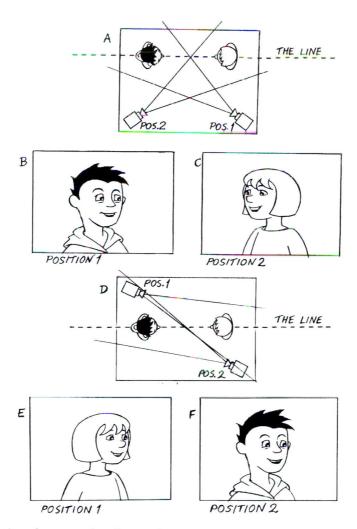

Figure 4.5 (A) Plan of two people talking with camera positions 1 and 2 the same side of the line: (B) shot of character 1; (C) shot of character 2. (D) Plan of two people talking with camera positions 1 and 2 different sides of the line: (E) shot of character 1; (F) shot of character 2 (both looking the same way)

conversing, the line of the action goes through them, so that if you shoot one character from position 1 and the next from position 2, the other side of the line, the result will be confusing. However, if the camera were to move, or track round from position 1 to position 2 while filming, the viewer would understand the geography of the situation (see Figure 4.5).

reverse angle shots

Sometimes you need to see a shot from the reverse angle, e.g. a character is conversing with another – if you angle the shot over character A's shoulder, looking at character B, the reverse angle shot would be looking at character A talking from over character B's shoulder. This kind of shot has an impact on the set – and can mean you may want to make removable walls.

camera move in a shot (pan, tilt, zoom, track)

One needs to think carefully about camera moves. Unless you have a large budget and can afford the equipment necessary for smooth movement, camera moves can be tricky to manage. Most stories are better told when the camera is unobtrusive. There would need to be motivation for a camera move. As in all cases, you will need to carefully calculate the increments for your camera move, working out how long the move needs to last for and then calculating the fairings to ease in and out of the move. I'm adding details at this stage as it may impact on your planning.

Panning, or swinging the camera from side to side on its axis, sometimes following the action, or moving from one character to another, may be necessary for the action. You will need to create a way to mark the increments on the tripod head, so that you can control the pan exactly. You would need at least a fluid head on your tripod and, ideally, for any camera move, you would use a geared head.

Similarly, a tilt, or tipping the camera up or down on its axis, needs careful controlling.

A zoom is used specifically to concentrate the viewer's attention, and because it is not a natural eye movement can be very distracting to the action. Personally I would only use a zoom as a real shock tactic. A zoom involves marking up the increments for the zoom either on the lens barrel or on a disc which is attached by a cog system to the lens.

Tracking is when you move the whole camera along the set. It can also be another way of moving the camera in on the action, so you could use a track to move the camera closer into the scene, but that would involve changing the focus on every move as well. The camera needs to be on some kind of wheels (e.g. a roller-skate with some form of track to keep the camera at exactly the same distance from the subject). A tracker bed is ideal, as you can wind the camera along the bed using very small, precise movements.

focus

You may need to shift focus from one part of your action to another. This could be a directorial choice, or simply a later decision made due to low lighting conditions, causing a narrow depth of field, so that the back of the set is at a different focus to the front of the set. In the same way that you would have to change focus if you were tracking in, you may need to adjust focus from one character to another on the set. This needs to be dealt with in the same

way, by creating some way of marking the tiny increments needed on a disc, or piece of card attached to the focal ring on the lens barrel.

sound

One of the most important elements of a shot is the sound, whether it's actual dialog, or music, or sound effects. The sound tells the story as much as the picture, and if something on the screen is creating a sound, then the audience should be able to hear it. You can hear things without seeing them, but you can't see a noise happening without hearing it. So if your character is pouring a cup of tea, we need to hear that tea being poured. Or if the character hears the phone ringing in another room, we do too, and if the next shot is a cut to the other room with the phone in, the phone will be louder in that shot.

Armed with this very basic knowledge, and your own experience as a filmgoer, you can make up a storyboard from your script.

the storyboard

The storyboard is a series of static images, a visual interpretation of your script. Your choice of which images tell the story is the indication of the style of your film. Many beginners I've known are reluctant to plan shots first – they want to get on with animating. But this inevitably lengthens the whole process, which is long and slow enough. If you are story-boarding for yourself, it just needs to be a code you can understand. But generally more people get involved on a production, and you need to be able to explain what is happening. Storyboarding is the most important planning stage of filmmaking, and the need to communicate your ideas to anyone else involved in the process is paramount. As you realize each image, you need to be thinking about the composition of each shot, the camera angles and the progression of one shot to the next.

Everyone involved in your film can get information from your storyboard. The set designer can see the scale and size of the set, and the cameraperson will begin to resource their kit (lenses, tracks, camera height) from the information on your storyboard. Obviously, all the details will be discussed as well, but the storyboard is the focus for all these decisions.

If you are making a storyboard for a whole team of animators, every move, every reaction and every change of attitude should be storyboarded. Proper (not necessarily professional) storyboarding requires knowledge of camera moves and lenses, it requires an understanding of the budgetary limitations of the film and it requires an understanding of film grammar. The professional storyboard artist needs to pick up the nuance of each character. Unless you are doing professional boards, you don't need great drawing skills, although it helps if you have some idea of perspective. The most important thing is to get across the story.

Storyboards and their accuracy become absolutely vital when work is going to different studios to be completed. The storyboards guarantee uniformity when animation is carried out by several studios, as sometimes happens on a big production, and especially with 2D animation.

Figure 4.6 (a) Storyboard for aspect ratio 1.33:1 or 4:3. (b) Storyboard for aspect ratio 1.78:1 or 16:9.

Figure 4.6 continued

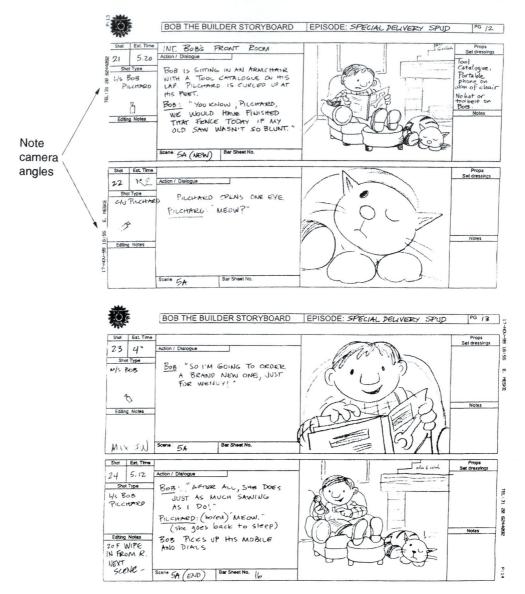

Figure 4.7 Storyboard examples: children's series *Bob the Builder*. Courtesy of HOT Animation. © 2003 HIT Entertainment PLC and Keith Chapman

visualization

If you are getting development funding, the funding organization will want an idea of the look of the film. Making visuals (a painting or drawing of a whole scene) to go with your script and character designs is important at this stage. Prepare a picture of each scene to convey the look of your film. The style of your characters and the style of your sets should be coherent.

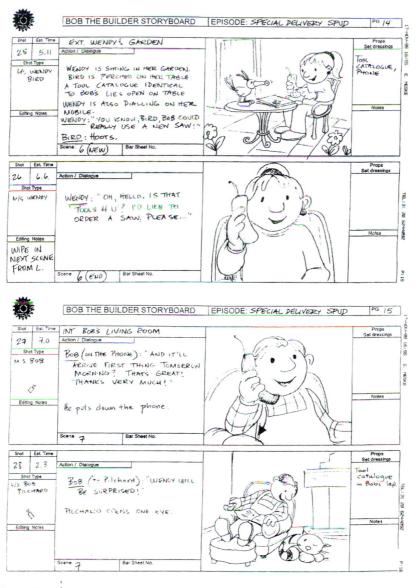

Figure 4.7 continued

editing - animatics and story reels

Once you have the whole storyboard done you can edit the storyboard itself, moving pictures around, adding or taking away scenes.

To work out your initial timings it helps to film your storyboard by scanning it into your computer; alternatively, use a 2D line tester (this is a video camera on a rostrum, with a feed into your computer). Rough filming like this is called an animatic. This helps you to work out your

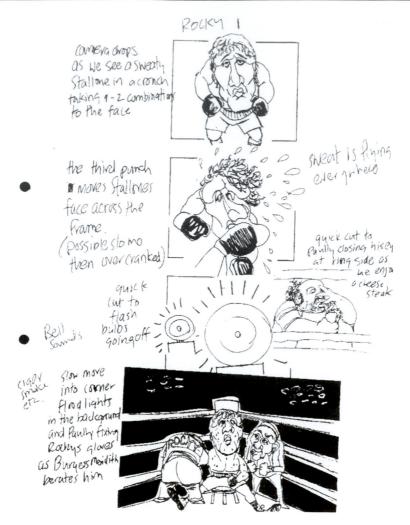

Figure 4.8 Storyboard examples: Brisk Tea commercial *Rocky*. Courtesy of Loose Moose Productions. © Brisk Tea/JWT

film before you start spending money on sets, voice-overs and model making. In the animation application, hold the image for the timing you've calculated so far. Once you have the storyboard on screen, you can do your first real edit. With animation, unlike live film, the film is planned down to the smallest detail before you start a shot. An experienced editor brings a fresh eye to your production and can see what works and what doesn't. They will implement the principles we have discussed above, edit and make more detailed decisions about the film. This can save you a lot of time and money. It may be that some scenes are actually superfluous in the telling of the story – or maybe you've missed a vital shot that could explain the gag. This is what an editor looks for. An editor can help keep pace in your film, keep tension and rhythm. Be prepared for a lot of cutting and pasting. When you finally shoot your film, you can then replace the animatic scene by scene with the final animation.

Figure 4.8 continued

If you are going to be using dialog, this is the time to record a 'scratch' dialog track. Rather than going to the expense of a professional voice-over and recording at this stage, record yourself or your friends. Depending on your computer, you can record sound directly into it, or if not, record onto a CD. Edit the images to your dialog track, and if you can, bring in an editor again at this stage to help with the story. Now you are ready to start working out your timings and putting them onto a dope sheet.

If you are working for a client, an animatic becomes an even more important part of pretesting the animation, as for the first time they begin to see their idea as a moving image. You could use cut-outs for your characters and move them across a background.

From your storyboard and designs you have the basic idea of your set. Before building the set it's a good idea to make sure you know where all the action is going to take place

Figure 4.8 continued

and how it's going to work. The set designers/builders usually make a mock-up of the set in card just for this purpose – then the director and the cinematographer can work out the action, the shots and angles. The rough cut-out figures can be moved around this set until you are sure you have a working plan.

Nowadays, directors are beginning to use CAD (computer-aided design) for pre-visualization, so that you can see how the action is going to work in 3D.

Once you are happy with the script and treatment, and the storyboard just needs tweaking, your characters can be made from model sheets, which we will discuss in chapter 5, and a set can be built (see chapter 7).

chapter 5

coat-hangers for armatures – making your own model

chapter summary

- character design
- working with modelling clays
- making your own puppet
 - simple wire and plasticine puppet
 - durable clothed puppet

I really admire all Ray Harryhausen's work. I did try to emulate him when I started with my own home movies. In the attic, I remember making a model dinosaur, which was bendable – wire coat-hangers as armatures – I didn't know anything about the right wire or the right rubber, materials or anything. I used foam rubber on the body, but I didn't know what to cover it with – what would make leathery skin – so I used my mum's old nylon tights and spray painted it. I never got to make that movie – I had big plans for it: Live Action/Animation movie – but it never came off.

Nick Park

Practice and experience lead you to your own favorite materials. I hope to give the beginner a basic route toward making their own puppets and some idea of the choices. The puppet used in this book is a relatively cheap example of a professional puppet. It is strong, flexible and versatile, and should require a minimum of maintenance. A variety of techniques have been used in making the puppet. There are many simpler ways of making an armature and covering; however, for the purposes of this book, I feel that a naturalistic-looking puppet with a natural movement of limbs will be generally more helpful to the beginner.

character design

I very much liked making the puppets for The Pied Piper [Cosgrove Hall Films], a film that we tried to do in the style of a Jiri Trnka film. The style of the puppets was very simple, but they had highly articulated armatures, so they could do an enormous range of movements. It had been done in the past, in Czechoslovakia and in Russia, but it was not something that had been seen on British television. For animation at its best, the one character I would choose from all the puppets I've worked on is the Pied Piper himself. He was very light, had a lot of articulation, the spine curved, but the look was very simple. A similar, more recently made puppet that had those qualities was the Periwig Maker from the film of the same name.

Peter Saunders, Managing Director, Mackinnon & Saunders

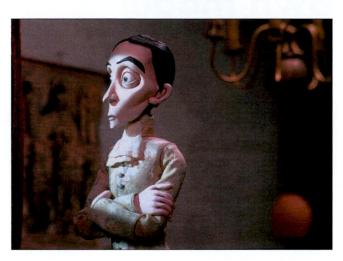

Figure 5.1 The Periwig Maker. Courtesy of Mackinnon & Saunders. © Ideal Standard Film

Just a few tips on character design – as with everything, keep it simple. Don't be constrained in your ideas by technical considerations, but when you are designing your characters, think about how they will relate to each other in size and style. Only when you have your ideas on paper, and you start thinking about materials and structure, might you need to modify them. If you are designing and building your own model, you will need to draw it to scale on graph paper, and it is always a good idea to get some advice on feasibility, materials and costs from a professional model-making company.

You will need to think of how your character will communicate: is there to be dialog? If there is, how do you intend to animate that? Chapter 8 deals with lip sync (mouth movements in dialog). You need to decide whether to have a Plasticine head, a head with replacement parts (a removable mouth), or a head armature (skull) incorporating a movable mouth. Or no mouth at all!

It's very difficult to say what makes a good character. Keep it simple – you can make it as simple as you like – as long as you put eyes in! You do need eyes. Having said that, of course, in the Polo ads [commercials made at Aardman], there weren't even eyes! Just polo mints bobbing around – but with a lot of emotion!

Nick Park developed a wonderful character design with both Wallace and Gromit – with the brow being the device to portray the emotion. Sure, Wallace's mouth is undeniable as a huge part of his face, but the eyes and the brows seem to do most of the expressing, and in Gromit's case, being a silent character, they do it all (Figure 5.2).

Figure 5.2 Wallace and Gromit. @ Aardman/W&G Ltd 1989

The voice you use for your character is as important as the look. Of course, you might choose to work without dialog and use only sound effects and music, but if you are thinking of a voice, take some time to choose the right one. The voices you choose will help shape your character even more.

You have an idea of the look of your characters, but what of their size, proportions and weight? The scale needs to be decided on for the set at the same time – all the props need to be to scale. What materials would you be making your pupper from? The more expensive the armature, the more responsive the model, the better your animation. Puppets can be made with a combination of materials: wire, clay, foam latex, silicone, wood, resin, leather, fabric, insulation board, polystyrene (styrofoam), fiberglass.

You will want to take the following into account when designing your puppet/model:

- How much does it need to bend? This will dictate how strong your armature needs to be, what to make it out of and where the weak points may be.
- 2. What's a reasonable scale to work with? The scale for a human figure of average size seems to be about 20–25 cm, although puppets can range from 15 to 35 cm. If you need to go to close-up it would be worth making something on a bigger scale so that textures look good on camera.
- How subtle will the movements need to be? You may need to make or have made a ball-and-socket armature.
- 4. How robust does it need to be? Do you intend to use it for a long film? A series? Will you need to make copies?
- 5. How will it stay fixed to the floor for each shot? Do you need tie-downs (screw the foot to the floor to stop it falling over) or magnets and therefore need a perforated steel base for your set? Or are the puppets light enough to just need double-sided sticky tape?
- 6. **Do all parts need to move?** Maybe certain parts of the body could be made with hard materials. Take this into account when preparing moulds.

If you have the funds, you can take your designs to a model-making company. If you decide to make your own models it will be a process of trial and error; there are certain rules, but there are just as many new ways to try out and compromises to make. You need common sense, creativity, adaptability, but above all – patience. And by doing it yourself, you will learn a lot more about the animation process.

staying upright

In order to fix their puppets' feet to the floor, British animators used to use strong magnets, while American animators have used the tie-down method for many years. British animators are now using tie-down much more. This involves either a threaded nut in the foot that you can hold down to the set by using a bolt coming through from underneath the set – or a bolt in the foot that can be screwed down using a wing-nut underneath the set. This means holes have to be drilled before each move, and then filled after.

A more flexible, quicker but less solid way of holding feet in place is to use a thin perforated steel table-top with rare-earth magnets under each foot to hold your puppet steady. These magnets are expensive but very powerful and should be treated with care – they can give you a nasty pinch! Make sure the magnets are kept well away from your computer and video equipment, as they can interfere with their magnetic fields.

There are simpler methods, such as using double-sided tape or pins through the feet, into a soft-fiber board floor, but the two methods mentioned above are a lot less risky.

working with modelling clays

I tended to steer away from techniques that needed a lot of process – a lot of materials. I think that's ultimately why I went for Plasticine – because there's always room for improvisation, no matter how much you plan it. You've got to have your puppet, you've got to know roughly what'll happen because you need your props and the set. But once you're on that stage you can improvise and change your mind a lot. Some forms of animation demand a lot more planning and then you've got to stick to it. It's like living on the edge – once you've started a shot you've got to keep going to the end. You can't say 'Oh I'll add a few frames there afterwards to slow it down or speed it up.' You've got to be on your toes the whole time.

Nick Park

The earliest use of modelling clay for animation dates from a few years after the invention of motion pictures, with James Stuart Blackton's sequence 'Chew Chew Land or The Adventures of Dollie and Jim' (1910). In the UK, in the late nineteenth century, William Harbutt invented Plasticine, a modelling clay that didn't dry out, but that couldn't melt either. The original recipe disappeared when the Harbutt's factory closed down a century later, but a similar clay is still manufactured in England.

Creating your character from Plasticine alone is probably the cheapest route for model making, but don't be mistaken into thinking because it's cheap it's simple. Plasticine demands skilled handling. Working with clay can certainly give you freedom, but this would have to be balanced by the amount of time needed to re-sculpt and return to your original shape. It means you have the ability to stretch and distort your figure, unhampered by any armature, but the other side of the coin is the uncontrollability of it. When you are new to the craft it's very easy to lose shape; joints, elbows and knees, for instance, can move about disconcertingly. So a character that isn't dependent on sharp edges or definition may be a candidate for clay. Aardman Animation's Morph is made with Plasticine and, as new animators find when they come to attempt animating him, nowhere near as simple as he looks (Figure 5.3). Plasticine models can be made in a mould. Gumby, Art Clokey's 3D character, was originally made with Plasticine rolled out flat and cut out. From the 1950s onwards they started making moulds, into which they poured melted clay. Now he also has a wire armature (Figure 5.4).

Figure 5.3 Morph. © Aardman Animations Ltd 1995

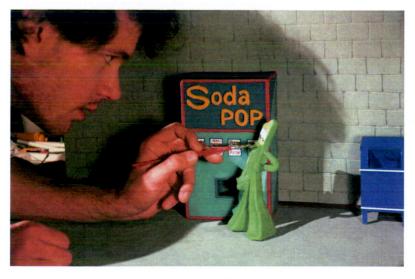

Figure 5.4 Anthony Scott animating Gumby. © Art Clokey

For Plasticine animation there are really very few clays that will do the job. The popular 'English' clay is Lewis's Newplast. These clays have a good color range, don't melt (which means they handle well under lights) and have a fairly firm sculpting consistency. Van Aken, the US equivalent, has a brighter color range and will melt, and is therefore very useful for moulds, but can get soft under lights. Richard Goleszowski's Rex the Runt, a semi-flat character, is made in a press mould using English clay (see the section on moulds further on in this chapter). This is a relatively fast way of making a replacement character. Rex was filmed against a 45° glass pane, with the background behind, allowing a greater freedom of movement for the characters, a degree of squash and stretch not seen before, and no rigging problems!

I prefer to animate foam puppets with either replacement faces or mechanical heads. I love the look and feel of clay animation, but the amount of time spent on clean-up and smoothing takes away from the flow of the performance.

Trey Thomas, animated James and the Giant Peach and Sally in Nightmare Before Christmas

Plasticine is notoriously difficult to keep clean. Always ensure your hands are clean before handling the material, using wet wipes – make sure you get a wipe that is not too fibrous and lanolin free. Or keep your hands clean by rolling the same colored clay in them; this removes dust and dirt and coats your fingers at the same time. Avoid wearing clothes that 'shed', like mohair.

Figure 5.5 Range of modelling clays. Back left: Lewis Newplast ('English' clay); in front left: Sculpey; back right: Van Aken; middle right: Plastalina; front right: Lewis's Uro; front center: Fimo. Photo © Susannah Shaw. (See glossary, pp. 100–1)

In hot, sweaty conditions, have some talcum powder available, both for your hands and to keep the Plasticine dry. Never try to soften the clay with spirit-based liquids or you'll end up with a sticky, slimy puddle. You can hold it nearer the lights to warm up. Or if the Plasticine is too dry, it can be softened with a little liquid paraffin. You need to be very careful about diluting the clay's intrinsic properties.

A useful way to keep the volume of your model accurate is to have a record of its weight, so that if you are adding or subtracting clay, you are always aware of what it should be.

Don't try sticking arms/legs/tails on to a torso. This will always be a weak point. Your model will be stronger if you tease your shape out of one piece of clay.

making your own puppet

I have laid out two approaches to puppet making. The first is the simplest and cheapest, short of just using Plasticine. It has a wire armature and Plasticine body, and will allow fairly free movement, but won't be very robust. I would recommend this only as a jumping-off point to more sophisticated model making. The second has a wire armature, covered with foam body and clothing, and includes silicone, Milliput and other modelling staples.

1. simple wire and plasticine puppet

Plan your armature by making a scale drawing of your puppet and working out the lengths of wire you will need. The best wire to use is aluminium, five-metre lengths of which can be bought online for between £3 and £6, and come in several thicknesses. Twisting two or

Figure 5.6 Tools and, materials needed for a simple puppet. Courtesy of ScaryCat Studio

three strands together in a slow drill will prolong its use. If you can't afford aluminium wire, you could use tin wire, but tin is more springy (has more memory) than aluminium, and will therefore make animation much harder.

tools needed for a simple puppet

- Drill and drill bits
- Small vice
- Wire snips
- Pliers
- Hacksaw
- Screwdriver
- Sculpting tools
- Bowl and spoon (needed for using Polymorph)
- Scissors
- Pen and pencil
- Ruler.

materials list for a simple puppet

- Two-part epoxy glue
- Balsa wood available from model shops
- 1 mm aluminium wire available online from wire.co.uk
- 1.5 mm aluminium wire
- 2 mm aluminium wire
- Cloth tape
- Masking tape
- M4 nuts
- M4 bolts any hardware stores
- Polymorph available online from maplin.co.uk
- Wood glue
- Plasticine Newplast, from art shops
- Beads (for eyes)
- Paint
- Baby wipes
- Sandpaper.

The cost of these materials new would be between £55 and £85 (\$110-170).

Make a drawing of your puppet exactly as you see it; consider how the armature will work inside the puppet – how many fingers, toes and where the tail will attach and so on. You will want some solid pieces of light balsa wood, which will keep the puppet light (you don't want a solid plasticine head or the puppet will fall over!). In the case of this design, the balsa can be used for the head, chest and stomach. The wire for the spine, arms and legs will thread through the balsa and be glued into place. Now you can start making the armature.

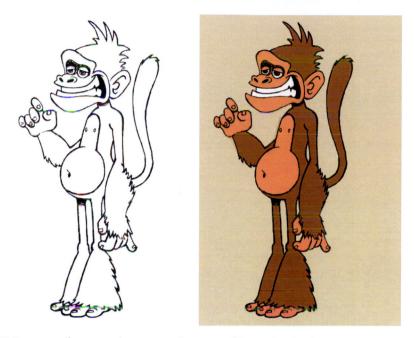

Figure 5.7 Drawings for a simple puppet. Courtesy of ScaryCat Studio

Use 2 mm wire and cut three lengths long enough for the spine and neck, both arms and both legs – put three lengths of wire in a drill and run the drill, holding the ends with a pair of pliers. This will make a strong and flexible armature. Then cut a piece of balsa for

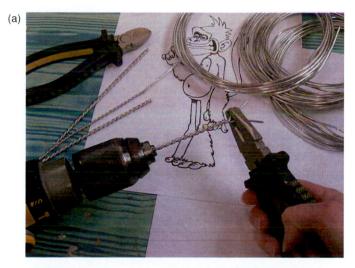

Figure 5.8 Simple wire puppet armature construction. (a) Twisting wire with a drill. (b) Drilling holes in balsa. (c) Starting to build the armature. (d) Fitting the armature together. (e) Glueing the armature together. (f) Glueing the head core together. (g) Sanding balsa head. (h) Cutting the hand wires to size. (i) Fixing tie-down bolts into the feet. (j) Adding Polymorph onto the armature. (k) The finished armature with masking tape. Courtesy of ScaryCat Studio

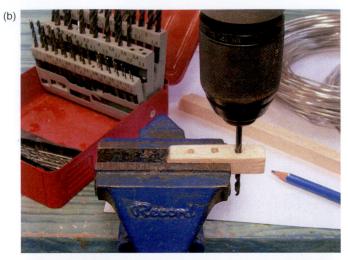

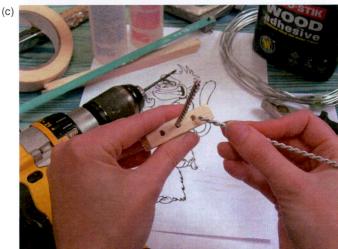

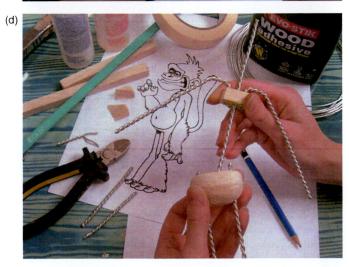

Figure 5.8 continued

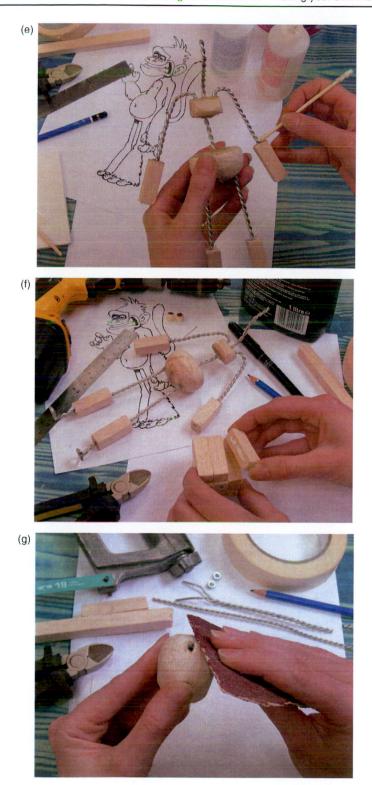

Figure 5.8 continued

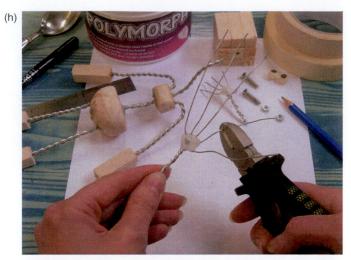

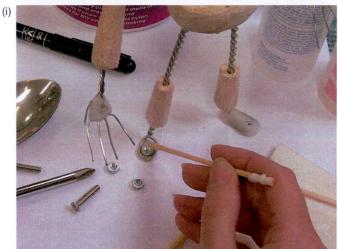

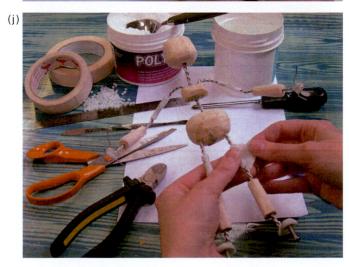

Figure 5.8 continued

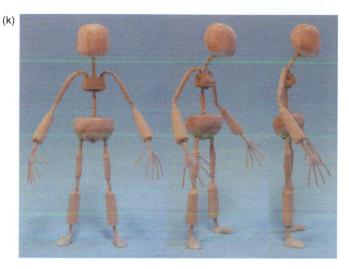

Figure 5.8 continued

the chest and, using a 2 mm drill bit, drill three holes through it so you can pass the spine through the middle hole and thread the arms through the two outer holes. Use two-part epoxy glue to hold the wire in place in the balsa.

Use wood glue to hold the wire in place in the balsa. Any parts of the puppet that you need to grab, or are particularly large, need to be filled out with a light material. For this puppet we've used balsa for the head, chest, stomach and lower arms. The head piece is made using several small pieces glued together, with a central hole drilled to take the neck. Once the glue is dry, the balsa is easily sanded to a basic head shape.

To make a solid core for feet and hands, use Polymorph, plastic granules that will melt in hot water into a mouldable mass. The hands are made using the finest wire, twisted in the drill, with a palm made out of the Polymorph.

Health and safety: you will be handling hot melted plastic; please use tongs to take the plastic out of the hot water and rubber gloves to handle it.

To make tie-downs for the feet, finish the feet in a flattened loop that can be filled with Polymorph, into which you want to sit a nut. This threaded nut will take the bolt that will hold your puppet steady, coming up through the set base.

Now you have an armature, use masking tape to cover the aluminium wire, to allow the Plasticine to grip. Start building up the plasticine and sculpt your character, adding the final touches.

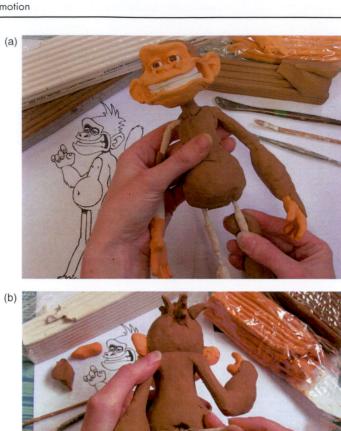

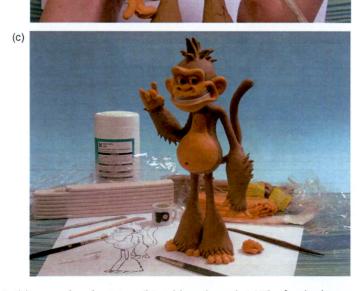

Figure 5.9 (a) Building up the plasticine. (b) Adding the tail. (c) The finished puppet. Courtesy of ScaryCat Studio

2. durable clothed puppet

The model described below has been also been designed with low cost in mind, but she is more robust and will be easier to handle – it's the same model we've used throughout for

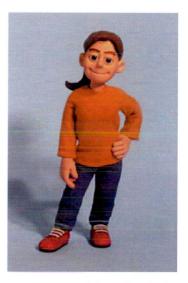

Figure 5.10 Model in relaxed pose. Courtesy of ScaryCat Studio

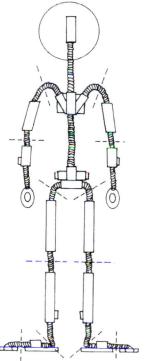

Figure 5.11 Drawing of the armature. Courtesy of ScaryCat Studio

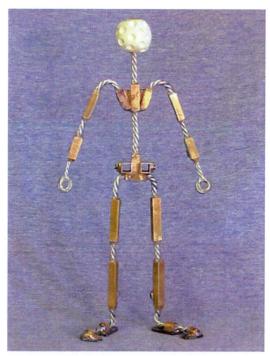

Figure 5.12 The armature. Courtesy of ScaryCat Studio

the animated sequences, so her flexibility is demonstrated. She is made with a variety of materials, each dependent on a different model-making process. This puppet should cost between £150 and £200 (\$300–400) to make. In chapter 6, I go into more detail regarding the professional processes; it may be worth referring forward.

First of all, get three lengths of 1.5 mm wire twisted together by holding them in a drill running on slow (Figure 5.13) to make the limbs and the spine, and a single strand of 1 mm wire for the wrists, looped round a washer for the palm, and twisted. If an armature for Plasticine is too strong, when trying to animate the puppet you will simply poke the wire through. Because of this our puppet only has wire in the wrist and not the fingers. It makes animating the hands a lot easier and less restrictive.

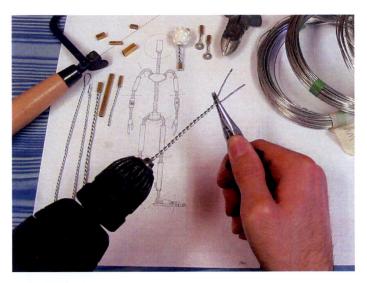

Figure 5.13 Twisting wire in a drill. Courtesy of ScaryCat Studio

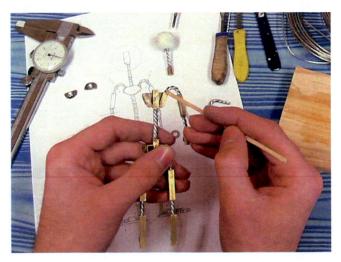

Figure 5.14 Glueing the wire armature. Courtesy of ScaryCat Studio

It's always a good idea to be able to remove head, hands and feet, as they often need extra work – so glue on a section of square brass sleeving K&S of sizes that will slot into each other for arms and hands, and head and neck. K&S is square brass tubing that you can buy in any model shop. It comes in different sizes, allowing a smaller size to fit into a larger, giving a firm, well-located joint (K&S is only available in imperial sizes). An M3 nut is soldered onto the larger piece of K&S at the wrist, neck and ankles. This allows the grub screw to be used to hold the smaller size of K&S in place. This in turn holds the wire in place. The strands of wire are then epoxy glued into the relevant pieces of K&S to form the armature. Washers are epoxy glued to the wrist wire to form the palm of the hand.

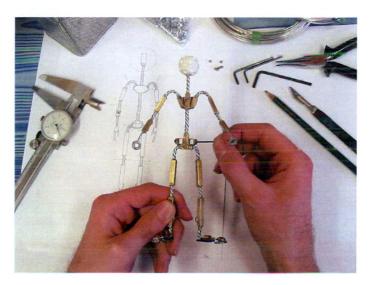

Figure 5.15 Finishing the wire armature. Courtesy of ScaryCat Studio

To keep definition of the elbows and knees, strengthen the upper and lower arms, and the thighs and calves of the figure by feeding the twisted aluminium through a short length of brass sleeving. Leave enough space for the wire to bend so that the strain is not always on exactly the same spot. Too small a gap between them will make it easier to break.

Steel plate cut with a junior hacksaw is soldered to the three pieces of K&S on the chest piece using silver solder.

head

It is useful to be able to remove the head and hands for sculpting, leaving the figure in position. It also means less wear and tear on the puppet. So neck joints should have K&S to slot into the head, i.e. $\frac{5}{32}$ " on the neck and $\frac{1}{8}$ " in the head. If you are using a clay head, always model the head with a lightweight core to the rear, to allow for eye sockets and a recessed mouth. Too much clay will make the head heavy. This head core is made with textured Milliput, to help the Plasticine 'key' to it. Inside the Milliput head is a piece of K&S for the neck and a piece of K&S for the hair. The head can be removed, as can the hairpiece.

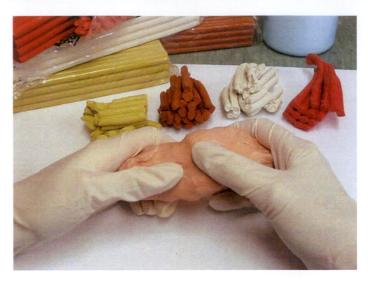

Figure 5.16 Mixing Plasticine. Courtesy of ScaryCat Studio

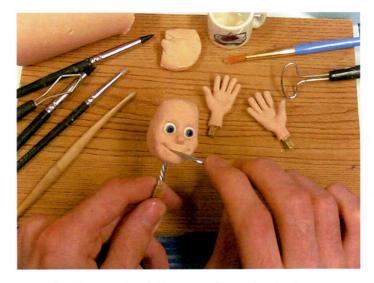

Figure 5.17 Sculpting the Plasticine head. Courtesy of ScaryCat Studio

If you are making an animal you might want to add a movable wire snout and ears to the head core. And if the animal is on all fours, you will need to design it a little differently.

hair

Resin cast hair is useful especially for series work, because the constant removing of the puppet's head to animate its mouth would mess up Plasticine-sculpted or theatrical or doll's hair. Our puppet's hair has been made with Milliput, with a Plasticine-covered wire attached for the ponytail (Figures 5.18 and 5.19).

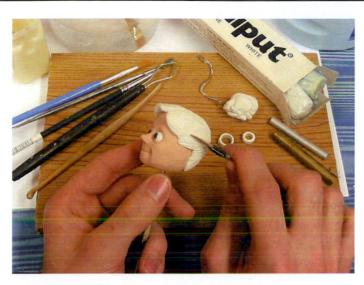

Figure 5.18 Sculpting Milliput hair. Courtesy of ScaryCat Studio

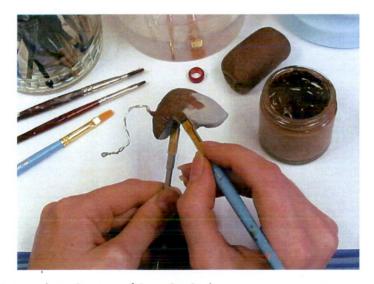

Figure 5.19 Painting hair. Courtesy of ScaryCat Studio

eyes

The easiest way to make eyes is using white glass beads, using the hole as a pupil that can be manipulated with a toothpick. Be careful if you're using a pin or paperclip, as it could scratch off any paint on the eyeball. Painting the irises can be done with a toothpick holding the bead, held by a slowly rotating drill – hold your brush steady and fill in the color around the hole (Figure 5.20). You can also buy eyes from specialist manufacturers (very expensive) or cast them yourself out of resin.

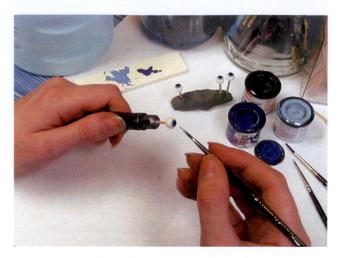

Figure 5.20 Painting an eye. Courtesy of ScaryCat Studio

hands

Hands can be just made with Plasticine on its own or, if you want to make it stronger, over an armature of fine aluminium twisted wire fingers stuck in a resin 'palm'. Plasticine will allow a fist to bend convincingly, and a firm connection with an object. However, endlessly having to re-sculpt and clean fingers is a drawback. An easier alternative may be silicone; however, that can be springy in comparison to Plasticine.

A square brass K&S tube joint is glued or soldered onto the wrist to fit into a tube on the arm. Spare hands are also useful, as during filming hands invariably become worn and grubby, and if they do have wires, they often break.

feet

Feet can be made with flat metal plates or aluminium blocks. It is best to make feet with two plates, as a convincing walk is very hard to achieve with a solid, flat foot. Hinged metal

Figure 5.21 Tie-down screws and wing-nuts for feet. © John Wright Modelmaking

plates for your feet can be made with holes drilled in so that the feet can be screwed down to the floor and locked with a wing-nut on the underside, or pinned down.

The shoes for this model are made with silicone: the shoe is first sculpted in a hard Plastiline. To smooth the Plastiline you can use lighter fuel – because Plastiline is much harder than other modelling clays it doesn't get slimy. The sculpt is set into a bed of ordinary potter's clay, which will come halfway up the boot. The Lego blocks make a wall around the sculpt so that plaster can be poured in and left to set. This will make the top half of the mould.

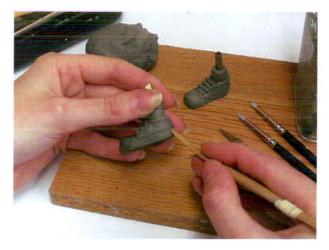

Figure 5.22 Sculpting boots. Courtesy of ScaryCat Studio

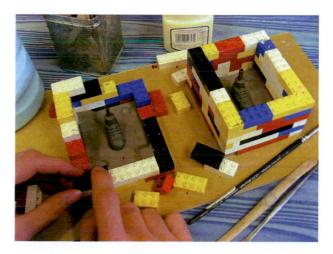

Figure 5.23 Moulding shoes. Courtesy of ScaryCat Studio

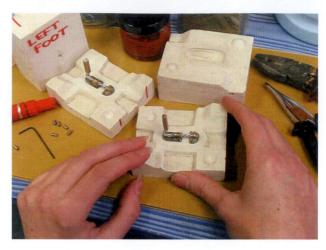

Figure 5.24 Foot armature in mould. Courtesy of ScaryCat Studio

The process is then repeated, making a mould for the other half of the boot. Then you will have two halves of a mould into which you can place the foot armature (see section on mould making for more details about the process).

Once the two halves of the mould are clamped together, you can pour in the silicone (see chapter 6, section on casting silicone). In this case the model makers have used a colored silicone. Once the silicone has cured, or set, it can be removed from the mould. There will be a little excess silicone around the joins of the mould – these are called 'flashlines' and will need trimming, either with fine nail scissors or fine sandpaper (Figure 5.25).

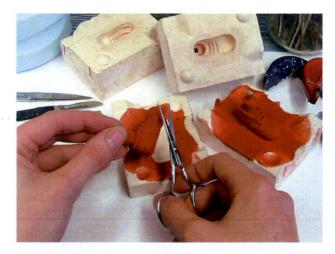

Figure 5.25 Trimming silicone flash. Courtesy of ScaryCat Studio

To cover the body, we have chosen snip foam. Other choices could be to cover her fully in Plasticine (a heavy choice) or with foam latex (a process explained in chapter 6). Snip

foam is cheap, easily shaped and light. It is basically upholstery foam, snipped into shape and glued on with a contact adhesive.

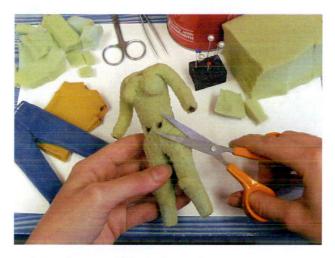

Figure 5.26 Snipping foam. Courtesy of ScaryCat Studio

Clothing her involves a hunt for fine-textured fabric that will nevertheless be robust with constant handling. Cat Russ used a fine jersey for her jumper and cotton for her jeans. Once covered with fabric, you have an individual, highly expressive-looking puppet.

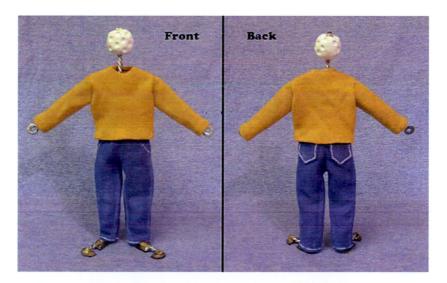

Figure 5.27 Clothes: jumper made with fine jersey cotton, jeans made with fine weave cotton. Courtesy of ScaryCat Studio

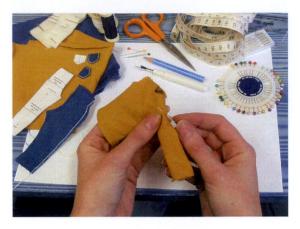

Figure 5.28 Sewing clothing. Courtesy of ScaryCat Studio

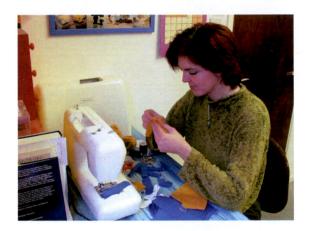

Figure 5.29 Cat Russ sewing. Courtesy of ScaryCat Studio

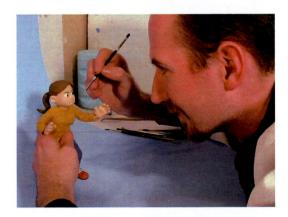

Figure 5.30 Gary Jackson with model. Courtesy of ScaryCat Studio

list of materials used to make this model

armature

K&S (square brass tubing, comes in different sizes – we used $\frac{5}{32}$, $\frac{3}{36}$ and $\frac{7}{32}$ of square brass K&S tube)

- Aluminium wire we used 1.5 and 1 mm thicknesses
- Epoxy glue steel plate
- Milliput
- Vice
- Soldering equipment
- Grub screws
- Nuts
- Washers for palms
- Jewellery saw.

hands and head

- English Plasticine mixed
- Sculpting tools.
- Latex gloves

eyes

- White beads
- Enamel paint.

Paintbrushes

hair

- Milliput
- Acrylic paint
- Plasticine for ponytail
- Paintbrushes
- Sculpting tools
- Wire for ponytail.

shoes

- Plastiline
- K&S
- Clay
- Plaster
- Sculpting tools
- Silicone pigments.

- Lego bricks
- Paintbrushes
- Vaseline
- Casting silicone
- Silicone paint base

snip foam

- Upholstery foam
- Scissors

clothes

- Fabric
- Sewing equipment
- Wonder web for pockets
- Fabric dyes

Evostick glue

Pins.

- Iron/ironing board
- Patterns.

This puppet would be strong enough to last for a short film. There are many cheaper and easier ways of making puppets. But in order to practise subtle, naturalistic movement, you will need a puppet at least this strong and flexible.

chapter 6

model makers – the professionals

chapter summary

- the maquette
- ball-and-socket armature
- mould making hard and soft moulds
- casting
- coloring
- costumes/dressing
- model-making masterclass ScaryCat Studio and the Duracell bunny
- glossary of model-making materials

For professional animation, a model-making company like the UK's Mackinnon & Saunders work from the animator's sketches and then make a 3D maquette, a blueprint from which they make moulds to make the models. Mackinnon & Saunders started working with Cosgrove Hall Films in Manchester in the 1970s. At Cosgrove Hall, they learned their trade as the company developed and grew. Many techniques we all use today were developed at Cosgrove Hall, and many world-class animators such as Paul Berry, Loyd Price and Barry Purves learned the ropes there.

Mackinnon & Saunders specialize in models for series work and features, making puppets that are robust and easy to repair, with standardized parts to keep them exactly the same all the way through the shoot.

lan Mackinnon gives an overview of the process:

A lot of the animators we've worked with over the years have done their own model making as well – people like Jeff Newitt and Ken Lidster from Loose Moose. They would probably make their own puppets if they had time to do it. They like to give us some sort of reference to work from, whether it's a sculpt or

a sketch. It's the job of the sculptors then to interpret it and take it from a sketch into 3D form. Whilst the sculptors are working on blocking the character out they've got to be conscious of what the job entails from a stylistic point of view. If it's Jeff Newitt's, there's a certain way that he would sculpt a character; similarly with Ken, so we try and mimic that. They would put their stamp on a sculpt even though they're not doing it themselves. The sculptors have to mimic the style so that, hopefully, when the costumes and the sets all come together they all look like one complete world.

There might be six or seven different people working on a character at any one stage – its got to go through the mould makers and the armature makers – so to have one [blueprint] model, whether it's painted or whether it's blocked out, is useful for everyone to go back to and make sure all the jigsaw puzzle fits together at the end. It's also to make sure we've not lost something along the way – for instance, that the proportions haven't altered because someone's taken a wrong measurement.

the maquette

With several characters in a story, the model makers will block out all of the characters as maquettes, spending about a day on each one to get the basic proportions. Complications of scale and proportion arise when there are a mix of human, animal and bird characters. These problems can all be ironed out in consultation with the animation director at the maquette stage.

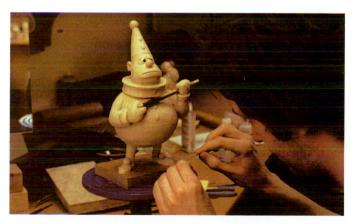

Figure 6.1 Sculptor working on a maquette. Courtesy of Mackinnon & Saunders. Photo © Susannah Shaw

At this stage the sculpt is made over a basic brass sleeve and wire armature, so it can be disassembled, which also helps when you're sculpting it. Little details on the hands and work on the head can be done separately, away from the body; this also makes it easier to finish off. The final materials should be decided on during the sculpting stage. It'll depend very much if the character's got to do lip sync – you might want substitute or replacement mouths. If so, you would choose a hard head. If it's going to be a mechanical mouth (Mackinnon & Saunders specialize in mechanical movement inside the head, as featured

in Tim Burton's *Corpse Bride*), then the head would need to be silicone or foam. Using a mechanical head is a costly process.

All the separated elements then go to the mould-making department. The whole process of building up the puppets is dealt with in different departments: sculpting, mould making, casting, painting and armature making. Once the sculpt is approved, the armature is machined and assembled.

ball-and-socket armature

A ball-and-socket armature is more durable and reusable, altogether tougher than a wire armature, and is necessary when a puppet is being made for series or feature work. Apart from its strength, it gives the animator a greater degree of control for finer, smoother movements.

English armatures tend to be made by steel rod and plate construction with ball-and-socket joints. Joints are made with one or two steel or phosphor bronze ball-bearings sandwiched between balanced steel plates. US armature makers use steel rods and ball-bearings made with chromed mild steel. The steel balls are annealed (heat treated) to strengthen them. Blair Clark, now a visual effects supervisor at Tippett Studios, was a model maker on Tim Burton's Nightmare Before Christmas and recalls:

'The animators required joints that could take a great amount of wear and tear. Light scoring on the balls, caused by tightening of the joints, could easily render the armatures unusable. So to prevent constant breakage of the armatures, we made them very strong. I remember the English animators who came over, Loyd Price and Paul Berry, were surprised at how hard they were!'

Figure 6.2 Working on a mill. Courtesy of John Wright Modelmaking

making your own ball-and-socket armature

If you are considering making your own ball-and-socket armatures from scratch, it can be a bit complex, but possible. The cost of the quality of equipment you need to make ball-and-socket armatures could become prohibitive. Rather than buying your own lathe, it may be wise to approach a local art college. A jewellery-making department, or even a sculpture department, will have all the equipment you need and may relish a challenge.

However, it is much easier to make one up from a kit. You can order all the pieces you need from some model-making companies (see appendix 1 for addresses). They can usually supply you with the information you need if you are going to build your own.

Tools that you will need to make up your armature include a hand blowtorch, pliers and Allen keys. Cheese head, flat head and grub screws are useful. Use silver solder, as soft solder won't solder stainless steel. Don't try using glue for holding your armature together – it will fall apart under any pressure! **Health and safety warning: take great care using a blowtorch. Use a mask when using silver solder as it releases harmful fumes.**

Good communication is essential when ordering a ready-made armature – so get your dimensions right and use graph paper to draw a plan of your armature (Figure 6.3). It's useful to show the dimensions of the covering material as well. You may know what size and type of joints you want, if you don't, it's useful to indicate on the drawing where and

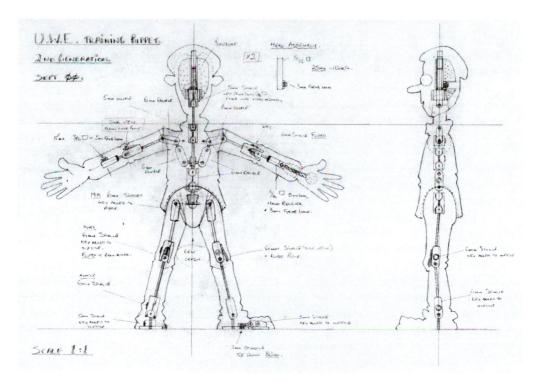

Figure 6.3 Scale drawing for an armature. Courtesy of John Parsons

how your character will need to bend. It may be useful to fix a lightweight block of balsa or insulation board on the chest or hip plates, below the covering surface, as something for the animator to get hold of, a grabbing point.

Depending on how many limbs your character has, whether it's humanoid, quadruped or even alien, you should be aware of the way it moves; this will then determine what kind of joints and what size of joints it will have. For instance, the hip joints can have a lot of wear, so you would be better spreading the tension over a double joint at the top of the leg, but you should use a single joint at the elbow to avoid it bending back on itself. Single joints allow for single axis movement and double joints for full rotation, but beware of double joints folding over onto each other.

humanoid joints

neck: double joint to allow for full rotation

• shoulders: two double joints

elbows: single joint, for single plane of movement

waist: double joint
hips: double joint
knees: single joint
ankle: single joint

• foot: hinged plate (a single flat-plate foot makes walking very difficult).

rigging points

Your character might need to fly or leap through the air, in which case it will need a safe point to attach it to a rig. You may want to incorporate a K&S rigging point either on the hips or chest of the puppet. This would slot into a corresponding brass tube on the rig. Or you might want to attach the puppet to wire, in which case you can attach tungsten wire, which is fine and very strong, and almost invisible. Or fine fishing line – this can catch the light a little more – but it can be dulled with wax, blackened with felt tip, or even colored to match its background. To keep the puppet steady you will want two or more rigging points – at the neck and the waist. The safest method is to use a rigging stand, with ball-and-socket joints; these can be removed in post-production. Painting out a rig in post-production is time-consuming for yourself and expensive if you are paying someone else to do it. It may be easier to use fishing line or tungsten wire to hold your puppet. It's a decision you can make, depending how complicated the move is. To master cleaning up a rig in post-production, see the section marked 'shooting with a rig' in chapter 12.

Use Allen keys of the necessary sizes to make fine adjustments to the joints when necessary. Don't over-tighten joints – never use excessive force manipulating the joints on your puppet; you can easily buckle the plates or rods. Once they are buckled they are very difficult to repair. If you feel that a joint is becoming too loose or too rigid it may be that the Allen key is worn, or that the bolt heads inside are worn, which can be worse, as they then become impossible to remove. It is useful to keep a drawing showing the joints and which keys are used for which joints, either to save time or if you have someone else animating your puppets.

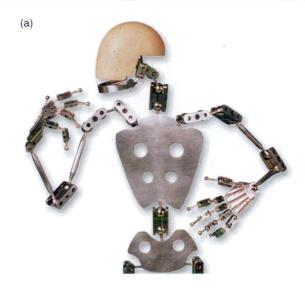

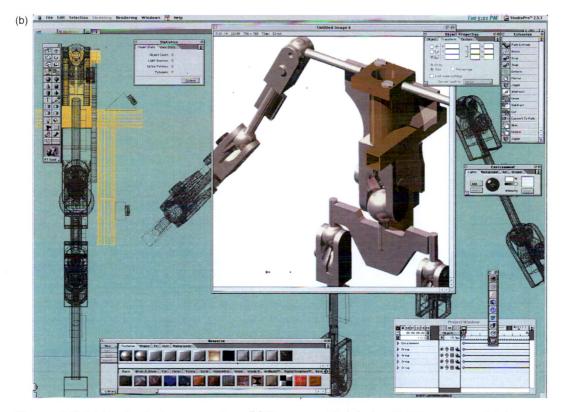

 $\textbf{Figure 6.4} \ \, \text{(a) Mechanical man armature. (b) Computer-aided design (CAD) armature.} \ \, \text{\odot John Wright Modelmaking}$

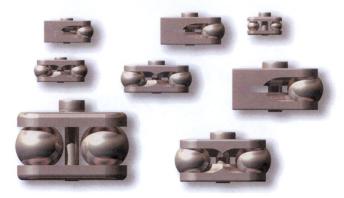

Figure 6.5 Ball-and-socket pieces. Courtesy of John Wright Modelmaking

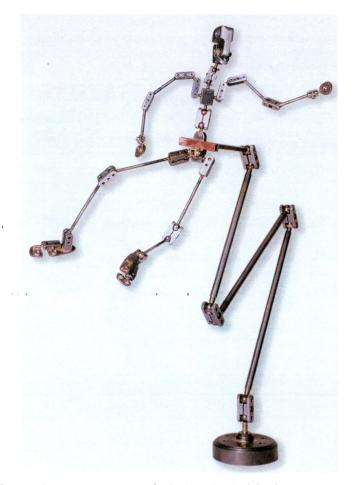

Figure 6.6 Professional rig arm. Courtesy of John Wright Modelmaking

mould making - hard and soft moulds

the sculpt

If the puppet is to have a foam latex- or silicone-covered body, you will need to first sculpt your model to make a mould to cast these materials in. This is called the sculpt or the maquette. You may also need to make some hard parts for your model: sometimes feet, or hair, or even faces may need to be hard. The general rule is: if you are casting a hard piece, you will need a soft mould (silicone) and if you're making a soft piece, you'll need a hard mould (plaster, resin or fiberglass).

When making your armature, you may want to make separate parts of the body that can join together. In this case it's useful to glue (epoxy) brass sleeve tubing on the armature at these points (arms to hands, neck to head).

It's best to use a very firm clay for your maquette, as details and fine lines have to hold as it goes through the foaming or moulding process. Blair Clark, visual effects supervisor at Tippett Studio, prefers a Chavant clay. Mackinnon & Saunders in the UK use Harbutts, now made by Newclay Products. Others use Plastiline. Build up the clay and sculpt to the right shape.

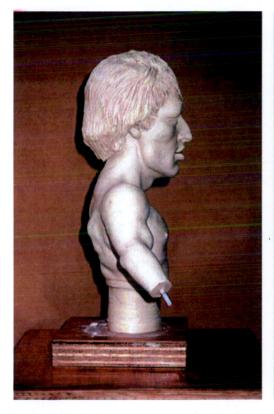

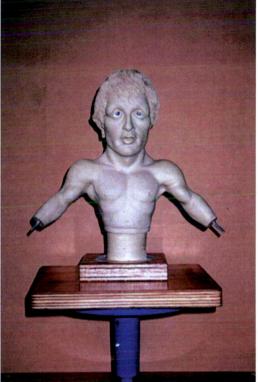

Figure 6.7 Rocky maquette made by Mackinnon & Saunders. Courtesy of Loose Moose Productions. © Brisk Tea/JWT

Sculptor Stuart Sutcliffe, working at Mackinnon & Saunders, sets a mirror on the other side of the character he is sculpting, so that he can check the figure for symmetry:

When you look at things, you tend not to see any discrepancies, your eye gets used to it. But with a mirror, the image is reversed, it confuses your brain and you can suddenly see all the discrepancies: there's a big lump on that side, or there's a sharper curve there than the other side.

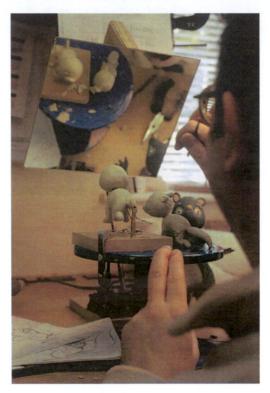

Figure 6.8 Stuart Sutcliffe at work. Courtesy of Mackinnon & Saunders. Photo © Susannah Shaw

textures

For textures such as wrinkly skin, dinosaur skin or fabric, you can use ready-bought stamps from various sources or make your own taking latex casts off any surface: old leather, almond stones, bark, leaves, stone. To make good facial wrinkles on Plasticine, cover it first with cling wrap, then mark with a sharp-edged tool; the cling wrap helps to soften the sharp edges.

undercuts

The presence of undercuts, i.e. a corner or curve that will be problematic when trying to release the mould, is probably one of the most important aspects of mould making. To assess how many pieces you will need for your mould, you will need to look the model over very carefully to see if there is an undercut. Don't rush this stage. You will need to work out whether you will need more than two divisions for the mould, and where those divisions should come.

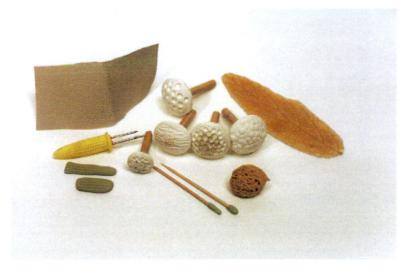

Figure 6.9 Texture stamps. Courtesy of John Parsons. Photo © Susannah Shaw

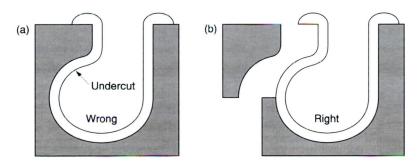

Figure 6.10 The problems of undercut. (a) Wrong. (b) Correct. © Alec Tiranti Ltd

seams

You will also need to think carefully about where the joins come on your model. This is because when you first take your cast out of the mould, you will inevitably have excess foam or silicone around the join, called flashlines, which will need to be cut or sanded away. It would be unfortunate to design your mould so that the seam comes over the face or some other exposed area. The sides of the body are generally easier to clean up.

The different elements need to be worked out – the body might be cast in foam latex, while the head and the hands might be cast in silicone, which means they'll need separate moulds. For maintenance purposes, if it's a series, hands need recasting on a regular basis. Because the wires in the fingers are heavily used, they should have a separate mould so you don't have to cast the whole body each time. The body should only need to be cast once – it should last for a whole series, especially if it's got a costume over it.

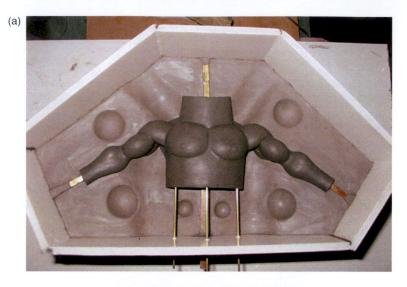

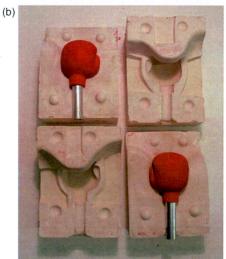

Figure 6.11 (a) Body mould. (b) Glove mould. Courtesy of ScaryCat Studio

making a hard mould

To make a plaster or resin (hard) mould for foam latex or silicone:

- 1. Make a bed of potter's clay or any clay of a different base to your sculpt potter's clay is water based and soft enough to bed an oil-based clay (Plastiline, Chavant) sculpt in without spoiling the detail.
- 2. Build up walls around the bed to the height you need, with card, foamcore or Lego. Lego is versatile, reusable and can easily be found at car-boot or yard sales. You can build up the walls to whatever height you need.

- 3. Bed the sculpt into the clay, making sure the clay comes up to your division marks. Ensure that the clay fits exactly around at your mark; it must seal all the way round the model. Cling wrap can be placed underneath the majority of the sculpt before it is embedded in clay. This is to make the clean-up process easier when preparing to make the other parts of the mould. Any creases can be easily touched up on the sculpt.
- 4. At this stage you also need to make 'key' or location points that will ensure your mould halves fit exactly together. These can be made using small cones of clay, or make a dip with a marble at several points in the clay around your sculpt (make sure you don't sink the marble any further than the halfway mark, or you'll have an undercut problem).
- 5. You will also need to put in channels to allow the excess foam latex or silicone to escape when you press the mould together.

plaster moulds

Plaster is cheap, non-toxic and quick. It can crumble if handled a lot. Cristacal or Ultracal is recommended. Health and safety warning: Ultracal has lime in it – wear gloves when handling. Keep away from eyes.

To make a plaster mould, brush on your first layer of plaster; this will ensure plaster has got into every corner. Coat the sculpt with layers of plaster, each coat being added when the previous has become warm. (Plaster warms up as part of the chemical process of hardening.) When cool again, it is set; turn over and take away the clay.

Coat the first half of your mould with a **release agent** – a petroleum jelly like Vaseline is the cheapest and most effective. Then repeat the plastering process over the other half of your sculpt.

If there are more than two parts to the mould (this can depend on the shape of your model), you will need to repeat the process for each part.

resin moulds

- Fast-cast resin more expensive, this is a polyurethane-based resin and therefore quite toxic, but useful for series work and features as it is very strong.
- Fiberglass resin (or GRP, glass-reinforced plastic) uses a catalyst (and an accelerator if required) and is built up in layers with a fiberglass matting. Useful for series work, very durable, but toxic.
- **Epoxy resin mould** brush on the first layer and then pour on the remaining resin. Make sure your box is tight, as you won't want resin leaking over your furniture. The resin can be mixed with metal powders such as aluminium for strength, e.g. a two-part 50:50 mix sets in about five minutes (depending on type purchased). Consult with the manufacturer.

With these polyurethane-based resins there are certain safety measures you should protect yourself with. Wear a mask to avoid inhaling fumes. Use a barrier cream on your hands, as prolonged use can cause dermatitis.

Wear goggles if there is any chance of the resin making contact with your eyes. All the containers should have instructions on them.

making a soft mould

silicone moulds

Silicone is very versatile. As it is so tear resistant you don't need to worry about undercuts, you can pour the silicone into a containing box and, once set, release the cast from the mould with one cut and maneuver your cast out. Silicone requires a catalyst. It can also be used as a press mould for Plasticine.

plasticine press moulds

Making repeat models in Plasticine can be useful; the Plasticine is built up layer by layer in the mould. A flat clay character, Rex the Runt, was made using silicone moulds. The silicone is tough and quick to release, making it useful for series work. Fast-cast resin or plaster could also be used to make a press mould. For hard press moulds you would need a reliable release agent. Soapy water, washing-up liquid or petroleum gel can be painted into the empty mould as a release agent to help remove the Plasticine after it has been pressed into the mould.

There are seven basic rules for mould making:

- 1. For a hard cast, use a soft mould; for a soft cast, use a hard mould.
- 2. Plan your undercuts.
- 3. Think ahead with seams/flashlines.
- 4. Remember to add location/keys to your mould pieces.
- 5. Remember your release agent.
- 6. Remember to block vents after casting.
- 7. Don't rush!

casting

casting foam latex

Remember to first brush your mould with a release agent (Figure 6.12a). The basic process for mixing foam latex is:

- Foaming up to desired volume at high speed
- De-ammoniation at mid-speed
- Refining cell size at low speed
- Gelling agent addition.

You will need good ventilation when mixing latex as it gives off ammonia fumes. Depending on temperature, humidity, mixer type and size of the run, this process can take anywhere from 15 to 30 minutes. (Runs smaller than 150g of latex are not recommended.)

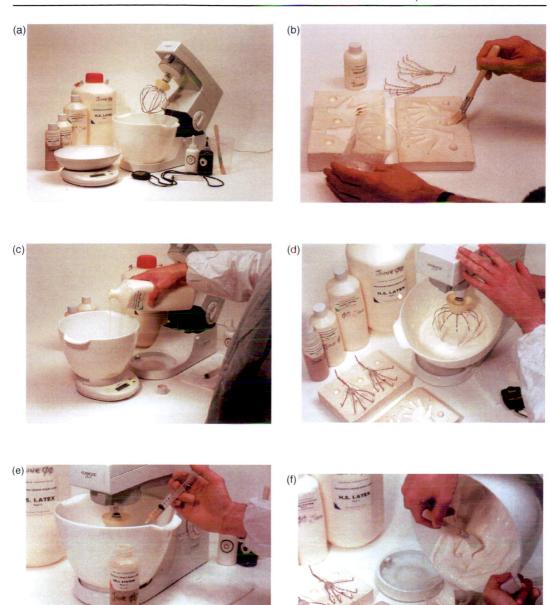

Figure 6.12 Sequence of photos mixing and casting with latex. (a) Materials needed for making foam latex. (b) Brushing on release agent. (c) Measuring latex. (d) Mixing foam. (e) Adding gelling agent. (f) Pouring the mixed foam into the mould. (g) Filling the mould with a brush to release large air bubbles. (h) Closing the mould. (i) Pressing mould halves together. (j) Weighing down the mould. (k) Putting the mould in the oven. (l) Trimming the mould. (m) Removing the new cast. (n) Trimming spare latex. (o) Snipping armature wires. (p) Sponging on paint. (q) Painting on details. Courtesy of John Parsons. Photos © Susannah Shaw

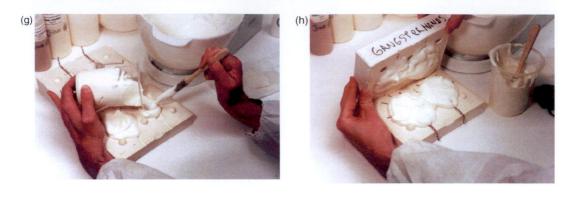

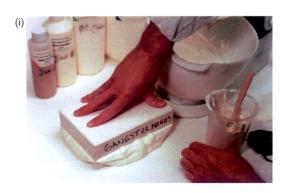

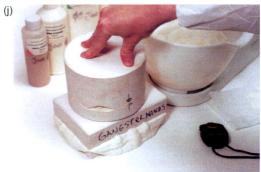

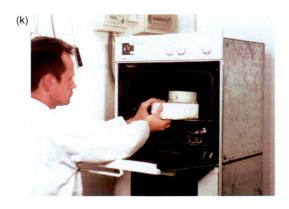

Figure 6.12 continued

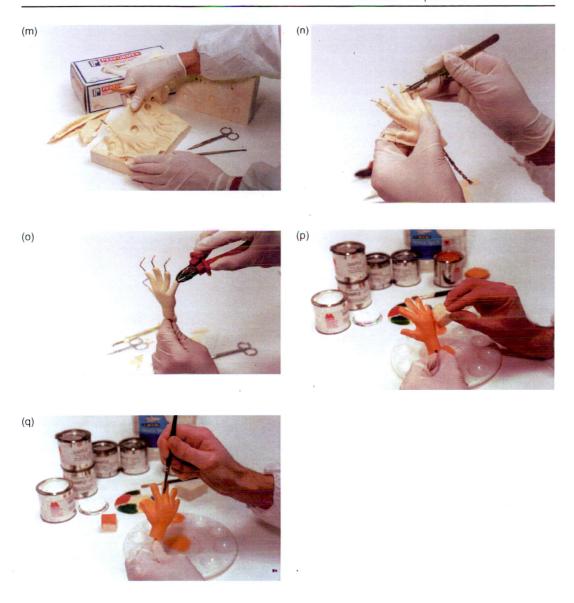

Figure 6.12 continued

The following set of instructions is meant only as a guide and applies for 150g of latex using either the Kenwood Chef mixer widely used in the UK (which has a choice of speeds) or the Sunbeam Mixmaster used in the USA (with the small bowl). The Sunbeam produces a foam of superfine mixture. It has a highly efficient beating action, driving off ammonia very quickly. However, the mixer is less efficient when used in a large bowl.

- 1. Shake all components well and into the mixing bowl, accurately weigh out:
 - 150g latex
 - 20–30g foaming agent
 - 20–30g curing agent.
- 2. Foaming mix at high speed for 3–5 minutes or until the desired volume is reached.
- 3. De-ammoniation reduce to medium mix speed for 3–5 minutes.
- 4. Refining reduce to the lowest speed for 5–6 minutes.
- 5. Gelling agent at the end of the mixing time add 5–10 ml of gelling agent to the foam. Mix thoroughly for 60–90 seconds (the addition of a latex color at this stage will give an indication as to when the gelling agent is fully mixed in). (The longer times given are recommended as a starting point for 300 g of latex.)
- 6. Put your armature in place in your mould. The PTFE tape on your armature stops any of the brass from the armature discoloring the latex. Then fill the mould by hand, brushing the latex in to ensure coverage (see Figure 6.12g-i).
- 7. Press together the two halves and weigh them down or clamp them. Then inject the foam down one of the channels; a large syringe can be bought at a plumber's store. The injection hole should direct the foam to the core. Let the foam work itself around the whole mould. When you know the latex is coming out of every vent, plug the escape vents with wet clay or English Plasticine (American clay will melt in the oven).

gelling times

The gelling or setting time of the foam at a room temperature of 20°C (68°F) is between 10 and 20 minutes. Longer gelling times may occur and produce perfectly acceptable foams. Faster gelling times can be achieved by slightly increasing the amount of gelling agent, increasing the de-ammoniation time. The foam must be set before placing in a hot oven, otherwise foam breakdown could occur. An easy way to test this is to pour leftover foam into a paper cup to a height equivalent to the thickest piece of foam you are casting. Once that has gelled, the foam in the mould should have gelled as well.

curing

When the foam has set (i.e. become a semi-solid, easily deformed material throughout), it may be cured in a suitable oven for 2–3 hours at a temperature of 90–95°C. Curing times may vary depending on the thickness of plaster moulds, etc. You may have to shorten times for fiberglass or epoxy moulds, and increase curing times for thicker moulds or silicone moulds with plaster positives. After curing and allowing sufficient time for the moulds to cool down, remove the foam from the mould and wash. Cured foam is more readily removed from warm, rather than cold, moulds (Figure 6.12I, m).

Plaster absorbs the moisture, generally allowing air to escape, but if you find an air bubble is trapped, more likely if using a resin or a fiberglass mould, you can drill holes in the mould to allow air to escape from likely trapping places. It can take two or three bakes to get a successful cast.

Wash and trim the latex carefully with nail scissors or a scalpel (Figure 6.12n, o).

care of latex

Latex wears well but will tear under strain. Human sweat will help to rot the latex, so keep hands as clean as possible, using wet wipes. Latex can be repaired with a contact adhesive: coat both surfaces, allow to dry and then press together.

Spirit-based cleaners will dissolve latex during the mixing and airing stages, although once baked, latex is more resistant. As with Plasticine, keep it from becoming tacky with a little talcum powder. Latex doesn't have a very long shelf-life, up to six months if stored in ideal conditions. It would make sense to leave buying it until you are absolutely ready for it.

casting silicone

Casting silicone does not involve baking. The main consideration when using it for your puppet is that it is quite resistant (springy) and may reduce the control you have over its movements. One good solution is to cover your armature with ordinary foam – upholstery foam – so that you are only covering a final layer with silicone. That way, you will get a reasonable response from your limbs, as well as an easily cleaned puppet.

Once you've mixed your silicone (as per manufacturer's instructions), it is injected into your mould until it is coming out of the vents. Remember to block any vents with wet clay or English Plasticine, as otherwise the silicone will continue to dribble out.

Leave to cure. Curing times for silicone depend on the type of silicone and how much catalyst is added. On the whole, silicone will take about 10–12 hours before it can be removed from the mould.

When set, remove from the mould and clean with isopropyl alcohol. You can sand the seams with fine sandpaper, or remove them using a fine buffing tool with a Dremel or multi-tool.

coloring

For latex there are liquid latex paints that can be painted or sprayed on. Before spraying, you will want to 'key' the cast first with liquid latex. The inks can be sponged on and thinned with white spirit. This will cause the latex to wrinkle, but it will settle again.

Water-based acrylic paint like Liquitex can give your foam latex a 'plasticiney' look and has a good opacity and a glossy finish. Acrylics can be mixed with Copydex, or similar latex-based adhesive, to bond well with the latex. For a similar look you can use a water-based gouache.

For resin or silicone pigments, check with the manufacturers for compatible dyes (Figure 6.12p, q).

costumes/dressing

Many puppets have their clothing sculpted and moulded in foam latex or silicone as part of the whole, but making fabric costumes for your puppets gives them a rich sense of individuality. The most important consideration is the type of fabric. You will want to look for prints and textures that suit the scale. If you want a specific pattern, you may print your own fabric.

Nigel Cornford has made costumes for puppets from the early days at Cosgrove Hall:

If a fabric is too light it is liable to 'crawl'. In other words, you're aware of the constant movement caused by the animator touching the fabric while filming. In King Kong and the early Harryhausen movies, you can see the fur 'crawling'. So the material has to be stable. I start with a basic white cotton which I dye or screen print and sometimes embroider; that way you can get the scale right. I prefer not to stiffen the fabric, but if it's necessary, for instance if a cloak has to flap in the wind, I'll wire the hem or sometimes I'll stick it to Rosco foil. I prefer to hand stitch costumes for puppets; machining is not versatile enough. I would say, choose the fabric you want and work your way around it.

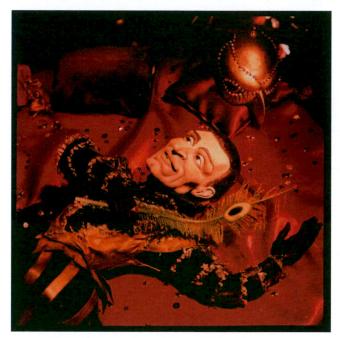

Figure 6.13 Puppet from Rigoletto. Wardrobe: Nigel Cornford. © Barry Purves/S4C/BBC

If you're using leather you would want a contact adhesive. If you want a close fit, use fabric cut on the bias, i.e. cut diagonal to the weave of the material; you will find it gives more flexibility as you stretch it around the puppet. Remember to leave access points for any refurbishment of the puppet. It is possible to glue the fabric to a very thin layer of foam to give it maneuverability.

For decorating your fabric, pens and fabric dyes are available from craft supply shops. If you are making an additional puppet on a bigger scale, for close-ups, you will need to take the texture and pattern of your fabric into account.

During the model-making process, it is worth documenting and photographing each stage – there is so much useful information you discover as you experiment, and it is useful to have a reference to the processes used. Model making is an under-documented area combining

an extraordinary range of skills, and as such the skills are always in demand for film and theatre, and even medical reconstruction and prosthetics.

model-making masterclass – ScaryCat Studio and the Duracell bunny

The Duracell bunny made its first appearance on US television in 1974 as the star of the 'drumming bunnies' commercial. Due to the success of this commercial, the Duracell bunny has gone on to appear in a continual string of television adverts and promotional material throughout the world.

The advertising campaign has long moved beyond simply beating a drum and the Duracell bunny is now seen partaking in a variety of exciting challenges. The bunny's appearance and mannerisms have evolved over the years to reflect the speed and fluid movements of today's toys while maintaining the charm of a traditional toy. The bunny also steers away from the characteristics of the hard-edged look of a high-tech computer creation.

Cat Russ and Gary Jackson started ScaryCat Studio in Bristol in 2000, having learned their trade at Aardman Animations. In 2003 they were given the job of building the new Duracell bunny and to date have made six versions. Gary Jackson describes the process:

The puppet is made of foam latex, covered with fake fur, with a steel armature. The creation process of the puppet begins, as with most projects, with the initial sculpt of the character. In this case, the naked body of the bunny puppet needs to be sculpted with the consideration that it will be eventually covered in fur. Sections of the bunny are roughly sculpted using Plastiline in order to test different fur lengths and to calculate exactly how much weight is added by the fur. The complete body is then sculpted using this information.

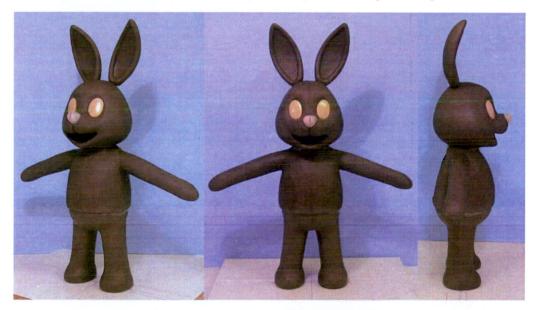

Figure 6.14 Duracell sculpt. © ScaryCat Studio. Courtesy of Duracell Ltd

The finished sculpt is constructed in such a way that it has the ability to be divided into separate pieces. This is not only for moulding purposes, but also to determine exactly how the puppet will fit together once foamed. All of the other separate components, such as the nose, the eyes and the battery, must also be built and fitted to the sculpt at this time.

Once all of these pieces have been built and fitted together, we can then mould everything. Some elements, such as the head, require a two-stage moulding process. This is because the head needs to be cast as a hollow and therefore the mould needs to have an internal core piece made. This internal core piece is then moulded again in order to make a fiberglass skull, which will fit inside the hollow foam latex head.

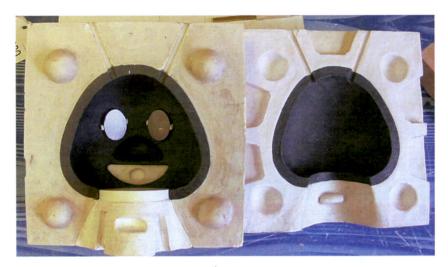

Figure 6.15 Constructing the head mould. © ScaryCat Studio

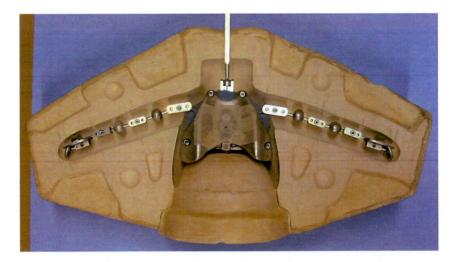

Figure 6.16 Torso armature in mould. © ScaryCat Studio

The next stage is the armatures. The Duracell bunny armature needs to be very sturdy, for not only is the bunny a reasonably large puppet, it also has high demands put upon it during the animation process. Due to this, the armature has evolved from shoot to shoot. The image of the standing armature is a fairly early version, and since then has had a number

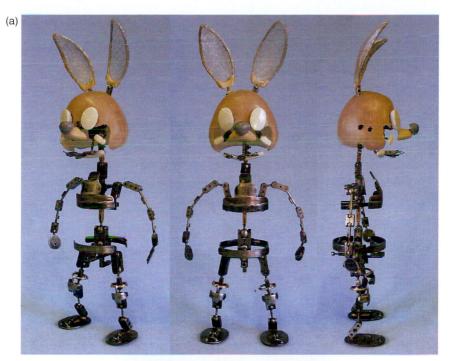

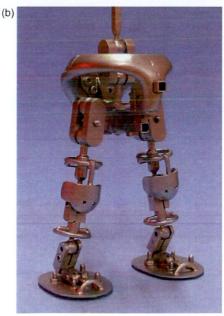

Figure 6.17 (a) Original bunny armature. (b) New leg armature. © ScaryCat Studio

of alterations and improvements added to it. With every new campaign comes a new scenario for the bunnies, with a new set of requirements for the puppets to achieve.

With the armatures designed and built, the phase of casting commences. The armatures are firstly suspended within the moulds and then foam latex is cast around them. The majority of the bunny is made from foam latex, with only the nose and eyes being cast in resin. We made a complete set of eye replacements so that every possible direction the eye could look in had its own pair of solid eyes. The battery is made as a separate model that connects onto the back of the bunny. A range of model batteries have been made to keep in line with the various Duracell batteries that are on sale.

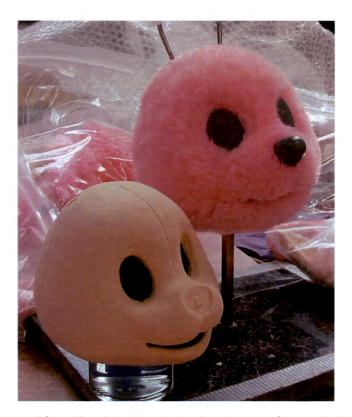

Figure 6.18 Foam and furred head. © ScaryCat Studio. Courtesy of Duracell Ltd

Now that we have a completed foam latex bunny, we have to cover him in his fur. The fur is a specially made, uniquely colored four-way stretch fur fabric imported from the USA. The application of the fur involves designing a number of patterns which, when sewn together, form his outside 'skin' and are then carefully stitched and glued onto the foam latex. The four-way stretch is essential in eliminating fabric restriction, thus allowing the bunny to be animated as freely as possible.

Beyond the bunny itself, we have made a vast wardrobe and a wide selection of props that have been created throughout the various commercials and advertising campaigns.

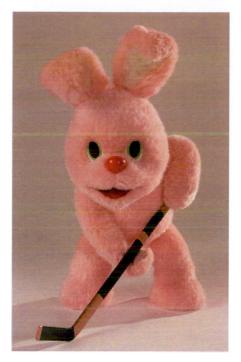

Figure 6.19 Fully furred bunny. © ScaryCat Studio. Courtesy of Duracell Ltd

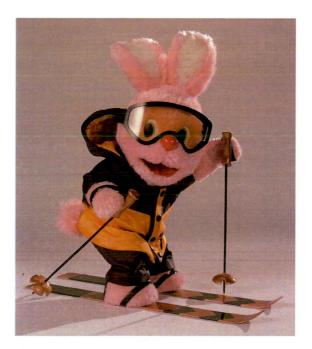

Figure 6.20 Bunny with outfit and props. © ScaryCat Studio. Courtesy of Duracell Ltd

His wardrobe includes the likes of his own tuxedo, casual shirt and jeans, a Santa suit, an underwater scuba suit, surf shorts, ski outfit and, of course, his famous running outfit. The selection of props include his own MP3 player, CD walkman, digital camera, surfboard, briefcase, racing bike, camcorder, Frisbee and a (must have for the street-cred) skateboard.

So, all in all, that's roughly what it takes to make a puppet that lasts several times longer than your average puppet!

glossary of model-making materials

For a list of manufacturers and outlets, see appendix 2.

Allen keys: hexagonal keys available in various sizes, metric and imperial, used for tensioning armatures.

aluminium wire (armature): comes in various thicknesses, ranging from 0.5 to 10 mm in diameter.

baking oven: must have a low temperature of 50°C showing on the dial.

ball-and-socket armature: you can order joints, rods and plates from specialist companies.

Chavant clay: a variety of sculpting clay.

contact adhesives: various makes available, e.g. Evostick, useful for sticking many materials.

epoxy glues: very strong glue; a standard five-minute epoxy is available from hardware and model shops.

Fimo: modelling clay, good range of colors, bakes hard. Used for making props (available at model shops).

foam injector: a large syringe that can be bought at plumbing shops. An icing gun can be used as a substitute.

foam latex: a 'hot' foam, it needs to be baked in the mould. Can be mixed to different densities for different purposes. If mixed fast, it will provide an airier, lighter foam (used in prosthetics). A slow mix will provide a denser, heavier foam that is good for models and puppets.

food mixer: Kenwood Chef/Sunbeam Mixmaster for mixing latex.

glass fiber: used with resin to make very strong moulds. Tendency to warp, so nuts and bolts are recommended to keep parts together when moulding and storing.

insulation board: dense foam that can be carved (available at DIY stores).

Lewis Newplast: Plasticine or English clay has a good color range (19 colors), colors more subdued than the US Van Aken, and does not melt. Available from model shops and art suppliers in the UK.

Lewis Uro: like Sculpey, similar use (available at model shops).

Milliput: an epoxy putty, also used for making props, white or pink (available at model shops).

Plastiline: comes in two colors – gray or buff. A hard modelling clay, ideal for maquettes for hard or soft moulds. Can be melted or can be made really hard if kept in a fridge.

rare earth magnets: otherwise known as neodymium iron boron magnets. Very powerful and quite expensive magnets to fix your puppets' feet to the floor when using a perforated steel base. From £6 (\$12).

release agents: Vaseline is cheapest and best; must be used judiciously to avoid clogging in corners. Available as sprays and aerosols.

resin: a cold-cast product used for making hard parts – hands, feet and hairpieces. Also used for mould making for silicone or foam casts. Can come with metal powder, i.e. Formite, aluminium powder in resin.

Sculpey: a polymer clay. Available in several types – Original Sculpey, Super Sculpey, Sculpey III and Premo Sculpey. Must be cooked and cured. Good range of colors (available at model shops).

sculpting tools: used for smoothing, texturing, gouging and shaping clays. People build up a range of tools to their own liking (available at model shops and pottery suppliers).

silicone: makes a rubbery smooth-textured material. It can be cast cold, with no baking required; the color is fast and can be mixed to match a Pantone reference. It provides a resistant and springy material. Ideal for replacements (substitutes). Very strong, tear resistant and easy to clean. Good for moulds for resins and Plasticine press.

sticky wax: a removable adhesive material useful for fixing props in place (available at model shops).

Van Aken (Plastalina): fudgy texture, it can get sticky and soft under lights. Has a melting point, which is good for moulding. Colors are saturated but not fast. Good for doing food and, when melted, makes a good gloss. Sold in the USA.

wood: for bases, blocks, and balsa wood for cores, props, etc.

chapter 7

four walls and a sky - sets and props

research the look
design and building of sets
interior sets
exterior sets
forced perspective
making props
rigging
glossary of materials for sets

research the look

Most of the artistic concepts – the character design and look of your set – are decided before you reach the storyboarding stage, and you will have already thought through the camera angles and lighting scheme. You have probably decided where there will be windows in an interior scene and what appears outside those windows. This chapter will help nail down some of those decisions.

If your setting is an important part of the story, you will want to create the right atmosphere. For your own project, if it's fantasy it's up to you, but for any period or realistic locations it's important to research the look. Get some location pictures of what it should look like: if it's your granny's sitting room, take a photo, decide what is the thing in that room that gives it atmosphere. An old 1950s radio? A pair of slippers? The cat asleep on the back of the sofa? A pile of magazines on the floor? It's probably a combination of all these things. Do you need to be able to see down the street? Does the exterior match the interior? What period is her house?

For a street scene, try to make the angles interesting. Looking straight on from a middle-of-the-road position to a row of terraced houses for a whole scene could be dull. Imagine the viewer looking down on it from a window or from an alleyway across the street. Give your set dimension, add foreground interest: dustbins you can look out from behind. An exterior

countryside scene presents many opportunities to create depth, with trees or hills and foreground interest with shrubs and bushes.

design and building of sets

In the early planning stages the director and DOP (director of photography) would go through the set design, working out the camera angles, depth of field (area that will be in focus) and so on, with the set designers. Then a mock-up of the sets would be made to scale. Some companies use **foamcore** (two thin cards sandwiching a layer of foam). It's a light and easily cut material, but is an expensive option. Artem, a London-based set and props company, make their mock-up sets with **MDF** (medium density fiber). It's cheap to change, and if the set is approved, it's already made. Stylistically, the set designer will work to the art director, and advise on budgetary restraints that may have to be taken into account.

The DOP will then check the mock-up with a viewfinder to make sure that shots work. At this stage there may be parts of the set the designer knows will not be needed. Allowances should be made for decisions about camera angles changing, for lighting and for animator access, and when the set is built it should have walls that can be removed for reverse angle shots (see chapter 4, section on planning your shots).

CAD

Computer-aided design is a useful way of trying out a set first. A virtual set can be built in the computer, allowing the 'camera' to fly through, check angles and lenses before committing the budget. Again, lighting set-ups can be tried and tested this way, saving on time and manpower. Once the original investment is made in the computing software, the advantages are obvious. However, as with everything done in this way, it leaves no room for the happy accident when you come up with something you wouldn't have thought of, through some external factor. Decent 3D software to allow for the sophistication of fly-throughs and lighting, like 3D Studio Max, Lightwave and Alias Studio, is not going to come cheap.

scale

With puppets being around 20–25 cm, a standard scale to work to is 1:6. The scale of the puppets is dictated by the pieces needed for armatures and by your depth of field. This is the range of your set that will be in focus. The smaller the scale, the harder it is to give it a sense of depth and, without that, you will create a 'miniature' look. If you want your world to look realistic, you will need to work at about a 1:6 scale and use plenty of light to give yourself more focal range.

Nick Hilligoss, animator at the Natural History Unit of the Australian Broadcasting Corporation, explains:

For animation, I do human puppets in about 1:6 scale, so they are around 12 inches tall. [Some people use eight-inch-tall puppets.] But I also have rats, frogs and insects, and for close-ups of those I make full-scale copies of small sections of the 1:6 sets. For wide shots of suburban streets, I make 1:24 scale sets [because you can buy a wide range of 1:24 model cars, and they're cheaper than 1:18]. I make 1:24 people for these sets, but they are not meant for seeing up close, they just add life to the shot and help with continuity of action.

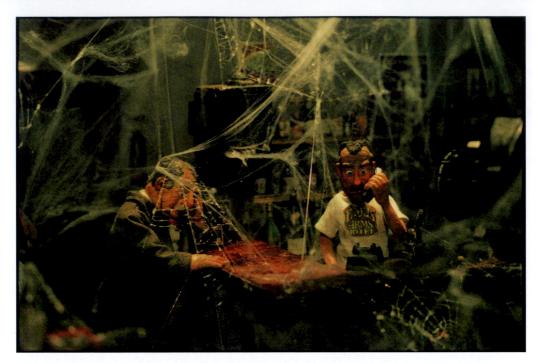

Figure 7.1 Human puppets at 1:6 scale. © Nick Hilligoss

Figure 7.2 Full-scale frog puppet. © Nick Hilligoss

You will need to concentrate on detail if you know something is going to appear in a close-up shot. In some cases, the close-up shot requires a larger scale puppet – and a larger, matching scale portion of the set may be needed.

the base

It's best to build your set at a comfortable working height for animators to get to, and to make it as firm and solid as possible. This may involve screwing things into the floor to fix it, or getting hold of stage weights or sandbags. Glueing table legs to the floor is a more desperate method; another is to use steel trestles, weighted down with sandbags, which have an adjustable height you can clamp your base to.

A solid base made of 12–16 mm plywood means you can fix your puppets' feet with tie-downs, i.e. threaded holes in the feet that can be screwed to the base through a pre-drilled hole using a bolt and wing-nut system. You can either drill the holes as you need them, or you could have a pre-planned route. Then fill the holes with a clay that matches your set base. Tie-downs are the best way of ensuring absolute contact with the floor but can slow the animation up. On a budget shoot, you could use strong flat-headed pins covered with matching colored clay. Or if your puppets are very light, you could use double-sided sticky tape. These won't give you perfect stability, but can speed things up.

If you want to invest in a permanent base, a more expensive choice is a perforated mild steel base (approx. £100 (\$200) for 2×1 m, 16-gauge thickness with $\frac{1}{8}$ -inch perforations — with the edges folded over and corners welded). The benefit with this is that you can use magnets underneath the table to hold your puppets in place. Rare earth (neodymium) magnets provide pretty good stability for animation, as long as the foot area is large enough. Magnets on their own might not be enough to hold a dancer on points, or a large dinosaur with little feet! Be aware, these are very strong magnets — handle them with care. Never put your magnets near any of the recording equipment, as they will play havoc with its magnetic field. As it is perforated you may use it for screw tie-downs, but if your movements are critical, the perforations might just not be where you want them to be — so if you prefer tie-downs to magnets, use a wood base.

If you are using magnets you want to make sure the covering is no thicker than 1 mm. Christine Walker, production supervisor at Mackinnon & Saunders, remembers her days working at Cosgrove Hall Films:

They started off covering the perforated steel sets with sticky-backed plastic sheeting – terrible stuff – put it on and you'd have to sand it a bit and add a bit of texture and then you paint it. Each time you increase the depth between the magnet and the base of the foot it's critical, because the magnetic draw drops off exponentially. So we came up with covering the sets with tissue, laying water glued tissue very fine, very thin. Then we discovered neodymium [rare earth] magnets. We needed them when we had to have texture – grass and snow, as in Pied Piper and The Fool of the World. We had problems with tie-downs because the animators weren't used to using them. On features like Nightmare Before Christmas they do several run-throughs and shoot the same scene maybe

about 12 times before getting it in the can. The tie-downs are planned. But you don't have that luxury on series work, you're on a very tight budget. So that's why they've always worked with magnets.

Shifting of the set is one of the animator's worst nightmares. Overnight the set may have moved; it may be due to camera movement, or it can be a problem with the frame grabber, or sometimes things within the set have drifted, drooped and flopped. The set can expand and contract with temperature changes. If you can keep the studio at a constant temperature, you will solve a lot of problems. At Christmas Films, a Moscow studio that provided the model animation sequences for *Miracle Maker*, animation happened at floor level. A back-breaking situation for the animators, but the only way they could ensure lack of movement of the set in that studio! Many animators will work through the night to get a shot finished to avoid overnight movement.

At Aardman they have a store of about 40 car jacks that they use under a set to correct the angle if there has been any shift overnight.

creating landscapes

If your character is going to climb up and down hills, jump into puddles, etc., you will need to think of the best way of securing it. But whichever way you choose, it is vital to keep the illusion of weight – and a crack of light showing under your puppet's feet will ruin it.

Nick Hilligoss makes a great many animated films with animals in various habitats:

If the ground's just a little built up, I use longer tie-downs. For monkeys walking on tree branches, I make hollow branches from plaster and fiberglass matting, with no back, so I can put the tie-downs in from behind. It's the same for tree trunks, rocks, hills, etc. I make a mound of clay, build the shell over that [like making a mould], then pull out the clay. Then I drill holes and use the same tie-downs. It helps to make up a block like a wooden washer to put on the tie-down, to tighten the wing-nut against, so it doesn't dig into the reinforced plaster. If the rock or hill rests on a flat base, I make a hole in the chipboard underneath for access. My puppets have aluminium blocks in the feet, with slots in them for the T-shaped tie-downs. On bare floors I usually fill the tie-down holes with colored Plasticine. Then it's easy to poke the Plasticine out when pushing the tie-down up from below.

I drill holes in a path beforehand because a drill can shake the set and make sawdust. I drill more holes than I think I need, then I fill them with colored Plasticine. Some sets have a coarse velvet 'carpet' which can have little slits where the holes are, which don't show. And with rough ground, shot from low angle, sometimes the holes don't show anyway.

Landscape textures can be made using sawdust or sand mixed with PVA glue spread over your base paper and painted. Trees can be made with plaster, glass fiber, wood and branches. A variety of greenery and foliage can be bought in model shops, but as always, creating your own textures is the key to an individual look.

Figure 7.3 Possum's Rest. Courtesy of Nick Hilligoss

To create hills and rocks and other irregular surfaces, you can use **two-part urethane foam**, a clear liquid and a brown liquid you mix together, which expands into pale brown rigid foam. (**Health and safety note: toxic fumes are released when mixing; use outside only, wearing a mask.) The hardened foam is easily carved, but the surface is also easily damaged.**

Flocking is another technique that can be used for a multitude of purposes. Flocking creates a velvety texture that is not only useful for close-cut grass, but also for animal skins. It can be added to make slightly longer 'fur'. Using a flocking adhesive, similar to PVA in consistency, coated over the object or area to be flocked, you can go for two basic effects. One is just a case of sprinkling the flock over the area – which gives you a rough finish. Or you can get a smooth, uniform finish that typifies the 'flocked' look using a flocking gun. This adds a static charge and stands all the fibers on end, giving it a velvety look. For thicker fur this can then be added to. (**Health and safety note: flock is an artificial fiber, so one should wear a mask to prevent any inhalation.)**

buildings

There are some things for which MDF is the best material to choose: cutting smaller, complicated shapes where you need a clean edge. Buildings appearing at a distance can have detail such as windows and mouldings painted on them. But the closer ones would need the detail added in three dimensions with a reflective window surface put in. Care should be taken that any reflective surfaces don't reflect light or off-set details. Cans of **anti-flare** can be bought at photographic outlets. These cover reflective or shiny areas with a dulling spray. However, because it is easily cleaned off, take care, as it can also be easily smeared with fingerprints.

For speed, use hot glue. If there are parts of the set that need to be removed for shooting, they can be held together with clamps. Always make sure that nothing has warped, and that edges and corners are true. You don't want a light shining through a badly fitting corner on your set.

interior sets

If there are windows, what is to be seen through them? And if there are curtains, will they be expected to move? Curtains that need to be animated can have thin aluminium wire threaded along the hem. Curtains, rugs or fur can be stiffened with roller-blind spray, which is basically a watered-down PVA solution. Alternatively, material can be glued to heavy-duty foil.

Any props, furniture, etc. must be fixed so it cannot shift during shooting. Furniture can be hot glued but props that need to be moved about can be temporarily held in place with **sticky wax**, a product that is less springy than Blu-Tak.

Walls and floors must meet perfectly – again, an illusion can be totally ruined by a crack of light appearing between walls.

Figure 7.4 Example of an interior set. Puppets, sets and props made by Artem. © Bob Thorne, Artem Ltd/commercial for Dairylea Lunchables; Oscar Mayer is a registered trademark of KF Holdings, Inc. and is used with permission

practical lights

What's your light source? Are there interior lights? They can enrich the atmosphere and are relatively easy to set up. If it is a night scene are there practical lights to consider – table

lamps and such like – that will need wiring that needs to be concealed? Flashlight bulbs or Christmas tree bulbs are the right sort of size for this. Small 20W halogen reflector bulbs can be used to good effect – with a domestic low-voltage lighting transformer that you can buy from a hardware store for about £15 (\$30), you can control the output of your various small lights.

Figure 7.5 Set with practical lighting made using aluminium milled lampshades and flashlight bulbs. Sets and props made by Artem, puppets made by Mackinnon & Saunders. © Bob Thorne, Artem Ltd/commercial for Brisk Tea/JWT

Lighting can alter the appearance of a set by creating illusions using shadows, such as jail bars or Venetian blind shades on a wall. These don't have to be built into the set, you can use a cut-out mask called a 'gobo' and place it in front of a light to create the shadow in the right place. A shadow effect of branches and leaves can be created in the same way, to break up a blank wall or hillside (see Figure 7.6).

exterior sets

Your main light source for an exterior set is the sun or the moon. Either will create shadows. You can choose a general diffuse light with no shadows – but it will give your film more life if you create a natural look that includes shadows. So when painting details such as shadows on buildings, the direction of the light needs to be ascertained in advance.

The backdrop is an important factor in the story. The size of the backdrop depends on the widest shot in the storyboard, and a skilled background painter can create a sense of great distance by use of color and exaggerating the perspective. If the backdrop represents

Figure 7.6 Lighting effects: examples of gobos. © DHA Lighting Ltd

the sky, it should be lit mainly from below, as the sky is brightest near the horizon. Allow a space between the back of the set and the backdrop for lighting. The 150W halogen 'garage' lamps have a wide throw, but may need a little diffusing as the reflectors in them can cause a 'streaky' effect.

Handle lamps with care, wearing 'gaffer' gloves: the housings of the higher intensity lamps can get extremely hot. Be aware of the heat generated and the flammability of your set. Don't put any lights too close to the set. The hotter the light, the softer any animation clay will become.

forced perspective

There are several ways of creating an impression of depth in your scene. To create a forced perspective, you need a vanishing point – a point on the horizon where all your horizontal lines will meet up. The example in Figure 7.7 has a central vanishing point.

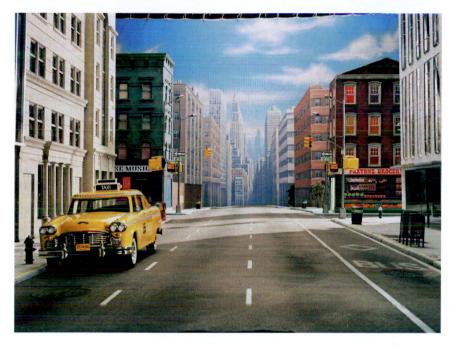

Figure 7.7 Background using forced perspective. © Bob Thorne, Artem Ltd

Place the background/backdrop at a distance from the back of your set if you need the background to be lit from below. The way you paint the backdrop helps to create depth. Distant hills/cityscapes get bluer and hazier the further away they are, a trick of the atmosphere. The sky gets lighter as it meets the horizon, and if you add a bit of yellow to the whitish strip before it meets the horizon, you'll be adding a realistic pollution haze!

If necessary, you can make your set as separate strips of landscape, or cityscape, with the details on each strip getting progressively smaller as you go back. If you put a fine spray of white over the trees/buildings, getting denser and bluer the further back you get, that will help the illusion of distance. When using paints, a good reserve amount of the colors mixed should be set aside for repainting and matching.

making props

Prop making is part of the model-making department in an animation studio, as many of the same skills and materials are used. It is dependent on inventiveness and attention to detail.

Milliput, Fimo and Sculpey can all be moulded and baked hard. Model makers all have different feelings as to which materials they use for different purposes. They will collect and hoard strange little bits of plastic and metal that will come in handy when making some item or other. Always keep your eyes open at junk sales, toy shops and electrical shops for items that can fit to your working scale. But when you need to get stuff in a hurry, there are mail-order catalogs of prop and set-building materials.

When making these miniatures, you have to think about your fingerprints because a close-up shot will pick them up. Wear latex gloves if you need to.

Insulation board or polystyrene/styrofoam can be shaped with a modelling knife and filed down for less detailed items. Aluminium is good for metal fittings because it can polish up like chrome, and can be cut on a bandsaw and sanded to shape.

Newspapers, leaflets and fabrics can be stuck to heavy-duty foil, making them malleable enough to animate.

rigging

There's a range of mini-scaffolding called **Climpex** made by S Murray & Co. They make a series of 13 mm rods, connectors and clamps, mostly for use in laboratories, but which have also been found useful by photographers and model animators to help prop or hang models and grip things like reflectors and boards. Needless to say, it all costs an arm and a leg, but it's worth looking into because it can save a lot of toil and trouble. You should invest in a range of G-clamps along with your toolkit.

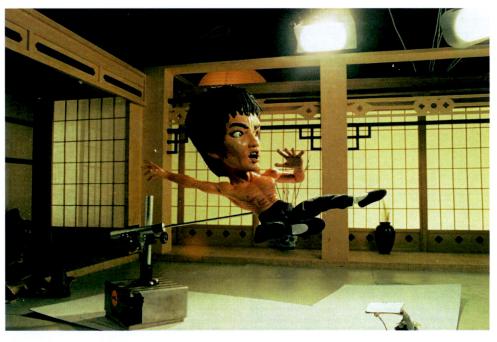

Figure 7.8 Climpex used to make a rig. Set by Artem, model by Mackinnon & Saunders. © Bob Thorne, Artem Ltd/Brisk Tea/JWT

Other than Climpex, a scaffolding rig around the set is useful. An equivalent US company **Berkey Systems** make an amazing range of modular support rigging.

There are very few rules for set design and prop making, other than the health and safety precautions when using MDF, spraying paint, etc. It's a case of experimenting, trying out different materials, collecting little bits and pieces, and hoarding them for when they just might come in handy. Hobby shops are a treasure trove of miniature items, but the cost of buying ready-made objects can become exorbitant.

glossary of materials for sets

See appendix 2 for a list of suppliers.

Climpex: a range of mini-scaffolding, with clamps and accessories with a thousand uses on a set.

Fablon: the original sticky-backed plastic – available at DIY and stationery shops.

fiber board (MDF): available in most do-it-yourself stores. Dust when cutting is said to be carcinogenic – wearing a mask is essential.

Fimo, Sculpey, Milliput: see glossary, chapter 6.

foamcore: a sandwich of set foam between two sheets of thin white card, available in different thicknesses, easily cut with a scalpel or modelling knife. Available at art suppliers.

gumstrip: brown paper tape with water-based glue on one side. Available at any stationery shop.

heavy-duty foil: Rosco make a black foil, also known as Black Wrap. It can be used for a variety of purposes in lighting, such as cutting down spill from a light or flagging off a bit of glare on the lens. Because of its versatility, it has found its way into prop making as it has no memory, i.e. it stays exactly where it's bent, making it useful for curtains, flags or any material that has to move.

perforated steel: a sheet of mild steel with uniform perforations to use as a base for your set, allowing a choice of magnetic fixing or tie-downs for your puppet.

rare earth magnets: see glossary, chapter 6.

sticky wax: a removable adhesive material useful for fixing props in place (available at model shops).

chapter 8

sound advice – the voice track

chapter summary

- pre-production
- recording dialog
- sound breakdown
- · lip sync
- music and effects copyright

In the late 1970s, a new approach to animation was used at the BBC in Bristol (England), when a series was produced by Colin Thomas called *Animated Conversations*. Real conversations were recorded in their natural setting – for example, a hippy commune, a pub or a dentist's surgery. Pete Lord and David Sproxton at Aardman Animations chose a Salvation Army hostel – they then developed characters from this dialog and animated to it. Their film *Down and Out* created a lot of interest and the idea was then taken up by Channel 4 – a new series, called *Conversation Pieces*, was commissioned. Aardman directed a total of 10 pieces for this and the following *Lip Sync* series. It was for this series that their new animator, Nick Park, made one of his best and most memorable films, *Creature Comforts*.

A film like Creature Comforts is much simpler to develop than Wallace and Gromit, because it all comes from the voice track. It all comes naturally from the person who isn't acting or isn't scripted. Because of that it has a certain naturalness that you can only do one thing with. As an animator you listen to the sound-track again and again, you design the character to fit that voice, then you animate it, very much inspired by what that voice is about. The reason you've chosen that particular voice and that particular section is because it says something naturally to you about what it should be. A good example is the Brazilian jaguar in Creature Comforts. The interviewee was talking at the time about student accommodation and the food and the weather here in Britain, he was praising the positive side of living with 'double glazing and things like that'. It suggested he could be a wild cat of some sort, and it fitted with him in a zoo as well. Every time he said 'space',

because he kept repeating it, I thought why not use that and work it in as a comedy thing. The soundtrack worked on its own in that film, the characters were so strong that I felt I was just pointing them up really.

Nick Park

If one is searching for an idea, a pre-recorded live conversation can be a helpful way to get started and can have wonderful results. It seems a simple exercise to try, but of course relies on the animator developing a good ear for dialog, recognizing a good story, and judicious editing.

pre-production

In chapter 4 we went into the preparation and planning of the visual part of the animation. The sound in animation is almost as important. As with the picture, you have to create the whole world around your characters. Although the majority of the sound design takes place after the animation, recording the dialog is an essential part of the early production stages.

If you have your idea, your script and want to proceed down that track, you will need to record your dialog. You know how your characters sound. At this stage, without going to the expense of a professional recording, record a 'scratch' track (a rough soundtrack of yourself or friends doing the dialog), either direct onto your computer or onto a CD, and edit it to your animatic on the computer. Using the dialog as your timing, cut your animatic to the dialog. When you are happy with the timings, you move on to record the actual dialog.

Once you start to give your character a history, you give it depth and can start to think of the voice he or she would have. Voicing your character is another art. You may have given it a voice yourself, but hiring a professional voice-over is going to make a great difference to the quality of your film. Many actors do voice-overs; these jobs are generally more financially rewarding than most acting jobs, especially if it is for a commercial. They will send a voice reel (a demo tape of their styles) to a voice-over or actor's agency. These agencies can help you to narrow your search if you tell them the kind of thing you are looking for. They will send out demo tapes or CDs. You can also hear the demos on websites, although audio quality over the internet is not always an accurate way of assessing a voice. Most actors, unless they are personalities, will do a free audition, but hiring them for recording is negotiable. Expect to pay anything between £100 and £400 for a one- to three-hour session. Check with the Equity (UK actors union) website for the basic rates of pay; I can tell you it's worth it. Having heard hundreds of student films voiced by the directors and their friends, to hear one that has been voiced by a professional is a revelation.

Don't feel you have to go for a well-known actor; there are hundreds of actors who've been doing voice-overs for years, whose faces you may not even recognize but who can do the job wonderfully for you. Take note of radio actors especially, who use only their voice.

The actor will want to know as much as possible about your character. Make up a character profile to go with the V/O script, and if you are paying professional rates, make sure

you have typed instructions clearly, so as not to waste a moment, but at the same time, don't rush rehearsals. A professional voice-over artist can help you by providing timings in their speech that you may not have thought of and inflections that may change your ideas about the dialog and therefore the animation.

A good idea, if you've got an actor or actors in to do your voices, is to ask if they mind you filming them. As they are doing the recording they may act out the character and you can pick up a lot of mannerisms and facial actions that will add character to your puppet.

recording dialog

When booking a recording session, discuss your needs first with the company, so as to get the best out of your time. The engineer will need a script as well as the voice-over, so bring a few copies.

> Lipton Brisk TV Rocky 1

Open on dramatic combination live action and slow motion sequences. Rocky is being beaten by his opponent. Cameras are flashing. A beautiful girl dissolves through holding a sign that reads the round numbers, etc.

SFX: Punching sounds. Ring sounds. Crowd screaming, Rocky etc.

Announcer: And Rocky Balboa is taking the beating of his life....

Cut to dolly shot directly into Rocky's corner as he sits down. Mickey is all over Rocky as soon as he sits.

Rocky: Who keeps ringing dat bell, I can't concentrate....

Mickey: They should call you the Italian Scallion, cause you stink!

Rocky (barely understandable): You like scallions Mick, Adrian makes a great scallion frittada....

Mickey: He's lost it. Give em' the ice tea, it's our only chance.

Cut to dramatic shot of Lipton Brisk coming out of a bucket. Mickey cracks it open and pours it down Rocky's throat.

Announcer: And Balboa needs a miracle.

Rocky: Ah, That's Brisk, Baby. Hey Mick, when d'you get here?

SFX: Ding!

Mickey: Get in there!!!

Rocky: Classic Stallone Grunting sounds.

Cut to wide shot POV of other fighter as Rocky gets up and comes right at him with an uppercut. We cut to a marquee outside the Spectrum. We hear the punch land and the crowd go wild. Announcer ad lib under.

Title: The Main Event. Beyond Cool. Brisk.

Figure 8.1 Extract from the script for a commercial. Courtesy of Loose Moose Productions. © Brisk Tea/JWT

If you really can't run to the expense of hiring a recording studio, you can do it at home. Try at least to get the best microphone you can afford, and deaden any extraneous noise. You don't want aeroplanes, doors slamming, phones ringing and 'voices off' that have nothing whatever to do with your story. A fridge will make too much of a hum, shoes and chairs squeak. You need a clean sound, so that you can bring in other effects that you want later. A 'dead' room can be created at home by making sure there's no echo. Clapping your hands in the room will show you how 'live' it is; you can hear how much the sound rings, bouncing off all the hard surfaces. It's best if you have carpet and heavy curtains in your room. Cover up all hard surfaces with pillows and duvets, make sure there's no one clumping about upstairs, lock the door, unplug the phone – and you will have somewhere to record your voice.

voice techniques

When recording dialog, put the mouth close to the microphone for a fuller and clearer sound; it helps to exclude the room ambience. Too close and you will get 'popping', particularly on the sounding of words beginning with Ps and Bs, such as 'presents', 'pingpong', 'backwards' or 'baseball', although you can buy foam 'pop' shields to go on a mic to help prevent this. In fact, you can make your own pop shield very effectively with a thick stocking stretched over a coat-hanger and placed between the mouth and the mic. It helps diffuse the pops. Differentiating your voices will help: the higher in your throat you 'place' your voice, the more high, or childlike, you'll sound; and the lower, the more bass, an older or more threatening character. Already these voices suggest different characters. An older person has more breath or air in their voice. Warm up your voice before recording, by running up and down the range of your voice a few times.

recording

You can record on to your computer if you have a decent soundcard, but the line input quality is relatively low. If you don't have access to a recording studio you could consider buying an audio interface, with a minimum of two mic inputs. This will connect to your computer by USB and a PCI card, or for a less powerful computer use the Firewire connection. There are many choices of audio interface; as with all equipment, make sure the one you use has timecode, other than that it's up to your budget. You will need a good mic. Certain mics are better for dialog than others, but to make your choice there are websites like **www.shure.com** to help you make your decision. One thing that is always useful to know is how to monitor your audio levels, both for recording and mixing. If you are recording digitally it is important that you never let the meter, or LED level display, peak up as far as OdB (decibels) – the resulting sound is horrible. Analog (tape) recording is more forgiving.

sound breakdown

Once you have the recording, you need to break down the voice track on a bar chart with each word broken down phonetically (how it actually sounds rather than how it's spelt), frame by frame (see Figure 8.2). This is so that you can understand what the mouth movement should be for each sound. If you were to break the sound down by the spelling, the resulting animation could well be unintelligible.

Figure 8.2 Bar chart used in the making of a *Bob the Builder* episode. Courtesy of HOT Animation. © 2003 HIT Entertainment PLC & Keith Chapman

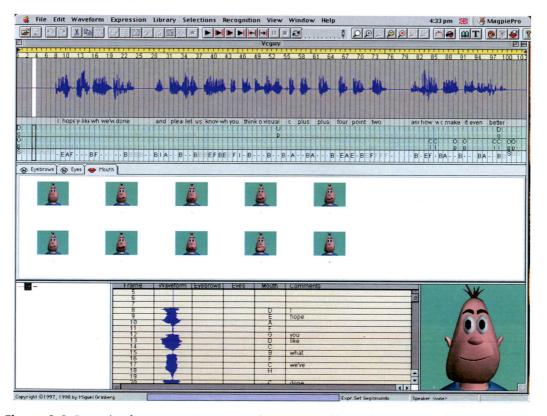

Figure 8.3 Example of a Magpie Pro screen, showing sound breakdown as waveform, frames and a dope sheet. Choice of expressions can be created individually and added to. Courtesy of Miguel Grinberg

The mouth quite often slides from one phrase to the next without punctuating every letter, sometimes moving very little. So unlike much of the other advice you've had about exaggeration, keep these moves simple.

- Place the voice track on your timeline to your satisfaction, listen to the track, and find the start and end frames for each scene (the 'head' and 'tail').
- Mark up your bar chart or X-sheet with the head and tail frame numbers, and fill in the frame count for the whole scene in your camera column.

• Find the first frame of the first sound – mark it in on your sheet in pencil.

- Find the last frame of the first word, mark it in then 'scrub' the word till you can fill in the phonetic breakdown of that word.
- Remember to number each sheet 1 of 5 or 6, or whatever as it is easy to muddle them up.

Breaking down sound by 'scrubbing' your sound file so you can hear every frame of sound phonetically takes a bit of practice, but you will quickly develop an aptitude for this.

Alternatively, introducing your dialog into the computer, using software like Magpie from Third Wish Software, the sound breakdown process is made very easy. Computer audio packages will give you a waveform – a visual representation of the soundtrack – so that you can track exactly, frame by frame, what the mouth movements will be. With a waveform you can see to the quarter frame where an accent or a consonant hits. So as you hear each sound you write the phonetic sounds onto the X-sheet or bar chart.

lip sync

The decision as to how to deal with lip sync needs to be made early on, as part of the character design process. If your character is going to have moving mouth parts, you need to decide whether to choose:

- A full Plasticine head
- A metal paddle as part of the head armature, giving you an open or closed mouth
- A replacement mouth that slots into the head
- A whole replacement head.

Lip sync just means the movements the mouth makes when enunciating sounds. However, it is misleading to think that's all there is to dialog. When someone is talking, the whole face is involved, and not just the face, the whole body is speaking – shoulders hunch, arms gesticulate, hands express. Eyebrows go up and down, cheeks inflate and deflate. Full facial animation is not always easy to take on board with model animation. The extreme movements a face can make when happy, hysterical, grief stricken, yawning are all very daunting to think of in terms of constantly re-sculpting a face – how much easier this is to achieve with the flexibility of a pencil.

This is when the skill of the model animator relies more on the tradition of puppeteering, as in the work of the early animators like Jiri Trnka. Use the body of the puppet to express the emotion: use *timing* to express the emotion. Make the face as simple as possible and rely on the mime of your animation to portray the emotion.

Dialog and therefore lip sync is sometimes better left to a minimum. There are some series when, because of the tight budget, the animators are forced to stick to dialog-heavy scenes

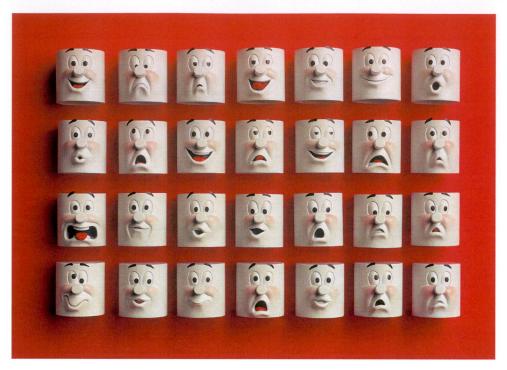

Figure 8.4 Replacement heads. Pritt Stick photo © Mackinnon & Saunders. © Henkel Consumer Adhesives. BDH\TBWA

that are low on animation, because the time taken simply to open and shut a paddle mouth is far less than the time taken to express the emotion through the character.

Once you have your character defined, the complexity of its communication style – the sort of gestures and mannerisms it uses – will start to emerge. Think through the essential characteristics and pare down, or simplify, the range of gestures you will need to tell the story.

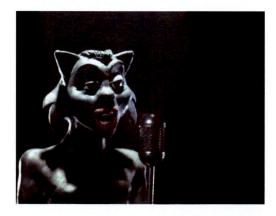

Figure 8.5 Promo for Nina Simone's My Baby Just Cares For Me. @ Aardman Animations Ltd 1987

In favor of full animation, clay gives you the freedom to create the facial acting to go with the mouth movements. Will Vinton's clay animation on such classics as *The California Raisins, The Great Cognito* and the *Adventures of Mark Twain* is a tour de force. Barry Bruce, creative director at Vinton Studios, comments: 'Now much of the animation is done with replacement mouths, it is much snappier, but when we animated with full clay – it was so much more subtle. It is very hard now to find sculptors that are good enough for full animation.' In chapter 10, Teresa Drilling, who learned this classic style at Vinton's, refers to full lip sync in her masterclass.

Nick Park used full facial animation in the early Wallace and Gromit films, A Grand Day Out and The Wrong Trousers, with Wallace's mouth being gouged out, re-sculpted and teeth being added or taken away, throughout the dialog. After that, to speed things up, his characters' faces became replacement from the nose down.

Nick's style works immensely well and relies on timing and emphasis. I don't think anyone could lip read Wallace – but the reason it works so well is because it's so emphatic. He tends not to soften things – he tends to jump to dramatic positions, more like old-fashioned drawn animation. When he says 'cheese' it's a huge E, when I say cheese, I bring the lips forward for the 'ch'. Nick wouldn't do that. My best lip sync is My Baby Just Cares For Me by Nina Simone [Aardman made a promotional film for the single in 1987]. It wasn't very dramatic, but it was quite accurate. When Nina Simone sings she has a kind of a slur – it's very subtle, but I was pleased with that.

Pete Lord, Aardman Animations

Figure 8.6 Bob the Builder. Courtesy of HOT Animation. © 2003 HIT Entertainment PLC and Keith Chapman

Bob the Builder™, a typical pre-school children's series character, is designed with practicality of filming in mind. HOT Animation, the studio that produce the series, would not, for instance, be able to produce the 12 seconds of animation a day that is required for a children's series schedule if they gave the characters 'full' lip sync. These puppets have moulded silicone heads over a resin skull with a mouth made with two hinged 'paddles' that can be simply opened or closed. This doesn't allow a range of facial emotions, but means the animators are reliant on their animation skills to make the most of the puppet's body language. The machines have expression changes − blinks and eye movement and a range of body language that mean they can shrug and express emotion. Like most children's series work, the puppets have a range of movements suited to the style; some animation is fluid and some dynamic with key poses.

Mackinnon & Saunders, the model makers who make the puppets for *Bob the Builder*, also made the armatures for *The Wind in the Willows* made by Cosgrove Hall Films. The lip sync for these puppets became more elaborate as the company developed more intricate forms of armature making. They built heads whose cheeks and brows could be articulated under the foam latex covering, allowing a variety of facial expressions. Peter Saunders recalls:

When they were doing the original puppets for Wind in the Willows they wanted the characters to be able to talk realistically. So we came up with the idea of making jointed heads with rubber skins on them, to do mini animatronics. Originally, for the one-hour special this was used well, but as the budgets progressively reduced for the series, the shots became tighter – they became like talking head shows, and to my mind that's not what animation's about. We created something that went against what we felt strongly about in animation.

Cosgrove Hall has another character, *Rotten Ralph*, employing another method for lip sync, used in a lot of children's series. Sticking on a drawn replacement mouth as a stylistic approach can work well (see Figure 8.7).

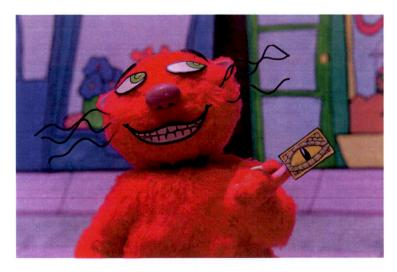

Figure 8.7 Rotten Ralph, made at Cosgrove Hall Films. © Italtoons UK Ltd 1999 and Tooncan Productions Inc 1999

a rough guide to mouth shapes: look in the mirror

The following are **suggested** mouth shapes, as are the images that appear on software packages. The 'relaxed' mouth shape also goes between words. The mouth doesn't close between words (or it would look like it was frantically chewing gum); it rests just open.

It depends on who's speaking, but a word like 'Hello' can look stupid with an 'L' shape put in; it may look better if you go from 'he' to 'o'. Or in the phrase 'I love you', you could miss out the 'v' and go from 'lah' to 'yoo'.

Another consideration: are you going to show teeth? Look at your character; should the upper teeth show when the mouth is open, or the lower teeth – or all the teeth?

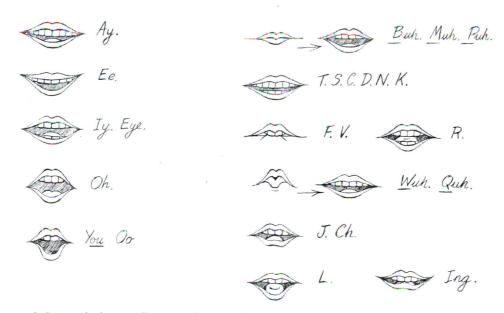

Figure 8.8 Mouth shapes. Illustration by Tony Guy

exercise

Record these phrases and break down the sounds, then animate your model. You could make a bigger head – but it is probably better to try using the puppet you have. Animate the mouth, adding teeth or tongue where they are needed. But don't just animate the mouth – frame your shot to show the top half of your puppet so that you can put more feeling into the phrases and give her character; don't feel she has to stay female, by taking off the ponytail she could be male.

'Hello'

'I love you.'

'Wait a minute! This is not the way to the airport! Where are you taking me?'

A word of warning: as with most studio work, you don't always have control over the design of the character you're animating. In many cases you are working with a character designed by an illustrator or graphic designer, and have to work out a way round it. Ange Palethorpe, who animated *Thunder Pig*, a pilot for a series made at Loose Moose, discovered this:

It was a bit of a shock to begin with. Thunder Pig was drawn by 2D illustrators, the puppet had this huge, heavy snout, which looked terrific on paper, but how to handle the lip sync!? I couldn't change the design, so I had him throwing his head back a lot, so that you could see some movement, but then that seemed to suit his pompous character.

Lip sync is a very small part of dialog acting. In any character a lot more than the lips move to tell a story, and it is worth looking at other animated films to see just how important, or unimportant, the lip sync is. And to see how much is achieved through body language and sound effects.

An animator is like being the actor in the film – we don't design the puppets, they were ready when we started working, the environment was already made, we bring the puppets to life. The dialog already exists as well, so you have to place the existing dialog into their mouths and make it theirs.

Guionne Leroy

music and effects copyright

You will probably want to add music and effects to your film (we'll go into that in more detail in chapter 12), but I want to make an important note here while thinking about sound, and that is to do with copyright. It is very tempting to make a piece of animation to your favorite sound track, and that's fine as long as that piece of animation isn't shown in public, unless you have the recording company's consent in writing. You can use library music or library sound effects – these are called 'royalty-free' soundtracks. You can download some sound effects and music for free from sites like www.freesfx.co.uk. But when it comes to commercial music, then you must write to the recording company for permission to use it. This can be a long and tedious business. It is unlikely that you will get your film onto sites like You Tube or into festivals if you have transgressed copyright laws.

chapter 9

the mechanics of movement

studies from observation
posing the model
timing
weight
anticipation, action and reaction
walking and running
the illusion of speed
animal and bird movement

I must have been into animation. Even when I was 17 I'd rush home to watch Morph. I loved Morph. Pete [Pete Lord, Aardman] said it hundreds of times – it's the performance. The potential of all this really made an impression on me – it was amazing to be able to tell quite emotional stories through this small scenario on your tabletop. And make a proper story that has a tactile reality. Plus you can muck around with lighting and do all your own filmmaking!

Jeff Newitt

This chapter goes into much more detail about the actual craft of animation, and I am giving you examples taken from observation of natural movement. Once you have a feel for creating natural movement, it becomes easier to create comic movement and develop comic timing.

studies from observation

using live reference

Your best reference for human movement is yourself. Work with a large mirror; feel the movements you are doing. Where are you putting your weight? Which muscles are you using? Which part of you touches the floor/the chair first? How do you pick something up?

Film yourself or your friends performing actions, study them frame by frame, analyzing the movements, and get used to timing your movements.

the invaluable Muybridge

A book originally published in the 1880s is still used by animators for reference today: the perennially popular *Animals in Motion*, and *The Human Figure in Motion* by Eadweard Muybridge. The story goes that, for a bet, Muybridge, an accomplished Victorian photographer, needed to prove that a trotting horse takes all four hooves off the ground at sometime in the cycle. He set up 25 cameras along a racetrack to take 25 sequential photographs in one second. The result proved conclusively that horses do take all four hooves off the ground at a stage of the trotting sequence. Muybridge then went on to further analysis of human and animal movement, providing us with very clear reference material.

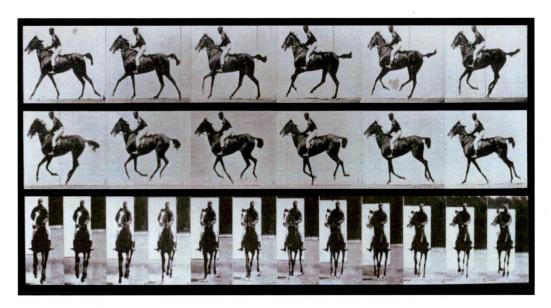

Figure 9.1 Galloping horse. © 1887 Eadweard Muybridge. Courtesy of Kingston Museum and Heritage Service, Surrey, UK

When you need to research something specific for your animation, you should view as much material relating to it as you can. This is not to mimic, but to understand. You can pick up characteristics and timings that will add weight to your character. You can look at frame-by-frame analysis of human or animal movement, where you can see the muscles moving, the inclination of the head, mannerisms, all the things that build up a character.

Drawing from life is a very good way to help understand the body and movement. You don't have to be able to draw, but it certainly will improve your drawing if you practise. The idea is that you will really study something if you are trying to draw it. Drawing something in motion is even better, because then you start to understand the 'essence' of the movement. It's a good idea to use charcoal or conté crayon, as you will work in a quicker,

looser way, and get a more instinctive feel for it. Many model animators or computer animators shy away from life drawing, but one shouldn't think of it as having to produce a finished artwork. It's merely one way of learning to coordinate or link your hand with your eye and brain as an aid to interpret movement. It could involve sketching people or animals in public as you go about your daily business, or attending life-drawing classes at your local college. If this is the case, discuss with the tutor the possibility of doing some fast drawings: 20/30-second poses or one-minute poses.

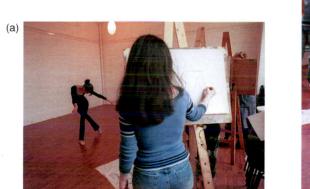

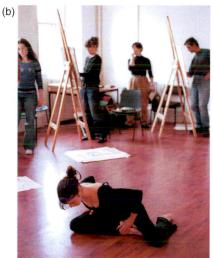

Figure 9.2 Students drawing a moving dancer. © Animated Exeter

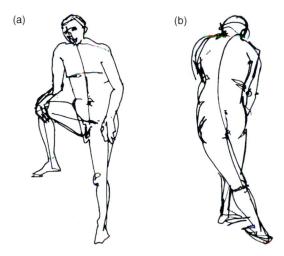

Figure 9.3 Life drawing examples. © Sara Easby 2002

posing the model

Before getting on to more complicated moves, get used to putting your puppet into poses, manipulating it into positions that tell a story.

balance

Stand your puppet on the set, then look at it from all round. Is the balance equal on both legs? Are the knees bent or straight? If someone is standing straight the knee joint will be 'locked' (unless it's an old character) with the arms hanging. Is the weight all on one leg? If so, the weight of the body should be right over that leg, so that the other leg carries no weight and is relaxed. Are the arms looking really relaxed? If the arms are relaxed, the elbows will be slightly bent, not held down stiffly. Hands – unless your hands are a solid cast, in which case they should be cast in a relaxed pose – won't be stiff with the fingers pointing down. Look at your hands when they hang by your side – when they are relaxed the fingers curl in toward your body. And most important of all, are the feet flat on the floor? This is important to register your character's weight.

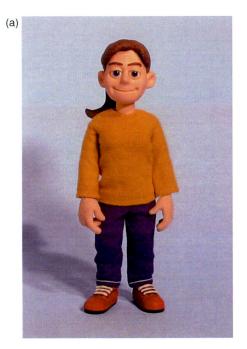

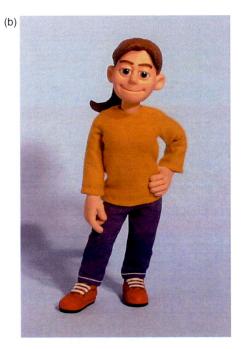

Figure 9.4 (a) Puppet posed standing straight – weight evenly balanced. (b) Puppet in relaxed pose – weight on left leg, with left foot centered under the body. Courtesy of ScaryCat Studio

line of action

Put your puppet in an 'action' pose, hitting a tennis ball, kicking a football or yawning. You might want to make up a few props to help.

Look at your character in its pose from the audience's point of view: does it present a clear image to the camera? Imagine your character in silhouette, just in outline – then is it clear what your puppet is doing? If the silhouette is clear and obvious, then the effect will be clear to your audience. The best way to tell a story is with simplicity and clarity, to make the actions stronger than they would be in real life.

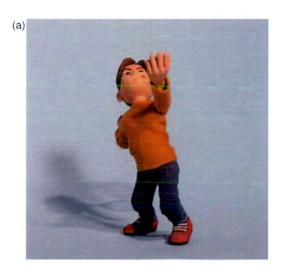

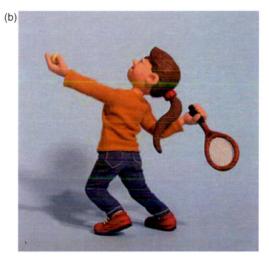

Figure 9.5 (a) The action is unclear from this position. (b) The same pose from a different angle – this tells the story. Courtesy of ScaryCat Studio

Look at the line of movement in your puppet – you should be able to draw a line that indicates where the energy of the movement is. Ask someone else to look at the puppet and tell you what the puppet is saying.

Barry Purves comments:

It's easy to forget where the camera is when you're animating. It's got to read for the camera, not for you as an animator two inches away looking at it thinking 'Oh this looks good' – look at it from the camera's point of view, because the arrangements of the arms may look ugly and may not read. There's no point doing something the camera can't see. Be aware of the camera; be aware of the framing, be aware of what shot you're coming from and what shot you're going to.

timing

It always foxes me, timing. I never feel confident enough to tell someone 'just hold that for 16 frames and move on', I can't do that. I'll say 'hold it for just the right amount of time'. Because if you hold it for too long then it looks really

stagey and you've lost all credibility. I remember Chuck Jones talking about rules and I'm so jealous – that would make life so easy.

Pete Lord, Aardman Animations

Although you may start out timing everything with a stopwatch, you will begin to develop what in the end becomes an instinctive feel for timing. Because animation is a created process of actions in time, you are the creator, you have to calculate how things work in fractions of a second. If something's falling you have to look at the object and assess, by its nature, how fast it will fall and what its impact will be. If someone is throwing something to someone else, how strong is that person, how heavy is the thing they are throwing, how far back will they need to lean to give the impression of the force they are putting into that throw?

The biggest mistake young animators make is assuming timing means live-action timing. It's not! It's not the same timing. You need to emphasize things differently. If someone falls on the floor you need to spend a few more frames developing that weight than you can in live action. Because in model animation we're deprived of blurring the image – you've got to find different ways to address that weight.

Barry Purves

Figure 9.6 Achilles, directed by Barry Purves. © Barry Purves/C4/Bare Boards Productions

I think my style is all about timing. The timing has to have believability. I plan it roughly, especially with the framestores and playback. I want to go off on little explorations to do with timing. Look for those natural little flicks.

Jeff Newitt

weight

The illusion of weight is created by a combination of observation and timing. Watch a weightlifter tackle a heavy weight. Because what they are doing is so extreme it is useful to study, as an animator. I watched an acrobat setting up her trapeze in a field recently. A slight girl wielding an enormous mallet. She moved very slowly, feeling her way with the weight, and it was that slowness of movement that told of the weight she was moving. She shifted her body to control and counterbalance the weight.

If you haven't observed how a weight is lifted or pushed, you will not be able to create the illusion. And your animation could appear as in Figure 9.7.

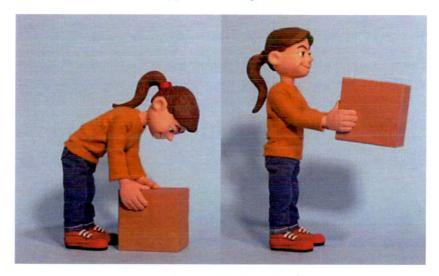

Figure 9.7 How not to animate lifting a weight! Courtesy of ScaryCat Studio

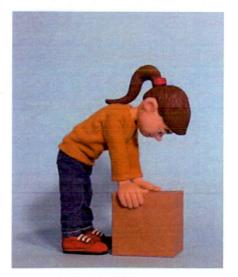

Figure 9.8 Courtesy of ScaryCat Studio

In Figure 9.8 the girl looks as though she is leaning on the box, or at least bending over it with no intention of doing anything. Even if she were to lift it up, we would assume the box was made of polystyrene – otherwise she would do terrible damage to her back! The anticipation in this should be the girl conveying the intention of picking up a heavy box.

lifting a heavy box

Lifting something heavy needs preparation. You can get more out of this move if, rather than going straight for the bend and lift, you have your puppet study the weight first and then prepare to lift. (Hold that anticipation.) Where does the movement start? Practise yourself – you can't very often see just from a videoed performance where a movement starts. You need to feel it in yourself. So practise the movement and decide which part of the body leads you into picking up that box. You probably bend at the hip and then the knees. But even before that, the first thing you would do is look at the object and size up the weight of the thing first. The movement will be slow – look for the slow and the fast bits. Once you're down (hold) – the hands shuffle about to get a good purchase on the box. Not all the body moves at the same pace. In order to get the weight off the ground, the body will lean back to get the center of gravity (the hips) under the weight. Once the weight is lifted, the action is either to stagger around with it and drop it, or to be in control (hold) and walk with it. Any walk with that weight will be slow, with the weight causing the feet to barely come off the ground.

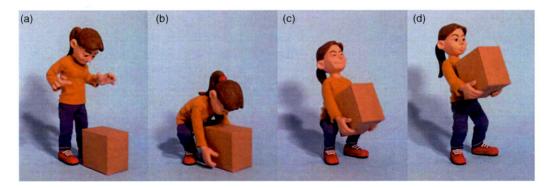

Figure 9.9 Positions for lifting a weight: (a) anticipation; (b) bend knees taking body right down; (c) lift by tipping body back; (d) success! Courtesy of ScaryCat Studio

The illusion you are creating depends very much on the size of the thing that is moving. If it is a small mouse, it will run and scurry about. It wouldn't walk or run at the same speed as a human. Giving it speed in its movements and using single frames will make it seem light and small. The bigger something is, the slower it should move and that will give it the illusion of weight. When filming buildings collapsing on a model set to be mixed with live film, the collapse would be filmed on high-speed cameras, making the buildings seem to fall much slower, and therefore giving them a sense of weight and mass.

creating a sense of weight

Leaning against it, the wall is not offering resistance so much as something that stops the body falling over. Whereas if you are pushing against it, the wall does offer resistance and the body pushes at an angle to the floor while the feet slide back. The difference between leaning against a wall and pushing against a wall seems obvious, but once again, it is important to get your line of action clear. The poses in Figure 9.10 here are extreme, but her intentions are absolutely clear. It can be easy to go wrong – as shown in Figure 9.7 with the box – by getting your angles wrong.

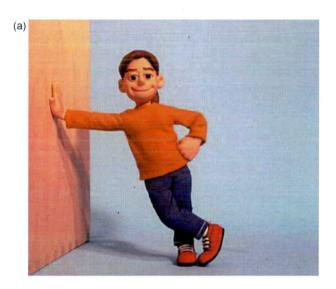

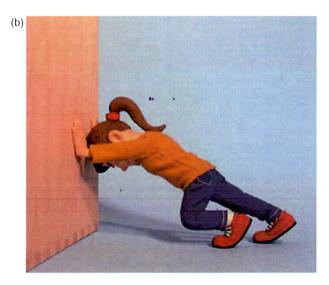

Figure 9.10 Courtesy of ScaryCat Studio

A leaf will float to the ground, making no impact on the ground as it lands. A rock crashing down will either embed itself in the soft ground or shatter on impact with hard rock. A tip here: if you have a very heavy weight falling, you can exaggerate the effect with a bit of camera shake – pan your camera a few increments left and right for one frame each way.

anticipation, action and reaction

Some people say this is what animation is all about: everything boils down to these three words. Before an action there is the anticipation of that action. The anticipation gives weight to the action. An action causes a reaction. A simple example of this would be a fist hitting a table. In order to hit the table the fist (1) is raised in anticipation (2) – the fist then crashes down (3), the action, causing everything on the table to jump in the air in reaction (4), including the fist bouncing back up a bit before settling back on the table. The anticipation move is what gives force to the action. A big move anticipates a big action, and consequently an exaggerated reaction.

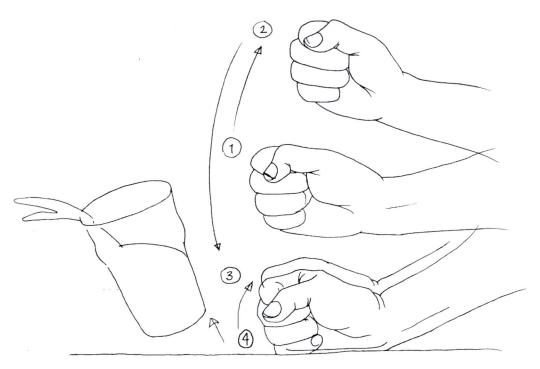

Figure 9.11 Fist hitting a table; position 4 is the recoil. Illustration by Susannah Shaw

Another example is serving a tennis ball:

- (a) Anticipation: raise the ball and pull back racquet
- (b) Action: throw ball and hit
- (c) **Reaction:** ball travels player follows through movement.

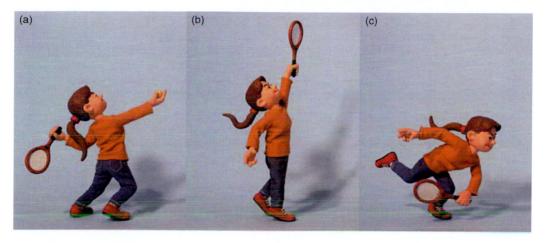

Figure 9.12 (a) Anticipation – preparing to throw the ball in the air. (b) Action – hitting the ball. (c) Reaction – after hitting the ball, the reaction is the ball travelling, having had the force applied to it, but the reaction of the body is to follow the movement through. Courtesy of ScaryCat Studio

But for each move (a), raising the ball and pulling back the racquet, there is another anticipation – before raising the ball the player will dip down in anticipation of the 'up' movement. And before the dip down, there will be a little upward anticipation.

(b) Throwing the ball and hitting: once the racquet is back and the ball's coming down, there would be an anticipation before the racquet comes forward – to help the forward thrust, the arm with the racquet will drop before moving up. OK, don't go mad here, but there is a lot to understand about how the chain of body movement works.

Another example: using a heavy hammer. The hammer would be held up for a moment, checking the aim is right and, just before it comes down, the hammer will be raised (anticipation), then it would come down fast (action) and bounce up after hitting the nail (reaction). This is a recoil movement, the same as the recoil movement of the fist hitting the table. It's emphasized by the sound (put the sound one frame after the hammer connects with the nail).

To get expression out of the movement, exaggerate it. So the 'hold' when you bring the hammer back would be given a longer time than in real life. Similarly, the reaction after the hammer hits the nail could be more violent, with the piece of wood flying up or the person's body shaking. These movements take the natural effect and make much more of the reaction.

Charlie Chaplin is quoted as saying 'Tell 'em what you're going to do. Do it. Tell 'em you've done it.' What he means is to make a gag work, you have to drive it home with a sledgehammer, and in animators' terms that translates as – make it clear!

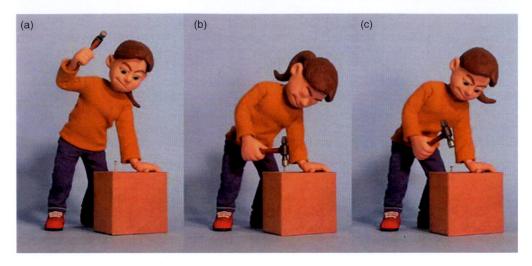

Figure 9.13 Hammering: (a) anticipation; (b) action; (c) reaction. Courtesy of ScaryCat Studio

exercise

Make a video of yourself doing these actions as realistically as possible:

- hammering a small nail into a piece of wood; the action should be your elbow and wrist working
- lifting a heavy box using your whole body
- digging a hole in the ground using your whole body.

Study these movements and break them down into timings. Work out the 'key' positions looking at the line of action.

If you want to try this with your puppet you may want to 'block out' your movements first. Work out the overall time for the movement and divide it up into the key positions. Then shoot each 'key' pose for that time. Once you are confident you have the right positions, you can then work out what is needed to get from one pose to the next, keeping the flow of the movement.

The next stage is to get **rhythm and pace** into your movement. It's not just a question of breaking the move down into evenly spaced timings. Each move has its own rhythm:

• **Hammering.** Lifting the hammer is a slow movement. The movement starts with the muscles in your shoulder. The elbow works as a hinge, pulling the arm up, with the hand following and, last of all, the hammer. The arm will slow down reaching the top until the hand and then the hammer comes up and back over the wrist – note the flexibility of the

wrist. This is a key position – hold – then the arm comes down fast, dragging the hand and the hammer, and the hand followed by the hammer pivoting over the wrist as the hammer hits the nail – hold – and the arm relaxes, bouncing up (with hand and hammer) ready to go back up again. You could hold here unless you are going to carry on.

 Digging a hole. In order to thrust the spade into the ground, she will first bring the spade back and up. The back is then bent over to drive the spade into the ground. The hip comes forward to help lift the spade out of the ground, arching the back and bringing the spade up.

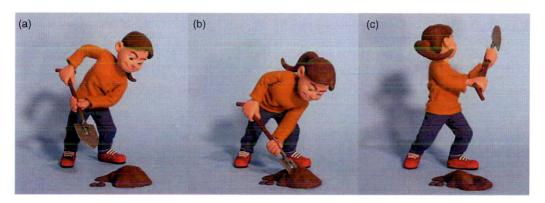

Figure 9.14 Digging: (a) anticipation; (b) action; (c) reaction. Courtesy of ScaryCat Studio

The bigger the movement, the more of the body we use. The gardener digging a hole is arching the body back and forth to lever the earth out of the ground – once she has lifted the soil, her body arches back to throw the soil, then the arms swing round and finally the soil flies off the end of the spade. In tennis or cricket, serving the ball or bowling uses the whole body; the energy 'uncoils' from the center of the body out to the extremity.

Hands and feet

You can bring this pattern down to smaller movements. For instance, with hands, if the arms are moving up and down, the movement starts at the shoulder, flexing at the elbow and then the wrist. The hand is the last to move and will flip over the wrist joint when it gets to the top of the move, and then when you bring the arm down, the hand will flip over the wrist joint again – giving fluidity to a movement. If the arm is waving a flag, the movement would originate at the shoulder joint, with the elbow and wrist each acting as a pivot.

One of the most painful things for a musician to watch must be a cartoon violin or cello player animated by someone who hasn't looked. The arm saws stiffly up and down over the instrument. What actually happens is, to keep control and flexibility over their bow, the musician leads the movement with the wrist, rather than 'driving' it from the shoulder. The wrist is raised as the bow is brought up to the heel and then the wrist drops, pulling the bow back again.

The foot has a rotary movement at the ankle and a hinge at the ball, helped on a walk by having a hinged plate in your armature. The heel hits the ground first, followed by the rest of the foot. When the foot is going to leave the ground to come forward, the heel lifts first. In the same way that the hand follows the wrist, the foot follows the heel.

follow-through

Actions have a natural follow-through, like a bowler throwing a ball. These moves are a continuation, a secondary reaction. In other words, the main action, as in serving at tennis, is the ball being hit. The follow-through is the arm coming down, the tennis player being carried forward as a consequence of the force used in the action (see Figure 9.12c).

This can be seen in many different situations: in the shake of a head, the hair will follow on after and then settle. When someone stops running, the body doesn't stop all in one go – the body staggers forward, hair and clothes carry on with their own momentum, as far as they can. This is also described as **overlapping action** – not everything in a figure moves or arrives at the same time. When the walk stops, a skirt keeps moving and catches up. If clothing is loose it will follow the limbs later. Usually, this is avoided as clothing is made with foam latex or stiffened fabric. But if it is important to the story to have the realistic swish of drapery following the body, the fabric would have to be stiffened on wire or stuck to heavy-duty foil. See chapter 5 on clothing.

snap

There is a point at which too much flexibility and flow in your movements can tend to make everything look rubbery, and the movements all seem to have the same sort of rhythm. This is when you need to know how to give some snap to your animation as well.

For a simple example of getting that impact into your animation, you can go back to chapter 3. In the section on planning, Pete Lord describes a fist slamming into the table to create a convincing illusion of speed, weight and solidity.

Another example that helps to counteract too much rubberiness: when you point your finger, that is an emphatic movement which would be entirely ruined if you kept the same rhythm of movements forward from the elbow through the wrist to the finger. To give this pace, make the finger 'jab' forward fast. To make that jab emphatic, take the finger to the end of the move, and then make it go a bit further and bounce back.

breaking up the movement

To make your animation more interesting, break up a move – so that, for instance, the whole body doesn't turn at one go, but it turns in sections. So if a person is turning, imagine they are turning because something has caught their interest: first their eyes glance over, followed in a few frames by the head turning, then the shoulders and the rest of the body – almost like an unwinding.

You can reverse that for a different effect. Someone really doesn't want to leave but is being forced to: the hand is being dragged, the body follows but the head is still facing where they want to be, and the very last thing to turn away is the eyes.

walking and running

People aren't choreographed when they move. There may be a natural element to certain movements that on the face of it looks unwieldy; you try to find those natural elements and incorporate them and then it looks right. But to do that – you can't 'think' it – you go looking for it.

I always think that everyone knows how things move; you know when things aren't right. But I suppose it's whether you want to see what's right and wrong. Especially on figurative stuff – just how you shift balance. The main movements are easy enough, but you kind of go searching for those little changes of balance and how that will affect how you'll move an arm. That is what's really fascinating.

Jeff Newitt

Most of the moves above involve weight transferring from one foot to another. In tennis, as you serve, you would rock back on your back foot as the body leans back with the racquet – then you will transfer your weight onto the other foot as the arm comes over, hitting the ball. In the digging movement, the weight rocks from back foot to front foot. A more elaborate example of weight transference is the walk. Weight transfers from one foot to the other to support the body as it 'falls' forward.

This is where you wish you were doing 2D or computer animation – where life seems safer! Walking a 3D puppet is very difficult – it's what people want to try first, but it needs a lot of practice.

Animators will use many tricks to avoid having to show a walk: a low wall or bushes. There are many ways to avoid showing a walk. In the planning stages, decide how crucial to the story is a walk or a run and unless you need to do it, find another way of getting from A to B!

Walking the puppet is difficult. It will shift from side to side, fall over when balanced on one heel. If it's Plasticine, the legs will squash down to become enormous feet – it's difficult! The only point at which the balance is evenly distributed is at full stride, with the front heel touching the ground and the back toe about to lift off the ground: the contact position.

rigging

It will be easier to carry out a walk or run and certainly anything taking both the puppet's feet off the ground if you can prop your puppet securely. Using photographic software, the process of removing a rig from a shot has become dramatically simpler. A rig can be a steel rod articulated with a ball-and-socket joint, fixed in a solid base with a piece of K&S soldered on the tip that can slot into a rigging point on a puppet, or even just a stiff length of aluminium wire clamped to something solid. A rigging point is built into the armature of your puppet as a K&S brass 'socket', usually in the back or the side, that will take the smaller gauge tube fitting into it that is attached to the puppet. For testing you don't need to worry about 'cleaning up' the rig from your shot, you can obviously keep the rig in. But when you are filming for real, you will need to plan how you are going to clean the rig

out – whether you will shoot green/blue screen, or against white, or simply using white paper behind the rig itself. This is discussed in detail in chapters 11 and 12.

Alternatively, you could try to keep the puppet upright with something you can disguise, like tungsten wire or fishing line (you can take the shine off these with candle wax) from a rig over the top of the set, but settling the puppet takes time (see Figure 9.16).

movement originates from the hip, so should your puppet's

If you study walks enough, you will see that the movement originates from the center of the body, the hip. The leg is pulled forward from the hip, the body rotates slightly from the hip as each leg comes forward, causing the arms to swing. The arm doesn't lead the leg and the leg doesn't lead the arm – but, in a relaxed walk, the movement starts at the hip and moves outward, so the hand is the last thing to move forward, as it is at the extremity of the body. You will find moving your puppet by grasping the pelvis and manipulating the legs and body from the hip means your puppet/armature will keep its shape much better as you walk it. Don't be tempted to pull your character forward by the foot, as the whole shape of the pose gets lost.

The full stride is the point at which both feet are touching the floor; the size of this stride is determined by the speed at which your character is walking. And the size of the stride is how you measure the distance your character will cover, and therefore when to bring your character to a halt.

relaxed walk - 16 frames

When you walk, the body sways from side to side because the weight is being transferred over one foot and then the other. When the right leg moves forward, the right arm moves back and the left arm moves forward. It's not unusual for beginners to get it wrong and swing the right arm and right leg forward together – I've even seen it on broadcast programs – it's really a very basic observation. This 16-frame walk covers one full step (Figure 9.15).

fast walk - 8-12 frames (one full step)

In a fast walk the body leans forward more. The weight of the body is ahead of the hips, making the legs move faster to stop the body toppling forward.

In a 10-frame fast walk, the body leans forward, the arms are less relaxed with a bent arm swing; it's an altogether more urgent action, with slightly more head up and down tilt.

If any of the walks need to go at singles, try to contrive that the step/contact leg position is straight for two frames; if not, it won't register and one gets a 'Groucho Marx' crouched action.

run – six frames (four steps per second)

The body leans forward and the legs fling further forward, the stride is very wide (Figure 9.16) – unless it's a jog, which is a much more up and down movement, with short strides. A run or a jump obviously takes the feet off the ground and you will need to support the pupper either with hanging wires or a rig support. A six-frame run should be shot at singles or the movement won't register properly.

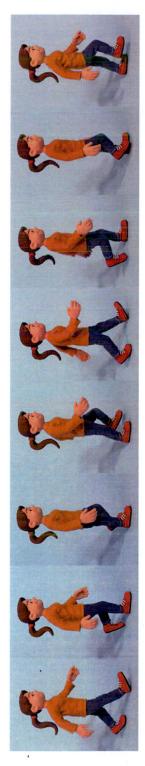

Figure 9.15 Relaxed walk. Courtesy of ScaryCat Studio

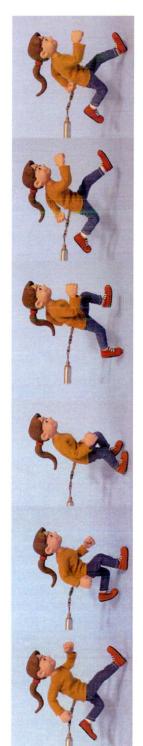

Figure 9.16 Run. Courtesy of ScaryCat Studio

Barry Purves' first walk was on the job at Cosgrove Hall Films in Manchester. There was so little model animation being done in England in the 1970s that everyone learnt as they went along, and made up the rules as they went!

My first job at Cosgrove Hall was something called Grandma Bricks of Swallow Street. It was a two-minute soap opera: a street full of characters and this feisty old granny with a dog called Fusby. My first job was to walk her all the way down the street – and I thought 'if I can do this I've got the job!' We didn't have monitors or videos and you could only rarely look through the viewfinder, and when it came back it was all wrong. At first I couldn't see what it was – and then I realized! She was walking toe–heel, toe–heel! Her dog was OK though, he had long hair and you couldn't see his feet!

the illusion of speed

Moving the puppet or the background while taking the frame to create a blur, known as *go motion*, is a very effective way of creating a sense of speed. The puppet is normally static – pin sharp when you take the frame. If you were to sprint across the frame in live action everything would be a blur. In model animation you have to work really hard to get those blurs:

- You can blur the background by moving the background when you take a frame.
- You can rig the puppet to the camera, so that they move together.
- Puppets can be on a wire/rig and moved during each frame.

Pete Lord from Aardman Animations observes:

Someone like Jeff Newitt will run the puppet over in a chaos of limbs. The knees come very high, arms flap around – it's a jittery effect, but a very energetic effect. Every one of those limbs is a straight line on the screen: the very fact that the lines of the limbs clash and clatter together gives an image of frenzied activity and a sense of energy.

A character crossing screen from left to right at speed can look clumsy. One way to get around this is to make a 3D blur in Plasticine. It does look quite ugly, but it works. (1) Make everything as blurred as possible because that gives a compelling illusion of speed and (2) make everything as frenetic as possible because that gives a different illusion of speed.

Animation is always exaggeration – take the essence of something and then exaggerate it. The human being is so fiendishly clever at putting in the right amount of give in their knees that we barely bounce when we walk. I was looking at sprinters the other day. They are such efficient movers that their legs go like the clappers but the body and head hardly move up and down at all, the line of the head is straight. But if you copy that, it's actually rather disappointing and doesn't look energetic. So the animator should exaggerate the up and down movement to make the effect he or she is after.

One tip as you get more experienced with walks: if your character is walking/running into shot, start animating off the set – it helps your animation to get into a rhythm and, if the lighting casts a shadow, the shadow should precede the puppet.

animal and bird movement

The best sources of reference for animal movement are the Muybridge books (see the beginning of the present chapter). Because Muybridge photographed humans and animals against grids we are able to see exactly how far and fast a limb is moving.

four-legged animals

On a walk, most four-legged animals put their feet down front right, back left, front left, back right, as shown in Figure 9.17.

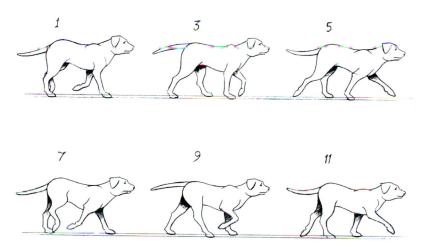

Figure 9.17 Dog walking. Illustration by Tony Guy

This 12-frame walk can be adapted to most four-legged animals – during a walk the dog/horse/cat will keep two if not three feet on the ground. At a run, as Muybridge proved in his series of horse photos at Palo Alto, a four-legged animal will take all its feet off the ground. Things to note: the tail follows a wave movement and the shoulders will be prominent as the weight of the dog goes over the foot. The legs move asymmetrically, i.e. the front and back legs don't come down on the same frame.

lizard

This gives a good example of following a wave movement through a figure – as the body is pulled forward by the front foot, the head turns toward the leading foot, creating a wave movement through the body (see Figure 9.18).

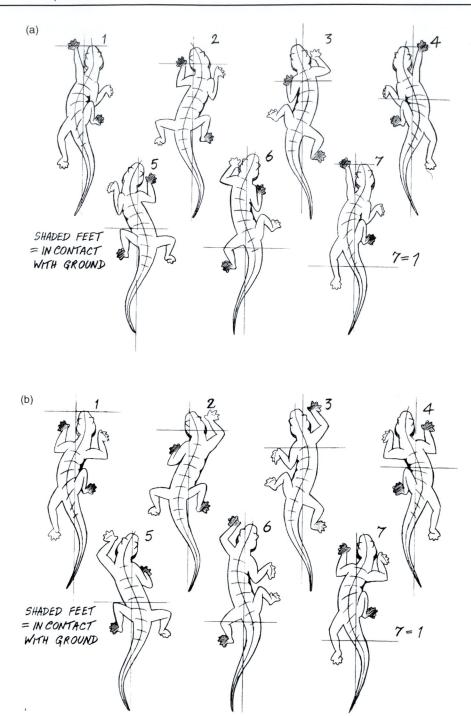

Figure 9.18 (a) Lizard walking: feet in symmetrical positions. (b) Lizard walking: feet in asymmetrical positions – this is the more accurate version, but (a) animates well to give that snake-like movement, and is easier! Illustration by Tony Guy

birds' walk

A pigeon or a chicken struts, moving its head back and forth (Figure 9.19).

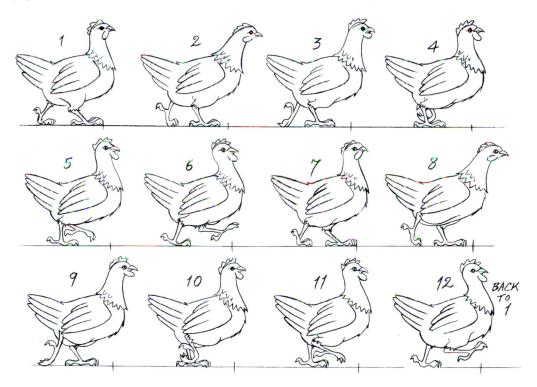

Figure 9.19 Bird walk, chicken, pigeon. Illustration by Tony Guy

Illustrator Tony Guy, an experienced 2D animator who has worked on many different styles, comic and naturalistic, from *Animal Farm* to *Tom and Jerry*, says:

I have spent many hours over the years trying to work out the relationship between the back and forth head movement and the steps – conclusion? There isn't one! But for animation purposes, throwing the head forward immediately after the step seems to work.

birds' flight

This illustration serves for most bird flight: for smaller birds such as sparrows, robins or blackbirds, single frame these movements; for larger birds like crows, double frame them. But look carefully at bird flight as the wing movement can differ – a pigeon has a more extreme movement. A bird coming in to land will increase the backward thrust of the wing to brake and come in more vertically to land.

Note: the wing movement will move the bird's body up and down in flight.

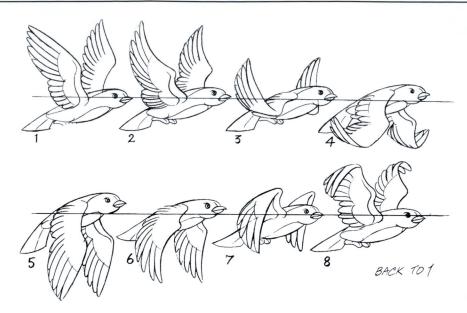

Figure 9.20 Bird flight. Illustration by Tony Guy

chapter 10

animation masterclass – Teresa Drilling

the model
on what creates a character
first position
the extreme downward position
summary
on Vinton's
beginning the upward move
slowing down at the top of the move
settling into the final position

Teresa Drilling has been an award-winning character animator for more than 20 years. She attended the Rochester Institute of Technology in the USA, studying graphic design and painting. For 14 years she worked at Vinton Studios, in Portland, Oregon, where she became one of their senior creatives. She won an Emmy for Outstanding Individual Achievement in Animation in 1991 for her animation on Vinton's Claymation Comedy of Horrors Show.

In 1999 she moved to Britain to work as an additional key animator on Aardman's Chicken Run, and followed this with work on Wallace and Gromit in the Curse of the Were-Rabbit. I met her at Aardman's features studio in Bristol, where she was working on the latest Creature Comforts series for the US market. She kindly agreed to create and animate a character for this book, describing her thoughts on the process as she worked.

The session, over two days, took about 13 hours; I've kept the conversation pretty much as it progressed, discussing aspects of stop motion animation as well as specifically the animation she was doing for me. There were long periods of silent concentration interspersed with fascinating observations.

the model

Character designed and sculpted by Teresa Drilling

Model maker: Johnny Tate

The monkey character was based around a ready-made armature lent to Teresa.

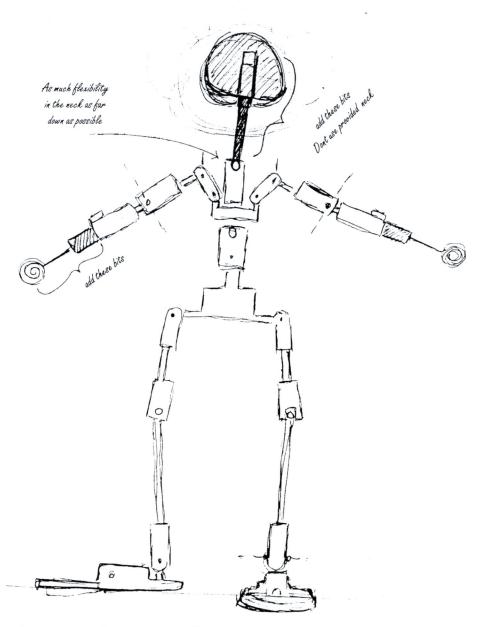

Figure 10.1 Armature design. Teresa Drilling

This armature had huge feet and really short arms – I don't know what it was before, but I think these may be the biggest feet I've ever put on a character – it was fun seeing just how big they could get. It seemed to suggest a monkey. This look is a little dainty, a little feminine, but hopefully not too cloying.

The armature is covered with tape first to give some grip for the plasticine, then the plasticine has been built up over the top. The bulk of the 'skull' is a chunk of rigid Plastizote, which helps to keep the head lighter and provides a solid point to rig the head into the body, as well as a good surface for the plasticine to adhere to. The move she will do suits

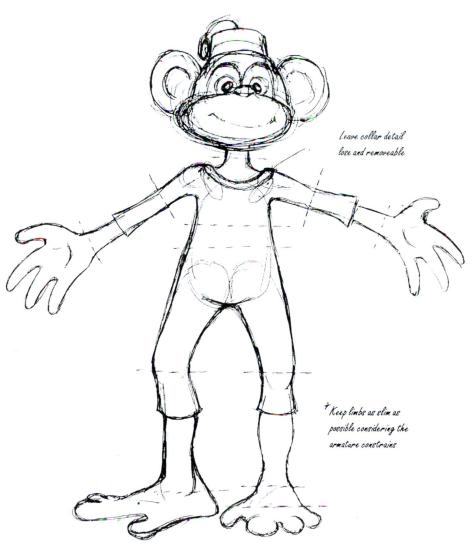

Figure 10.2 Character drawing. © Teresa Drilling 2006

the monkey character – she will leap from standing into a sitting position – a very quick move, but one that incorporates some squash and stretch.

on what creates a character

When I was working at Vinton's, the Children's Television Workshop gave us an opportunity do something for Sesame Street. We came up with a character for them, adopting some elements of an internal animation exercise we had been working on. We each had one pound of orange clay and the challenge was to shoot four seconds of metamorphic animation that started and ended with that pound as an 'Orange Ball' in the center of frame. That sort of range and malleability was perfect for a Sesame Street character, so we started with the orange ball from the exercises, gave her a mouth because she had to sing, and let her metamorphic demonstrations and ultimate return to ball form be her signature identity. One of our producers kept trying to give her eyes; he found it hard to accept her if she had no eyes. That would have turned her into a disembodied head though, which would have been more limiting, and put the focus in the wrong place I think. Somehow we prevailed, and she stayed a singing ball with lips. We named her 'Cecille the Ball', as a homage to the red-headed physical comedienne, Lucille Ball, and as a wry illusion to Saint Cecilia, the blind patron saint of music. It was great to develop a female character that didn't have to be coy and feminine - I think that was the first female character the studio did that wasn't an overt stereotype – with the exception of Becky Thatcher (from The Adventures of Mark Twain).

You know Aardman specifically decided to cast female animators on *Chicken Run* – because the chickens were female.

first position

The first position is a resting position – she's poised. I've got her weight on one leg. It's always nice to have the model a little asymmetrical, to have the weight on one leg or the other; it gives it a little more life and it also gives you some place to come from. I check her from different angles to make sure she's balanced nicely – it's really easy, when you're looking for reference at a two-dimensional image on a flat screen, to animate yourself into a corner if you're doing large body movement and improvising as you go.

The funny thing is that an animation position, which looks great in motion, can look a bit lackluster sometimes as a still, so I try to do both here – get the position correct for animation and have a nice pose as a still.

For this movement the head will lead – so I'll start with the eyes. Eyes first, then head, shoulders and hips.

Most movement is led by the eyes in most performances, unless, for instance, a character is being led reluctantly, as if they had to leave a party but there was still someone there that they wanted to talk to, in which case their body would start moving for the door, but their eyes would still lag behind. In most cases eyes lead action – and eyes move quicker than any other part of the body, so eyes can go from one side of the head to the other in just one frame and still look natural.

Figure 10.3 Frame 1. Photo Susannah Shaw

Usually, I knead a little bit of wax into the clay of the eyelids, because then they're not as soft and you can adjust them a lot easier.

If you look closely at eyes, you'll notice that there's a small area of the eyelid that's pushed out slightly by the cornea. As someone looks from one side to another, the cornea rolls along under the eyelid, like a wave under the surface of the water. This bulge looks like a little tent over the top of the iris. As the iris moves from side to side, this little tent shape in the eyelid should also stay with the iris and move from side to side as well.

You get so much expression out of the eyes from the angle at which the eyelid is positioned over the eye. Sad eyes tend to have the eyelids angled up in the middle of the face and down on the outsides. Angry eyelids tend to be slanted in the opposite direction.

Figure 10.4 Frame 13 – at 24 frames per second. Teresa notes that there would be 11 frames between Figures 10.3 and 10.4. Photo Susannah Shaw

It's interesting to work with shifting weight – it's a shame to just have your character standing flat-footed and straight-legged. Just shifting a little weight onto one foot or the other really helps give your character more life and poise.

I pre-visualize breaking the movement down and imagine it in slow motion. I think about the performance, both emotionally and physically. And physically I think – where is the energy coming from? What is the main mass of the body doing? This character's main mass is low in the hips because she's female – which is nice as she's going for a jump. So the question is – what parts of her body are actively supplying energy and which parts are being passively pushed by the energy? That makes a difference.

When I first joined Aardman on *Chicken Run* they were specifically looking for experienced clay animators. I really lucked out when they decided to give me and my clay experience a shot. I was first put in a testing unit that doubled as the prep space of one of the key animators, Guionne Leroy.

I was given a Bunty (a character from *Chicken Run*) to do a little animation test with. I wanted to move the head and couldn't find a positioning plug anywhere on it. What we'd do at Vinton's, because the clay was so soft, was to have a little square hole in the back of the head with a piece of K&S in it – and you'd stick a tool in this hole to use as leverage to turn the head without touching the clay (a technique lan Whitlock used to animate the Were-Rabbit on *Curse of the Were-Rabbit*, to avoid disturbing the fur).

So I'm looking and looking, and I can't find it. I finally ask Guionne, 'How do you move the head?' She looks at me and, maybe because she's thinking I must be a little dim, very slowly reaches out, takes hold of the head and simply turns it. I thought, 'My God!!' I touched it and discovered it was hard, unlike American clay, and didn't pick up finger-prints! She must have thought I was crazy.

I realized that this was why the Aardman characters had their sort of look – why their characters were often individually sculpted by hand instead of moulded – because it made sense with this harder English clay. So that's why they don't do the fiddly lip sync work that was a Vinton hallmark, I thought – because the clay is hard.

I started out sculpting in American clay years ago. American clay is much softer and much more oily than the Newplast (English Clay). Newplast is softer today than it used to be, about halfway to American clay in consistency from where it was, but I still find it a useful alternative to the American Van Aken for some applications. This little monkette is sculpted in Newplast.

With the much softer American clay, it's very easy to work in a lot of subtle detail. You lightly drag a tool across the surface and you're done. Because the clay was so sensitive to handling, one of the things we used to do at Vinton's was make replacement hands – we would make a series of 'hero' hands in different positions: open, pointing, closed into fists, and set those aside. We would start with a hero hand in a pose, replace it with a less perfect hand that we would animate through to the next pose and then, at the end of the move, replace the beat-up animated hand with a pristine hero hand for the new final position.

A lot of characters here at Aardman have heads that come off, so you can sculpt the mouths and details easily – the hands, however, don't – and that took a little getting used to.

the extreme downward position

She's still moving downward. Make sure the foot that will be pushing off is clearly grounded. Now she's going to tighten up her face in anticipation of the jump. 'Anticipation' is just compressing everything for a nice big release in the opposite direction. There's a great trick to use for squash and stretch action – when you're doing the squash, squeeze your character's eyes shut; and when you get to the stretch, open the eyes way up. But for now, she's just tightening up her face.

You generally can't go too far with anticipation – it's kind of magical. A lot of people, including myself, tend to be too tentative when they push the extremes – you play it safe and then when it comes back and you see it you realize, 'Damn! I could have given it so much more!' I say push it more!

Figure 10.5 Frame 25 – there would be 11 frames in between Figures 10.4 and 10.5. Photo Susannah Shaw

I look a lot at the silhouette shape of my animation, what Ollie Johnstone calls the 'staging'. The staging is not the same thing as the 'pose'. The pose is the position your puppet is in. Staging is how that puppet looks compositionally in frame at any given moment. A good way to check it is to look at the graphic aspects of your character – this is especially helpful to keep in mind if you're sculpting. You can check the visual rhythm from this perspective – spot odd bulges and put things back in place. Cleaning up your silhouette strengthens your staging and clarifies your action.

This is where I'm going to give her some knuckles. That's the beauty of English clay – it's stiffer so you can do more structurally with it. American clay is soft and easy to dent, so you

can unintentionally damage as you go. I'm convinced that different animation styles evolve from the different sorts of materials available to work with.

on Vinton's

The classic Vinton style uses a very realistic, precisely sculpted lip sync, where you're not using replacement mouths but literally sculpting through the caricatured, but anatomically correct, mouths. It made you really good at sculpting, especially sculpting a convincing human face. The result was that after five or six years of doing lip sync like this, studying reference film intently and practising in front of a mirror, you've pretty much memorized how the mouth really moves – to the point that you can take a sentence and just sculpt it through, without having to look at reference. It's just practise, practise and practise.

One of the nice things about clay is that you can just sculpt details you cannot get out of a foam puppet. The classic Vinton sculpting style would be worked in with tools. As with Mark Twain (*The Adventures of Mark Twain*) – everything was from closely watched live-action reference. I think there are now only two or three of us practising that old classic style.

Barry Bruce, the creative director at Vinton's, was a really good mentor to me. Barry was to Will Vinton what Ub Iwerks was to Disney. He'd let me try out ideas and techniques that I was really sure would work – I was a really precocious young animator, and in that way I was able to contribute to the evolving style and look that the studio was putting out.

In my formative years working at Vinton's we would do 'expression studies' to determine key facial expressions. We would sculpt just the head of the character in a neutral position, then make a flexible mould of it and cast several copies using American clay, which could be melted and poured in to set. Using these 'blanks' we would sculpt the various key expressions that would be needed for a particular character. Then we'd take these expression studies onto the set. As you animated in and out of expressions, you had the next position as reference to match. So you learned to sculpt quickly and with confidence. You do enough of those and you begin to understand what makes 'sad' and you begin to understand what's going on with the underlying anatomy – 'Why does the mouth go down? Because the jaw's dropped.' I was able to learn this way, but after a while, as years went by and budgets got smaller, people no longer had the luxury of time to learn this way.

Thirty-second commercials used to have 12-week schedules. Now they need to be produced in four to six weeks, so there's just not the time for the same sort of development. There's a tendency to be more inventive than creative. By that I mean finding different ways to recycle stuff that's already in existence rather than bring something new into the world.

beginning the upward move

I really want to keep her feet well planted for her push off. It'll kill the illusion of weight if those feet aren't grounded.

Think in terms of 'where's the energy coming from?' rather than calculating a mathematical formula in your head, 'This part of the body has to accelerate at x per mass ...'. That will

Figure 10.6 Frame 31 – there would be five frames in between Figures 10.5 and 10.6. Photo Susannah Shaw

just make you crazy. Allow your intuition to take you where it needs to go. Be mindful of the energy and where it's travelling and let the force work for you.

Teresa is sculpting all this while. Suddenly she picks up a scalpel and makes an incision ... Every once in a while you'll get an air bubble – it's something that happens with clay characters on armatures – and if you don't take care of it, it'll start moving around and cause the clay to start to separate off the armature. The best way to deal with it is to slice into the bubble, push the air out and then seal it up again. That air bubble undoubtedly got in there when I built up her stomach. I had put a piece of clay on her stomach and smoothed it out, not realizing that I had an air pocket in there. The more you try to smooth out an air bubble instead of removing it, the more damage it can do.

Plasticine can develop a marbled look over time as incidental dirt gets worked into it. It's really important to keep your clay clean – especially on a commercials job, when clients are looking closely at each frame. As soon as you see dirt on your character, try scraping the very top layer off with a scalpel. It becomes more difficult if the dirt has gone deeper, because then you may have to replace a big chunk with clean Plasticine. That can be tricky because you usually have to do a lot of blending in with the Plasticine around it to make it match.

Generally, I don't like to add or take away material from a character; you want to try and maintain your volume. This is particularly important when you're referring to a two-dimensional screen. Your character's volume might be your only spatial reference point. But occasionally you expose a joint in your armature and you have to cover it with extra clay. So I'm always doing a mental evaluation – How much have I put on? Will I need to take it off again? If things are going really well there'll come a natural point where it'll be obvious, and will bulge out at you, wanting to be taken off. It helps to realize that it needs to be done, that it's part of the ongoing clay animation process.

Figure 10.7 Frame 32 – there are no frames between Figures 10.6 and 10.7. Photo Susannah Shaw

The energy is now pushing up into her torso, but hasn't reached her head yet, so the motion of her head is still a passive following through. So we've gone from the energy pushing up out of the knees into the torso, straining upward and arching the back.

Once she's in the air I'll have to go with the trajectory I've started on, so she has to be at exactly the right angle from the toes up. I can't readjust after she's airborne without it looking like an unnatural shift.

I like to keep a 'home' position in mind – if at any given point the animation has strayed too far one way or another, it's really useful to know the location of that natural relaxed home position. It helps you from getting lost in the middle of complex action, when there's a lot going on. I can make a note of it on my log, for instance, when a portion of a character is making a really strong movement, then makes a rebound, then another, and so on, decreasing as they go – you have to end up finishing the movement at what would be a natural home position. So if you already have that position in your head, it makes your job easier.

A lot of people will ask, 'How do you know how far to move it?' Well it depends. Because I'm thinking 'How heavy does it need to feel? How much resistance should there be? What sort of emotion is behind a gesture? Is it in the water? Is it on the moon? How will gravity affect it?' You could go crazy trying to figure out everything mathematically – or you could just allow your intuition to guide you. Look at it as it goes: well, it needs to go there – why? Because it looks right. And now it doesn't look right – why? And then you do a tiny little adjustment – that's perfect! Why? – because it's right.

For stop motion work you need stamina, focus and concentration. But I think, probably, the aptitude that is most crucial to have, if you're going to do any kind of animation, is not how good are you at sculpting or how athletic you are – or how good you are at engineering – it's how good you are at seeing. You have to train your eye to perceive tiny little shifts and flicks. In using reference film, look at when a movement starts – does it start with a flick of an eye? You look for the tiniest things. You see a person swallow – and you think

Figure 10.8 Frame 33 – there are no frames between Figures 10.7 and 10.8. Photo Susannah Shaw

'Will that detail help?' And you can decide whether to use these details or not, but the ability to see them is what makes the difference for a character animator. Things like drawing classes, sculpting classes or perception classes help you to learn how to see – or just sit in the park and watch. Sit and watch people walk – how they move.

One animator friend of mine was telling me it's easy for him to learn a lot about someone when he watches them walking now. He can tell if a person's hip is hurting, or if they have a problem with their knee, or their shoes are too tight. It might be harder to lie to animators. Maybe we would be good poker players!

Sure, it takes a terrific amount of concentration, but at the end of a bad day, you have to remember it's not brain surgery; no one's going to die if you made a mistake, maybe just lose a little money.

Figure 10.9 Frame 34 - there are no frames between Figures 10.8 and 10.9. Photos Susannah Shaw

Figure 10.9 continued

As the monkey leaves the ground Teresa has brought in a rig that fixes to a K&S slot in the monkey's back. The tie-downs have been removed and the holes where the tie-downs held the feet to the floor have been filled.

Two shots are taken of the monkey in this position – white card simplifies the monkey's silhouette so that painting out the rig is a quicker and easier job. This carries on until frame 13.

slowing down at the top of the move

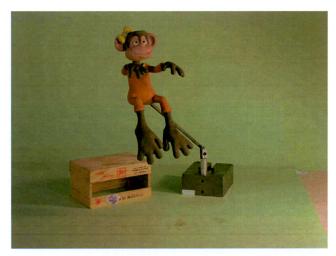

Figure 10.10 Frame 36 – there is one frame between Figures 10.9 and 10.10. Photo Susannah Shaw

I'm putting a little marker on the set so I'll know she's moving along the correct line of action. I used to put all kinds of markers on the set. Before we had frame grabbers we

would set up a video camera next to the film camera and look at the live image on a nearby monitor that we could mark increments on with a grease pencil. I would put a mark on the back wall of the set and then I would put myself right in front of the camera, making sure I had the corner of the video monitor in my sight. Then I'd shift my stance until the monitor corner would line up with the mark on the back wall. That way I'd know I was looking at the monitor and my marks on it from exactly the same spot every frame. We had parallax issues between the film and video images back then, and that was a way to keep things more precise from frame to frame.

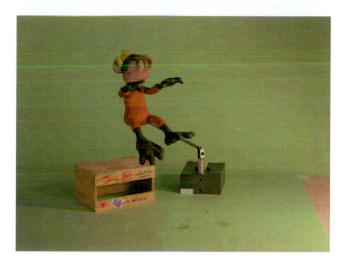

Figure 10.11 Frame 38 – there is one frame between Figures 10.10 and 10.11. Photo Susannah Shaw

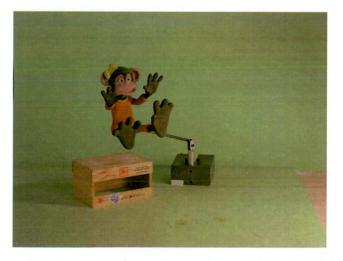

Figure 10.12 Frame 39 – there are no frames between Figures 10.11 and 10.12. Photo Susannah Shaw

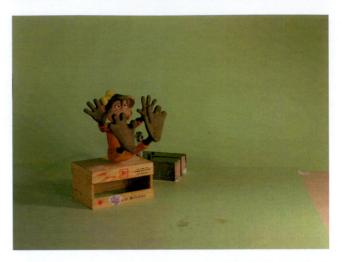

Figure 10.13 Frame 40 – there are no frames between Figures 10.12 and 10.13. Photo Susannah Shaw

Clay is nice – often, when the puppets bend at a joint that they've got clothing sculpted over, they get automatic wrinkles. Clay has a long shelf-life; it improves with age, up to a point – but it also requires being worked up to a useful malleability. There was a place I worked at that had a store of Plasticine that was beautifully aged, but they didn't know what they had and they tossed it out. And then when they got another clay job they could only get new clay that didn't sculpt as well. It was really a shame because a lot of people would have shared clay advice with them if they had known.

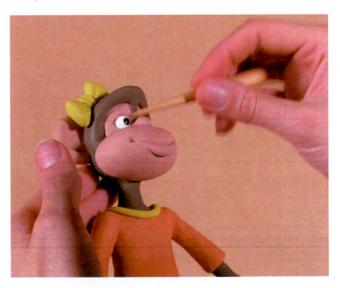

Figure 10.14 Using a tool to 'roll' the eye socket smooth.

I have many tools, some expensive, some cheap, but I guess my favorite little tool is this one, with a graduated point that's perfect for rolling.

If you don't want to get clay colors on your character cross-contaminated, take a bit of the color you're about to work with, knead it between your sculpting fingers and the clay will clean any other clay color or dirt out of your fingerprints.

Hands are really important. You can get as much expression from a hand as you can from a face. Portrait painters know that.

Anatomy is a really good thing to know about. I found a local art college where there was a really good teacher. He taught us all the bones, then went over the muscles. I do figure drawing too. It helps with your seeing. And with understanding spatial animation too, it's

Figure 10.15 Frame 43 – there are two frames in between Figures 10.13 and 10.15. Photo Susannah Shaw

Figure 10.16 Frame 45 – there is one frame in between Figures 10.15 and 10.16. Photo Susannah Shaw

really crucial, even when you're not doing a realistic face – even if you're doing a graphic stylization of a face. In order to know what to make it do – to imply a certain effect – it's really useful to know how it works in real life. Like right now – on the pig (the character Drilling is animating for *Creature Comforts*) – I'm doing a lot of work with eyelids, probably more than some of the other characters are getting, and that's part of my Vinton reference interpretation experience that I'm bringing to animating in the Aardman style.

It's programmed into us to watch eyes. Thoughts and intentions are first expressed in how eyes move, and the eyes almost always move first. They indicate what action is going to come next. Paying attention to eyes comes in really handy when you're doing character animation. Basically, good eye animation will make the character come alive – and transmit what that character is actually thinking.

Often, you'll notice that while your character was nicely finished for the frame you just photographed, imperfections in the sculpt will catch the light once you turn your character to another angle for the next frame. That's perfectly all right, you just have to do a little cleanup that wasn't needed before because it wasn't visible. It's just an ongoing dialog between you, the puppet, the set and the lights.

Note for sculptors – don't bother doing finished sculpting where the camera can't see it – no matter if you feel it would complete your sculpting – NO! That wastes time. Let it stay rough and clean it up as you go.

settling into the final position

Figure 10.17 Frame 49 – there are three frames between Figures 10.16 and 10.17. Photo Susannah Shaw

Figure 10.18 Frame 53 – there are three frames between Figures 10.17 and 10.18. Photo Susannah Shaw

Susannah Shaw: In her final position you can see her shoulders are beautifully defined.

Oh that's because of working with Gromit – Gromit was all shoulders, held just right. Nick Park would say, 'That's it, right there' and I would say 'But I can't see the difference,' but by the end of it all I really could see the difference – so thank you for training my eye, Nick!

Working with Nick has been a fantastic experience. A great learning experience on so many levels – in terms of how he can be in charge of a whole project and keep that all in his head, and still be the sweetest, most gracious personality. You don't have to be a bully, you don't have to be a tortured genius.

At the end of the day we're all here for the same purpose – to create something new in the world that hasn't existed before.

Figure 10.19 Teresa Drilling. Photo Susannah Shaw

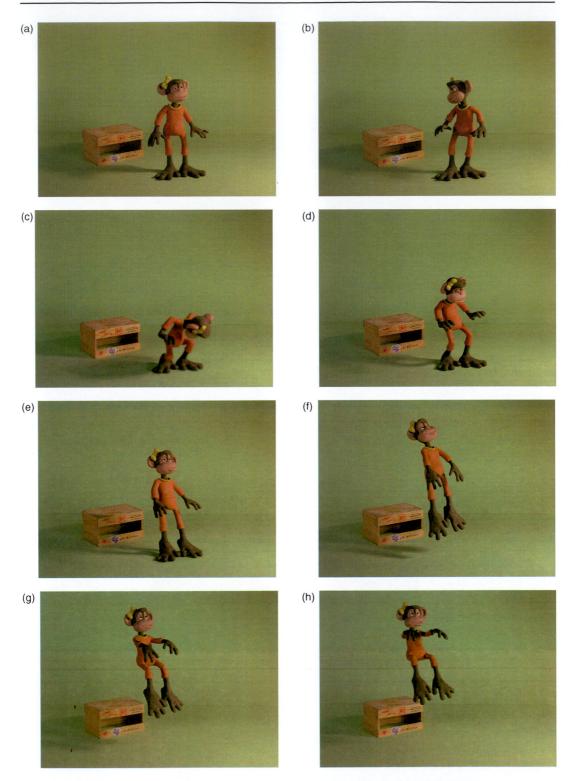

Figure 10.20 (a–o) Monkey jump: the completed sequence. Photos Susannah Shaw

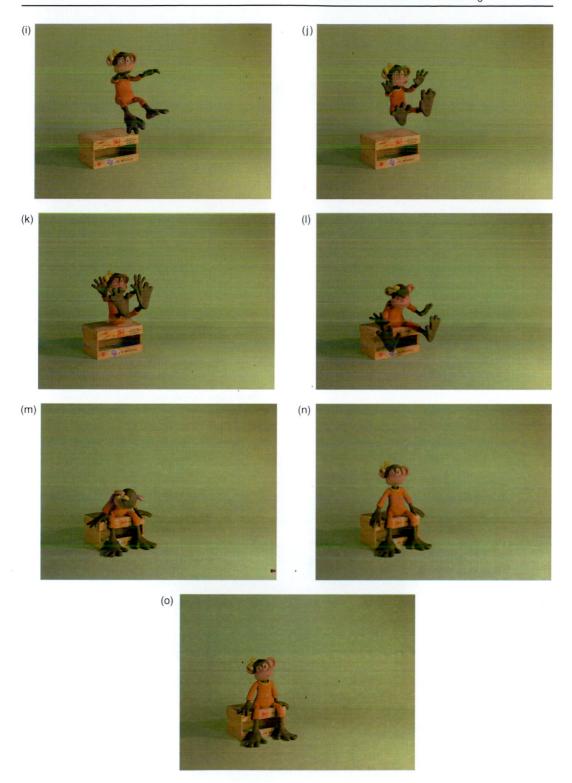

Figure 10.20 continued

chapter 11

the performance

chapter summary

- character animation
- comedy and comic timing
- subtle character animation

The important thing is performance – and that's not to do with the technique of animation, more to do with acting. Things like performance, timing, sense of comedy, feeling for poses and how to communicate – those are the things that apply across all techniques, and the things that make good animators.

Pete Lord, director, Aardman Animations

Figure 11.1 Pete Lord on the set of Adam. © Aardman Animations Ltd 1991

character animation

As animator you are the director and the actor, through your hands this lump of clay becomes a believable character. Whether you are animating a dog, a dinosaur or a

human being, you still have to think about timing, expression, pose, silhouette, lines of action and choreography. You don't need to be an actor, but you need to know about the process of acting, about what reads with an audience.

It's very close to how actors think. I learned a lot from reading books about acting. Like Stanislawsky. I think I learnt from reading actors' books but mainly watching, watching, watching.

Guionne Leroy, animator on Max & Co, Chicken Run, Toy Story

Guionne worked on *Toy Story, Nightmare Before Christmas* and *Chicken Run.* Her advice is pertinent to any beginner, and you should think about acting as a necessary skill to study in order to develop your animation. Although most animators would rather die than perform on stage themselves, they need to understand the process in order to translate the drama into their characters.

Jeff Newitt (animator on Monkeybone) explains:

I like the idea of being thought of as an actor. When I went to the States, they almost treat you as an actor, it really felt good. When Henry [Selick, director of Nightmare Before Christmas, James and the Giant Peach and Coraline] would go through a scene, he would be going through the motivation, and then when you'd go through testing the shot you were encouraged to go for the performance and bring something to it. Then after the first test, talk about what elements were working. You felt as though you really were bringing something to it.

This is not the longest chapter in the book, as it is difficult to itemize the thousands of ideas and tips you develop as a character animator over the years, so I have listed some of the major areas. Performance is at the heart of good animation. Your characters are actors that have to perform, and as the animator you need to understand how to perform. If your character is to be angry, morose, cocky or sensitive, you first tend to think of the stereotype poses or movements for those characteristics. The good thing about a stereotype is that everyone recognizes it. And as you are in the business of getting your ideas across to an audience, using stereotyped characteristics is not a bad thing.

If you go back to the idea of animating an inanimate object or giving a character to a teaspoon or a matchbox, you will have found it is quite difficult to do without sound effects and without dressing it up. The skill in all character acting derives from mime. This silent art form has been admired by many as being the ultimate achievement in performance art. Even if an actor or a comedian has dialog, they won't achieve the same effect unless they use persuasive body language. The reason so many of the great animated films have no dialog is that the great skill of the animator is dealing in mime or body language, so films can be enjoyed internationally (have a look at 2D director Michael Dudok de Wit's *The Monk and the Fish* and *Father and Daughter*).

The story's going to be told by a series of little moments – and it's the order in which you put those moments, those gestures, that make the story. For instance, you want a guy to slump in an armchair in a depressed way – you've got the idea of how it should look – but can you do it cleverly, persuasively, humorously, believably? That's what all animators aim for. It's funny to talk about because the difference between good and bad is quite small. It's obvious when it's technically crude, but the difference between a good performance and a bad performance is very hard to define.

Pete Lord

exercise

A well-known first exercise for character is to animate a flour sack. It's a very simple shape and it's also a recognizably inanimate object. The point of this exercise is to be able to put life, to put character, into this little sack. It has a relatively amorphous shape, but the volume of the shape must remain uniform. This is a very important point when working with Plasticine, as it's risky to adjust the volume by adding Plasticine or taking it away; you can lose the identity by changing the volume.

So as with Pete Lord's quote about the depressed man, can you make this flour sack act through various different emotions? Because if you can do it cleverly, persuasively, humorously, believably – then you have a little character that you have created.

Using Plasticine, make yourself a flour sack, with four sharp corners that can be used expressively, and go through a few emotions: perky, angry, dejected. Think it into the little sack. Bounce the sack on, or, if it's depressed, have the sack shuffle on, using some of the timings you've learned from the bouncing ball in chapter 3. It's always good to get back to original exercises, as you will find they help to answer some problems you get stuck on.

Remember to ease into the move. Your timing and spacing will give it character. Slow timing could suggest depression, unhappiness, whereas joy and excitement are characterized by quick movements. Remember to anticipate the movement to help it read. However small the movement, it is still helped by a small anticipation. It is not a simple matter of rules – to get a feel for it, act it out and develop your intuition.

Keep it simple. Keep it economical. Some animators want to give you fancy stuff but it gets fudgy and messy. Instead of four gestures you can do one really important gesture. Let it breathe – let it have time! Do your homework and plot out the pauses.

Do dance training, go to the ballet – see how a dancer will hold a move – let it read, and then move on. Listen to music, the way a tune is developed and the breath before the next idea comes in. Look at sculpture – the way a story is

told just from a single image from different perspectives. I think it's just getting this absolute clarity about what a gesture's about – what a pose is about – and don't ruin it by rushing on to the next one.

Barry Purves

Figure 11.2 Barry Purves' Achilles. © Barry Purves/C4/Bare Boards Productions

The voices of experience all have the same message, but of course it's easier said than done. The more experienced you are, the more you will understand what keeping it simple means. But if you use it as a mantra when going over your ideas, and planning your moves, it will help you.

None of these skills are achieved overnight – people take days over moves. A very good student I knew, doing a project she had to complete in three days, spent two days without shooting a single frame, just thinking about her character. The exercise was to complete an action in character – walking through a door, find a surprise and react. She spent two days thinking about her puppet's character and motivation. So that when it came to the actual animation, it was carried out quickly because she knew exactly how the puppet would move: how he would put his hand on the door knob and walk though the doorway, what he would see and how he would react to it. The animation was almost automatic to her.

comedy and comic timing

In animation, as opposed to real life, you may have to exaggerate your reactions for maximum effect. A sense of comedy in animation is created by exaggerated expression.

You can really see timing at work in comedy. For comic timing, watch the geniuses of comedy and mime at work and study their timing – how they set up a gag. Charlie Chaplin, Laurel and Hardy, Buster Keaton – they were great masters of timing. Phil Silvers as Sgt Bilko, or Tommy Cooper, Eric Morecambe of Morecambe and Wise, and Jaques Tati's Monsieur Hulot. These are all people who have learned how long to hold a look, or when to put in a shrug, or an eye movement to convey a big moment, because their incomes depend on getting a laugh.

The cartoon 'take', when a character has an exaggerated reaction to something, is generally accepted as a 2D convention, with highly dramatic squash and stretch action – eyes popping out on stalks, tongues dropping to the floor, like Tex Avery's wolf in *Red Hot Riding Hood*. With model animation, every now and then an inventive animator has ignored the static qualities of the medium and pushed it further. Richard Golezsowski, whose successful series *Rex the Runt*, about a group of doggy characters, employed plenty of squash and stretch, with huge, exaggerated movements, by animating on glass, thereby avoiding the constrictions of gravity.

But there's no reason why you can't use some of the typical comic conventions in stop frame animation. If you are doing a 'take' as in a comic reaction, the character can anticipate, pulling their head down, hunching their shoulders, and then turn their head toward the action. This turning of the head can be repeated two or three times for effect (see Figure 11.3). Maybe the arms will go in the opposite direction (to counter the force of the head turn). Concentrate on the body movement first and the expression at the end. This gives much more impact. If the expression changes along with the speed of the move, it kills the anticipation.

The expression on the face should only change at the end of the move. There are various ways to do this comedy take – it can be extended with a small anticipation before Figure 11.3d. If you try this sequence, play around with the timings till you've caught the transition from daydreaming to shock.

A comedy dash: this is such a cliché, but it's good fun to try it, as once again it's a 2D convention, when the character exits in a cloud of dust – or rushes off leaving speed lines. It can be done with our puppet – with a *big* anticipation pose, and then take the puppet away, leaving the stage empty! There are different ways to create a blur left by the character. Have the puppet attached to wire so that she can be swung across the set as you expose the frame, or as Pete Lord suggests, create a blur of Plasticine.

This brings us back to persistence of vision. So how much does the audience need to see? One of the great things about the human mind is that it fills in the blanks. That is how film works after all; we actually spend an awful lot of the time looking at a black screen, but we don't notice that. It's something to consider when planning your moves in animation. You can do the same sort of thing with kicking a football. To get the right impact with a foot kicking a ball is a tricky combination, as it relies on speed (and all the complexities of Newton's laws of motion!) – difficult to achieve with model animation. But what does the audience need to see to understand that a great moment in sporting history has just occurred? You need to see the footballer approach the ball, draw his foot back – and wham! The ball going into the net! Perhaps you don't need to see the actual kick and the

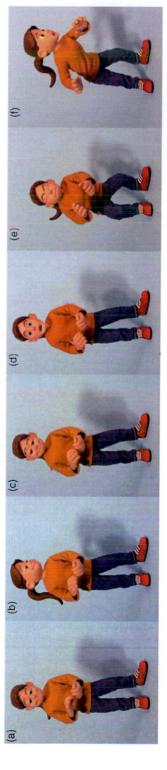

Figure 11.3 (a) Daydreaming. (b) Distraction: something causes her to glance left. (c) Nothing has registered, she has returned to her original pose. (d) Realization: the jaw drops and eyes widen. (e) Anticipation: the girl hunches down, so the next move will have more impact. Note the ponytail is following the movement down. (f) Action and reaction! The arms swing in the opposite direction to the head, to counter the weight shift. Courtesy of ScaryCat Studio

Figure 11.4 Puppet pose in typical comedy run anticipation. Courtesy of ScaryCat Studio

trajectory of the ball for you to believe that that footballer scored that goal. Knowing what to leave out comes with experience.

eyelines

To convince your audience that your character is alive, it is important to get the eyelines right. Think about the focus of their vision; whether they are gazing into the distance or at something close-up, the focus will change. If it's very close, the pupils will be slightly crossed.

blinking

How often to blink? Well – don't go mad – but it's quite a good idea to blink on a head move. If the character's startled and does a 'take', they might do a blink as the head draws back. People blink a lot when they talk. A shyer character will blink more than a bold one. The actor Michael Caine, when playing a difficult character, has learned to keep blinking to a minimum.

Have plenty of flesh-tone clay to cover the eyes standing by, as eyelids just disappear. A one-frame blink with the eye covered works fine, but you might want to refine that by giving it three frames.

With repeat movements, like blinking with the eyelid going down and up, you have to realize how it would read to the audience. Putting the eyelids halfway both on the lids down frame and the lids up frame will make that position more dominant than the open or shut frame, as you are seeing it twice, so the shut frame won't register – the lids will only seem to go halfway down.

The eyelids can convey different moods by being heavy (i.e. tired, depressed, superior or in love) or not there (happy, alert, slightly mad).

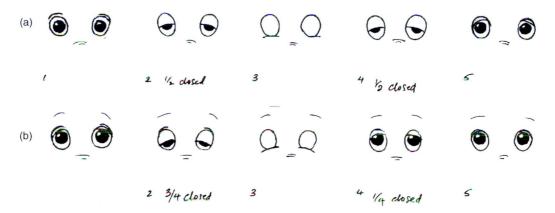

Figure 11.5 (a) Blink (single frame). This sequence results in the impression of half-closed eyes, as frame 3 does not register. (b) Effective blink sequence

more than one character

If you are dealing with more than one character, you have to think about which one is drawing the audience's eye. And where do you want the audience to look? Obviously the sound-track helps, but it's a good idea to always think in terms of mime, so that you draw the eye towards the right character. Block out your moves so that you know they will maintain the right composition for your intentions, that one character isn't masking the other, or upstaging the other and so on. Make sure the camera is focused on the right character at the right time.

Keeping the secondary character out of the limelight is an important dramatic technique. Watch how still secondary characters stay when the hero is taking center stage. Unnecessary movement distracts the eye of the viewer. As we are not dealing with live actors we have to make sure our characters stay 'alive' – in other words, that they don't just 'freeze'. An occasional blink or a very small shift of weight from one leg to the other is enough to keep a character alive.

subtle character animation

Thinking always in terms of comedy effects can lead to the animation losing its flavor and becoming repetitious, going from pose to pose: hold – move, hold – move, hold.

Subtlety is created by taking the animation further, using observation – looking for the expressions people use that are most telling of their character.

We did some live reference work for Chicken Run for ease of communication – so that Nick could get the ideas across. You could pick up what he was interested in right away – an eye movement – timing of a head gesture. ... Generally you wouldn't follow the whole thing – but key things – and have them on hand.

Jeff Newitt, animated Mr and Mrs Tweedy on Chicken Run

In his short film *Canhead*, the American animator Tim Hittle animates the hero, Jay Clay, casting aside his weapon in a little, but beautifully timed, movement that shows a huge, complicated emotion. In this movement he conveys disgust at the appearance of his own aggressive nature and an ability to shrug it off as quickly as it appeared:

In my own films there is no dialog. The characters are just made from clay so I am able to sculpt any expressions that I need. A lot can be done with an eyebrow shifting or a mouth turning up or down. I watch silent films, athletes and people in general. My main source of reference is myself. I go through the actions over and over with a stopwatch until I am sure of the timing, and then it is a matter of execution.

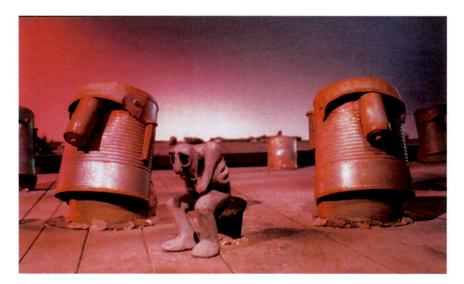

Figure 11.6 Still from Canhead. © Timothy Hittle

Look at how much of your character needs to move. In the original *Creature Comforts*, Nick Park animated the Brazilian jaguar to start with, swishing its tail back and forth as he spoke. But very quickly he realized it was a distraction and just left it to hang. Only move what's necessary. In so much animation, especially early computer animation, there is too much movement.

To make another comparison, using Aardman's skills as an example again, the penguin, Feathers McGraw, in *The Wrong Trousers* is a magnificent example of underacting. Guionne Leroy, a Belgian animator who worked on *Toy Story, Nightmare Before Christmas* and *Chicken Run*, elaborates:

With the penguin in The Wrong Trousers, Steve [Box] was really teasing us, making the penguin stop – the sense of surprise. He can make a character move in a way that's full of life inside.

So pacing and rhythm are enhanced by putting some stillness into your acting – only move what needs to move, or what helps the story along. Think yourself into the character and let your instinct guide you.

If your character is to be still – you want them to have reached a comfortable position to hold as a still pose. If they haven't achieved that 'relaxed' look – a hold isn't going to work. You'll need to know your character's 'relaxed' position very well, so that you always know how far you need to move to get back to it. Stillness can look dead, as mentioned before, so that slight shifts in weight and blinks are necessary.

Creating subtle animation is a subjective business – research, sifting through reference material and constant observation are needed. Practising observation through sketching and life drawing, study of acting – using all these different approaches can only develop your skill. Then it can translate into whichever medium you want to apply it to – it is the essence of animation.

All animators put something of themselves into their puppets. It is a very full emotional experience for the model animator, as the performance is a one-off, just like a stage performance.

You feel this incredible connection, you feel you're giving them your soul, you're giving them your life, giving them your emotions. You're being a kind of channel for them really, allowing them to really become alive, allowing them to live with all the juice that they have. It's a wonderful, beautiful work. If you have this desire to offer your hands, your body and your sensibility at the service of expressing a life that is contained within a puppet, but needs a conscience to bloom – that's the beauty of it. To me that's the essence of animation.

Guionne Leroy

chapter 12

the production process

chapter summary

- lighting
- health and safety issues
- setting up the camera
- shooting with a rig
- special effects tips and hints
- final checks before you hit that button
- interview with Tim Allen
- glossary

Stopmo can be nerve racking. You start at one end and work through to the other. Any sour frame along the way can contaminate the whole shot. It is much like a live performance and each shot is unique; if you have to do it twice it may be better or worse but it can never be the same. You have to stay awake and aware of lights blowing or props moving or the camera getting bumped. You learn to know the correct sound of the camera advancing the film one frame at a time. If the shot comes back with problems it can be a heartbreaker. You are always taking a chance to be disappointed. But when it comes back and you've nailed it and everything you wanted is there, it is a joy! That's when I begin to feel like an artist.

Tim Hittle

Tim describes the tension of animating using film, when the results weren't seen until they came back from the labs. Even now, with digital production, there are still plenty of pitfalls on the way to getting your film made. This chapter could help you avoid some of the more obvious disasters.

You have far more control making an animated film than any other kind – you control the weather, the lighting conditions and the timing, all the elements that shorten the life of a

'live' film director. Now it's no longer the planning stage, but the real thing – so approach everything with patience, a cool head and get into the animation. Once you have your script, storyboard, sets built, models made, sound breakdown and animation instructions on your bar chart or X-sheet, you are ready to shoot. You will need to have your camera positions planned, and then set the lighting for your first scene.

lighting

What is your light source? If your action is indoors, your light source can be from interior light or from daylight coming in through the windows. If your location is outdoors, the sun or the moon would be your main source of light.

In a traditional lighting set-up you would have a **key** light, a **fill** light and a **back** light. The key light is the main source of light representing the sun, so set your strongest light at the position of your 'sun' or 'moon'. The fill light helps to soften the shadows cast by the key light, and the back light or **rim** light, shining from above and behind your character, helps to highlight them and separate them from the background.

Film and video don't register light and shade in the same way as our eyes do, so we find things look better if the shadows are reduced. In order to reduce the shadows, we use fill lights, which are diffused or 'bounced'. You can set a light so it's bouncing or reflecting off a white surface. A polystyrene (styrofoam) board is often used; this creates a very soft, even light with almost no shadow. The very simplest effective lighting can be achieved using just one light set, a 'key' lamp at 45° to your model – this leaves a very black shadow on one side of the face. Place a sheet of polystyrene (styrofoam) so that it picks up the light spilling off the set and 'bounces' it back onto your subject, lightening the black shadow caused by the key. This will provide a fraction of the light, but will soften the shadow – depending how close you place the **reflector** (see Figure 12.1).

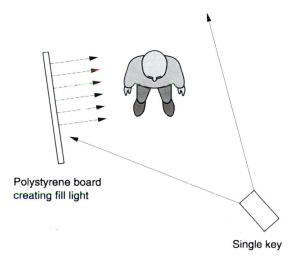

Figure 12.1 Achieving lighting with fill, using only one (key) light source and polystyrene (styrofoam).

You can cover lights with a variety of diffusion filters, and you can use gobos (see chapter 4) to create atmospheric shadows. If you need to cut down and soften the light a bit, you can put an old metal sieve directly in front of your lamp. Lighting gels and diffusion can be bought in sheets or rolls from theatrical or film lighting suppliers.

Multiple shadows can create confusion, so try to keep one main light source or direction, and keep the other lighting soft, by reflecting or diffusing it.

For moonlight, use back lighting to cast an edge of light on characters, hedges, etc. Moonlight is a hard light, like the sun, but less intense. You can use a blue gel; it does help us believe that it's moonlight – and use some bounce off the back light to fill the front of the set and give a soft light to your characters. Look in chapter 7 at Nick Hilligoss's *Possum's Rest* image (Figure 7.3).

A lot of series animation is shot with a very uniform-looking bright but diffuse light. This is a safe way of creating 'shadowless' lighting, with all the lights bounced off white or shining through a large screen of diffusion material known as 'trace' (looks like stiff tracing paper), suspended above the set. This can make the characters look a little flat and their environment highly unrealistic, which may be the desired effect.

lighting the background

Halogen 'garage' lamps throw a good spread of light. The sky is brightest at the horizon, at sunset, sunrise and at noon. So if you are using a painted background flat, placed a bit away from your set, it is best lit from below, with the light falling off towards the top. Your light meter should read about a stop more than the key light. Avoid any 'hot' spots (unless you want to create one for a sunrise or sunset). Garage lights may need a bit of diffusion clipped over them as they can throw a 'streaky' light.

To avoid lens flare, check that no light, especially the back lighting, is shining directly into the lens. If it is, it could ruin the shot, so you need to protect the lens by flagging it. The lens hood may be enough, but if not you could attach a purpose-made black **flag**, or use **black wrap** (heavy-duty foil) that you can shape.

measuring light

I've only talked sketchily about lighting, but lighting is as important to your film as the sound. Light can be measured mathematically, using the meter in your camera or a separate light meter, so that you can create a coherent balance of light and shade. The lamps need to complement each other in terms of output. For instance, you would want your fill light to give you about a maximum of two **f-stops** less than your key light. Similarly, if you have an exterior seen from a room window, that will be a brighter light than the interior, maybe one **f-stop** more than the (interior) key light. Light can be measured in various units, but light meters use EVs (exposure values), which for any given ASA (DIN) rating give you a combination of 'f-stops' and shutter speeds for the correct exposure.

light meter

Using your camera as a light meter, zoom in to measure the light falling on your characters and your set; this will take **reflected light** readings. Alternatively, to get more accurate readings, use a separate light meter which measures the **incident light**, i.e. the light falling on your puppet, rather than the light reflected off your puppet. Once you've set the ASA/DIN (the **film speed**, still used as a rating with digital cameras) and the **shutter speed** on the meter, measure the incident light that falls on your puppet and your background using the white dome that comes with your light meter. Place the dome as close as possible to the object you are filming and angle the dome to the camera, so that the incident light, falling on your puppet, is the same as the light falling on your meter. That will give you your light reading, and you can make your decision about what the exposure will be. This can differ from the reflected light, which may be what your camera meter is measuring. You can either set that on your lens barrel aperture ring or on your camera menu.

f-stops

The lens aperture on the camera is a diaphragm that operates like the iris of an eye, closing down to reduce the amount of light coming in, or opening up to let more in. The size of the aperture is measured in f-stops, an agreed sequence of numbers relating to the brightness of the image: each change to a higher number halves the amount of light passing through your lens. The numbers typically start at f/2, f/2.8, f/4, f/5.6, f/8, f/11 and f/16, with f/2 being wide open, letting a lot of light in, and f/16 being a smaller hole, letting less light through. On a completely manual camera it is controlled by turning the aperture ring of the lens barrel, otherwise it is set using the camera's menu.

shutter speed

Working manually, you can control how long the camera shutter stays open, therefore controlling the length of time the image sensor in your camera is exposed to the light coming through the lens. The aperture controls the volume of light hitting your sensor, and the shutter speed controls for how long the light is hitting it for. Traditional shutter speeds are 1/1000, 1/500, 1/250, 1/125, 1/60, 1/30, 1/15, 1/8, 1/4, 1/2 and 1 second, but because in stop motion everything is held still for the frame to be taken, nothing will blur if you leave the shutter open for a long time. The shutter speed can be set to be open for anything from a quarter of a second to six seconds, relating to the amount of light you use for your set and accordingly how large or small the lens aperture or f-stop is set at.

depth of field

Your depth of field means the area of your shot that is in focus. In animation, because you are working on a small scale, very much closer to the action than you would be when making a 'live' film, your depth of field is much more critical. Closing down your lens aperture or using a wide-angle lens can increase the depth of field. The smaller your aperture, the more light you will need (see Figure 12.2). Rather than adding more and more light, you can do this by slowing down your shutter speed. A shallow depth of field exaggerates the miniature aspect of your set, whereas if you increase your lighting to give a good depth of field, you will create a more natural impression of distance

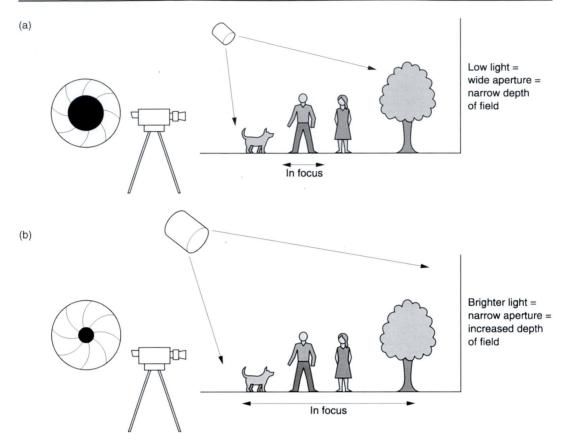

Figure 12.2 (a) With less powerful lighting, the area in front of the camera that is in focus is reduced. (b) With more light, the camera's iris can be smaller, increasing the depth of field and helping to overcome the sense of a 'miniature' world.

health and safety issues

Using lighting and electrical equipment is always potentially hazardous. Overloading any system could blow fuses, if not your equipment. Take sensible precautions for yourself and anyone working with you to protect yourselves and your equipment. Some safety tips for setting up lighting include:

- 1. Check that you have enough power to cope with the lighting you are setting up. A 13-amp circuit is standard for the UK, 15 amps for the USA. No single normal circuit can supply more than 3100 watts (UK) or 1800 watts of power (USA).
- 2. So first check the **amperage** (amp rating) of the electrical circuit you are using, and then the total **wattage** of the lamps and equipment you are using. If the total is above the wattage mentioned, you will need outlets from two different circuits, which could mean running a lead from another part of the building.
- 3. The UK standard voltage is 240 volts; in the USA it is $100-120\,\text{V}$. The sum you need to remember is: watts = volts \times amps. Use extension cables that are powerful enough to

deal with the current you are running through them. A cable drum usually has this information on it (i.e. max 7 amps wound/13 amps unwound).

4. Using an extension cable on a drum for lighting is not recommended, but if you have to, completely unwind the cable, as the heat generated could easily overheat and ignite the cable. Make sure the cable is capable of taking the power you want through it.

5. Cables shouldn't be frayed, and once the lighting position has been set, cables should be made as unobtrusive as possible, with all cables on the floor taped down with 'gaffer' or 'duct' tape, and hanging loops of cable should be clipped out of the way. In other words, ensure that no one can trip over a cable or knock against a lamp stand. Use hazard warning tape – the kind building sites use to warn pedestrians – to alert people to danger areas on your set.

6. When changing bulbs, first ensure the lamp is cool enough to touch and, second, don't handle the bulbs with bare skin as the sweat from your fingers will shorten the life of the bulb – fit it using the plastic wrapping it comes with. The color temperature of a new bulb will be different from the old one. As a bulb ages the light coming from it becomes warmer (nearer the red end of the spectrum) and the new bulb will be brighter. You might want to correct the color a little with a gel to match it up to the rest of the shot.

setting up the camera

camera position

You should have all your shooting angles planned in the storyboard – which will save you time setting up. Check when you set it up that the position you have is correct for the entire shot. Once the camera is in position with the correct zoom, focus and aperture, everything should be locked off: the tripod taped or even glued to the ground; anything that moves on the tripod tightened and locked, and anything that can move on the lens barrel taped down so it can't be nudged. It's useful to have the lens information, zoom, focal length, aperture and camera position all noted down so you know the lighting and camera conditions for each scene, and if anything does get moved you know where it needs to return to.

camera moves

- Pan: moving the camera from side to side on a fixed tripod. Take into account the focus
 difference from one side of the set to the middle of your set, and check for lens flare (light
 that may be shining into your lens this can make an image look milky) from beginning
 to end.
- Tilt: moving the camera up and down on a fixed tripod. Once again, focuses may change, so remember to check.
- **Track:** moving the camera forwards, backwards or side to side, best done on some sort of track. Professionally done with computerized motion control on a track.
- Zoom: zooming in with a lens is tricky as, depending on the quality of your lens, it can
 create a telescoping effect with your background. It's not recommended to use a zoom
 too much, but if you must, it may well be safer than attempting to track in.

All camera moves should be planned in advance. You need at least a good solid tripod with a pan and tilt head, or better still a tracking system. It is possible to slide cameras

along on tabletops and correct the position on the screen, or use a mic boom to swing a camera over a set, but this is very difficult to control and is not going to look that great. However, you can add batons as guides on the tabletop to give you a fixed track and place your camera on a roller-skate base, and this will improve your chances. If you are lucky enough to have access to a proper tracker bed, you have the means to control your track in/out or side to side perfectly by moving the handles incrementally. Make sure you have checked the focus for the length of your move and marked up any different focus positions on white **camera tape** around the lens barrel. Remember you will need to cushion in and out of any movement. There are many ways of marking off your increments for the move, as long as your pointer, either on the camera or geared head, is rigid and comes close enough to your markings for accuracy. Martin Shann at Aardman Animations remembers marking up knicker elastic with calibrations for camera moves: 'You could use the same piece and then stretch it for different distances!'

Consider carefully the need for a camera move, as it is a very time-consuming business in the planning and is very hard to control. It can only really be achieved successfully at a price.

panning or tracking speeds

If you are planning your move to follow a character walking across the screen, you should plan your move in accordance with the timing of the animation. If your pan starts too soon, it looks as though you are anticipating the puppet's move. You probably want to literally 'follow' the puppet, so make your pan slightly behind the puppet's move.

motion control

A professional animation studio would generally approach a camera move nowadays with computerized motion control. A motion control rig is a huge robotic 'arm' with a rotating head that can move the camera into almost any position you need it. The camera operator programs the rig depending on the shot required. This data then enables the rig to be used again, creating exactly the same movement which, in turn, allows for several passes, each matching exactly the ones preceding it. This programmed data, used within the original shoot, of either a model environment or live-action background, may then also be transferred to a computer in order to 'drive' the camera within a computer animated sequence. Alternatively, one may choose to use chroma key – 'green-screen' – techniques to shoot the background separately from the foreground or the animation elements.

To achieve perfect synchronization of separate moving elements, specifically animated elements in a real background, is a specialized process known as **match moving**.

white balance for video

In order for your video camera to 'understand' color, you need to tell the camera what 'white' is by showing it something white under your lighting conditions. Most cameras will have automatic white balancing, but for older, analog cameras, you'll need to do it manually. Set up a white card on your set with the key (strongest) light falling on it, point the camera at it and zoom in so that most of the viewfinder is filled with white, and go through the

white balance procedure for your camera. Do the white balance before you put any filters on, then the filters will do their job. If you white balance afterwards, the camera will try to normalize everything.

blocking out your shots

Make time on your shoot to block out your shots first; it is another step in the process that helps you be sure of your moves. You can refer to the frames of your animatic – you can paste them up on your monitor screen. Place your puppet in its key positions on the set and hold it there for the amount of frames you have doped for those moves. This way you are able to check the lighting, the framing and composition before you embark on the final shoot – and if you are animating for a director, it gives you time to discuss any final details with them.

shooting with DV

Make sure your camera is fixed firmly in position and everything is set as you need so that you no longer have to touch any of the controls, your lens cap is off and you have white balanced. As you shoot each sequence lay it into your animatic, replacing the rough scenes with the finished article. If you can't have manual override on your video camera, remember to let the automatic controls settle before you take the shot. This is especially important to remember when you're wearing black. Many animators wear dark clothing so as not to reflect light on to the set. If you're wearing black and lean in to move your puppet, then lean out and take a frame before the exposure has settled, the frame will be burnt out.

shooting with digital stills

As I mentioned in chapter 2, if you are able to capture your frames as RAW files from an SLR camera straight to computer, you will need plenty of space on your hard drive, as each file is so large. You can shoot for the highest definition resolution of 1920×1080 pixels here, so each separate frame needs to have a new folder. Make sure you've labelled each folder distinctly as scene, shot and frame number; simply numbering them 1, 2, 3 will get you in a terrible mess once you move on to another shot. Once you have completed your animation, open your photographic software (Photoshop, Adobe Light Room, Aperture). You need software that can manage batches so that you can highlight all the frames in your shot, open them all and see them displayed on the screen. This way, if there are any changes you want to make to the shot, like lightening the shadows, adapting the color slightly, adding contrast, tinting the color, sharpening the image – this can all be done at this stage. If you make those changes to one, the software will apply those changes to the whole batch. This can then be transferred to a new folder as JPG, TIFF or PSD files, and imported to your edit software or back to your stop motion program.

your own welfare

When you set up your shot, try to leave yourself some room to maneuver. This can get difficult with the accumulation of lights, set and various stands holding bits and pieces. You've got a long time to spend with that set and the repetitious moves you make when you're involved with the animation can make you very uncomfortable. One tip is to put your animation control unit or keypad in a different position each day, so that you vary your movements. It sounds a bit precious, but could save a very stiff neck.

If you are working in a cold studio on a concrete floor, you will spend so much time on your feet, it's worth putting a thick piece of polystyrene on the floor to stand on where you are animating. It helps keep you warm and helps to ease leg ache.

shooting with a rig

If you need to use a rig, you can remove it digitally using a photographic software. You will need to:

- Shoot a clear plate of your background, at the start of your shot, before the character is in place.
- Shoot a clear shot of background with any props that involve the character.
- After shooting the frame with the rig in, place a white card to cover the rig, as can be seen in Teresa Drilling's shoot, and repeat shoot the frame.

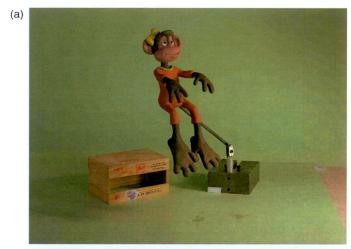

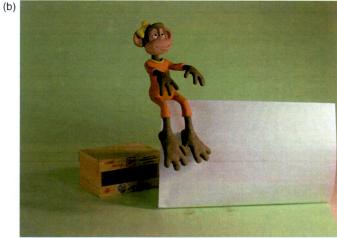

Figure 12.3 (a) Jumping monkey on rig. (b) Rig masked with white paper.

Then go on with your animation. When you've finished, import the image sequence into your photographic or image manipulation software, then you can open them as individual frames. Paste the clean plate and, if you have it, the frame with prop(s) as a separate layer for each of the frames.

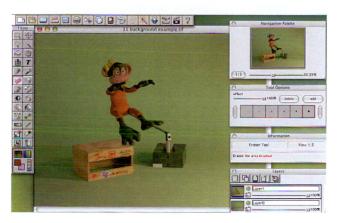

Figure 12.4 Image manipulation software.

Select the frame with the rig and copy it. Open up the clear background frame and paste the rigged puppet frame onto it. This will then become your layer 1 image.

Figure 12.5 Layers.

Working on layer 1 (it will still be called 'Background' if you need to check) – select the erase tool. Tool options will then show up on the right of your screen and you can choose how big or small you want your erase tool to be.

Figure 12.6 Eraser option.

Zoom in on your image to show the area you need to clean up, and if it's fiddly, zoom in tight and use a smaller erase tool.

Figure 12.7 Selecting areas to clean up.

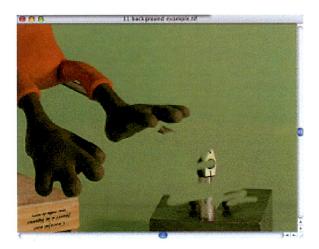

Figure 12.8 Using the erase tool to clear out the rig.

The clean plate will show through and you will have your cleaned up image. Repeat this action for all frames containing the rig. Then you can import your frames back into your edit program or back to your stop motion program.

The white card can be used as it gives you a clear outline of your character to work round. But it can provide complications with shadow. Remember you also need to erase the shadow of the rig.

As you can see, the whole business of taking out a rig is very time-consuming and tedious. The process is not as creative as working out better ways to rig your puppet invisibly. Ladislaw Starewitch managed to make extraordinary films with props and wires holding up his puppets – so can you.

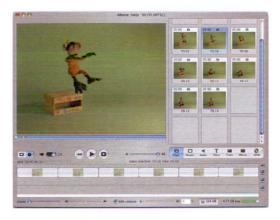

Figure 12.9 Final cleaned image placed into the editing program.

chroma key or green screen/blue screen

Chroma key can also be used for rig removal, but you would need to take your character out of it's original set, animate the move with the rig against a blue or green screen, then replace it into the original set. A more common use for chroma key **compositing** is to put your characters into a situation that is either too expensive or difficult to create as a set. To set up a blue/green screen, you need a large solid-colored background, preferably blue or green, if necessary covering the floor as well and any rig support. The background has to be far enough away from the action to prevent light from the background falling on the action. It needs to be lit overall, separately from the lighting for your characters and objects, with additional blue or green gels over the lamps. The choice of color for the background screen should be a color that isn't included in your puppet, as if that color appears on your puppet or puppet's clothing it will create a 'hole' through which you can see your new background.

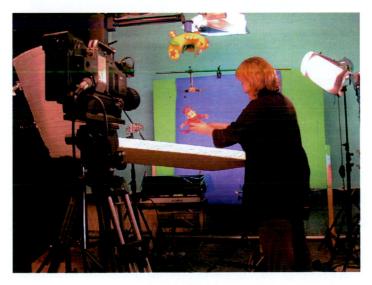

Figure 12.10 Shooting a scene from Cosgrove Hall's Engie Benjy against a blue screen.

When lighting your characters/objects you want to light them in a way that will complement the background you are putting them into – in other words, replicate the lighting of the new scene into which they are going to be composited. You will need to shoot the animation at the same camera angle as the shot they are going to be matched into, i.e. if you are looking up into trees, you would have a low-angle shot of your characters.

using glass

A large pane of glass placed in front of the background allows all sorts of special effects to be created. You can animate water droplets running down, splashes, smoke, explosions. It also enables animation to go ahead in a sort of 2D/3D, allowing more squash and stretch and dynamic movement of all sorts without the need for rigging, as in Richard Goleszowski's series *Rex the Runt*. Of course, the animation doesn't have to stay on the one plane, the background can be animated as well. Lighting becomes much trickier, as you may be casting shadows onto your background. You may also want to give some dimension to your characters – so side/top lighting at about 45° to the camera helps.

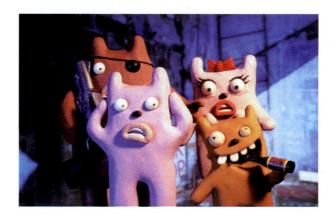

Figure 12.11 Rex the Runt, created by Richard Goleszowski. © Aardman/Rex the Runt/BBC Worldwide Ltd 1991

Reflections in the glass have to be cancelled out, by blacking out the camera with black card on a frame covering everything but the lens. A **polarizing** filter will help reduce or eliminate reflections. If you are using more than one pane of glass, or if you have glass that is too thick, it could become a problem that there will be some light loss through the glass – glass also has a greenish color which you might need to take into account. Optically correct glass, with no green in, is expensive, and you can also get filters for the camera which counteract the green. But generally, it's only worth being aware of in case you start to get problems.

special effects – tips and hints

With stop frame filming the most ordinary occurrence becomes an extraordinary challenge and calls for an inventive solution. As stop frame developed over the years in little studios, separated from each other by hundreds and thousands of miles, there was very little communication – nobody wrote a book of rules. Each studio had its own way of dealing

with water, fire and smoke effects. Now I know old-school animators harp on about this – and I'm going to too. People will often use computerized special effects when they think an effect is too difficult to create, but it rarely blends in well with stop motion – unless you are spending a fortune, the quality is just not good enough. It was disappointing recently to hear of a student who needed to explode her character decide to resort to a computer effect; she assumed that would be the only way to do it. I remember assisting Pete Lord (Aardman) making a commercial where a pizza had to explode and we made a forest of rods and tungsten wire, and I wish I could remember just how many pieces of pizza Pete had to animate out of the center in this explosion – and this was shooting 'blind' – no frame grabber, just markers on a monitor from a video assist camera.

So I've included here some ideas for making your own special effects - old-school style.

fire

There are many solutions, depending on the size of flame you want – one can create controlled effects using reflective material like Scotchlite®. It's used for road signs and when light shines directly on to it, can be almost blindingly bright. This makes it useful for effects such as a striking match or bright flames. As it is a sticky-backed plastic material, it can be cut out into the shapes you want. Shine a small spotlight on it directly from the camera, and alternate shapes. Vary the colors of gel on your light.

explosions

Depending on the style of your film, try cartoon explosions. Replace the puppet with cut-out card explosion shapes changing shape and color every four frames, as in Peter Peake's spoof children's short *Pib and Pog*. Explosions can be created very simply with paint on glass placed between the camera and set. Front-lit Scotchlite, as suggested in 'fire', can also be used for explosion effects.

camera shake

Explosions, earthquakes and volcanoes can all be accompanied by camera shake to enhance any effect. A few frames right and left of the original position, and maybe up and down too.

rain

This effect can be composited with your scene. Film rain, water spray falling (a situation that has to be very carefully monitored as you have water and electricity closely combined) against a black background. A side light will make the rain show up. For the rain, if you use a hose, you will need a large area so that you can get well back to allow an even fall of drops. It helps if the size of your shot and the size of raindrops are compatible with the size of your matching shot. You could always give yourself a range of 'stock' shots in different scales while you're at it.

snow

Here's another that can be composited. Film polystyrene beads or shredded paper falling against a black background, this time lit from the front. Again, remember to make the size of shot compatible with your scene.

footprints in the snow

I found a posting on Anthony Scott's website, **Stopmotionanimation.com**, asking how somebody would make footprints in the snow. After various complex theories had been put forward, Anthony himself answered, as he had animated Jack Skellington walking through snow in *Nightmare Before Christmas*:

I animated shots with snow in the 'Poor Jack' sequence. The snow was made of styrofoam that was sculpted and attached to the wooden set. To create footprints, I just punched through the styrofoam and drilled a hole to tie down Jack's foot. It was a simple process, although I had to be careful not to crush the snow as I climbed onto the set. I made a special wooden platform that I placed over the snow for certain shots just so I could reach the puppet without crushing the foam.

I can't remember exactly what I used to punch through – probably a wooden tool of some kind. I did use a frame grabber but I also gauged the puppet so that I could keep track of all the pieces of torn cloth as well as its legs.

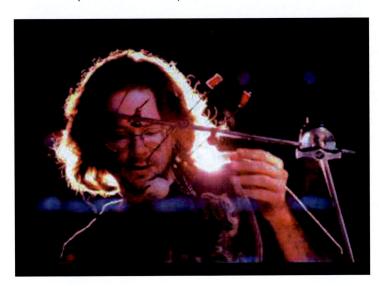

Figure 12.12 Anthony Scott animating Jack Skellington in Tim Burton's *Nightmare Before Christmas*. The scene has Jack's clothing in tatters and Anthony used gauges to keep track of the position of each fluttering piece of cloth as he animated. Photo © Jim Mattlosz

American animators tend to use gauges far more than UK animators; it's just a different way of working that has grown up between the two countries.

water

Add either splashes cast out of clear resin or cut out of clear or frosted acetate, randomly appearing for two/four frames here and there. Glycerine is thick enough to use for drips running down a window. Use KY Jelly on a reflective surface to animate ripples on a pond. For pouring water, or a torrent, use cling wrap or cellophane.

smoke

Cotton wool teased out to thin wisps.

fog/mist

A few layers of net stretched on a frame catching the light and animating gently could create fog. Tristan Oliver, DOP on Aardman's *The Wrong Trousers*, lit stretches of net further back in the set for shafts of sunlight on an early morning street scene; this helped to create a sense of depth in the scene.

wind

This is a bit fiddly to achieve on a whole set if it's an exterior, although it would bring a lot of life to the usual stiff trees and hedges. It would mean having all your branches made with aluminium wire that you could animate. To achieve an effect of wind with curtains, thread thin aluminium wire into thin seams on the fabric, so that it can be animated. Flags can be treated similarly. Alternatively, the fabric could be glued to heavy-duty foil.

Leaves tumbling by could be animated on glass over the set.

motion blur

To achieve an illusion of speed, you could either move your background from side to side while exposing (not always an easy option!). An exposure of half a second to two seconds helps here. This would give you a blurred background. Or you could attach your character to the camera on a rig so that it was locked into the camera move, and shoot on the move, again with a long shutter speed. This technique was used for the motorbike sequence in Aardman's A Close Shave and the train sequence in The Wrong Trousers.

consider the editor

While filming, if your budget can stand it, consider the editor. They can always use a little extra at the beginning and end of each shot so that they can get the cut in exactly the right place for the rhythm and pace of the piece. If you are walking a puppet on, start it right off screen. As well as helping you to get into the rhythm with your animation, it also allows a shadow to precede the puppet if the angles of the lighting cause it. Let your opening move start a little earlier than you'd planned, and the same with the final move.

final checks before you hit that button

Is everything there that you need? Or is there something there that you don't want?

- Do you have spare everything? You don't want to get started and then have to break off in search of bits and pieces. It's very important to keep your rhythm and concentration going. Do you have spare bits of Plasticine/clay in the right color for eyelids, teeth, spare hands standing by?
- Are your sculpting tools all there? Small mirror to check lip sync; wet wipes to keep hands clean?

- Check that nothing is on the set that shouldn't be there. Check around the four corners
 of the frame: that will remind you of your composition, as well as show up anything that
 shouldn't be there.
- Is the lens in focus? Is the aperture correct? Shutter speed?

Is the camera locked off/tripod weighted/glued to the floor?

 Check for any unwanted reflections and shadows – there may be reflections in shiny areas that you don't see looking at the set, but you can see through the viewfinder. You can buy dulling spray from photographic shops, but check later in the shot that it hasn't smudged.

Mark it: identify the shot with a board giving the title of the film, scene number and 'take' number if necessary. This is helpful to the editor – and you – identifying your shots. If you have forgotten to put it on the start of the shot, it can go on the end, but it must be upside down – an editor recognizes this is marking the end of a shot, rather than the start of a new one.

interview with Tim Allen

Since Tim Allen graduated from the Glamorgan Centre for Art and Design Technology, he has worked on a variety of stop motion programs, starting with *El Nombre* – a popular schools program that contained some great low-budget animation – moving on to *Fireman Sam*, various programs at Cosgrove Hall Films, including *Enjy Benjy* and *Rotten Ralph*, and had a great opportunity animating the dinner table scene in *Corpse Bride*. He then spent a while in Poland, animating on Suzie Templeton's *Peter and the Wolf*, and more recently worked on Aardman's *Creature Comforts*. He leads the life of a typical freelance animator. I asked Tim how he approached each new job:

When I sit down with a new puppet to animate, I first talk to other animators on the job – to find out if any of them have handled this puppet before, if there are any idiosyncrasies with this armature. Sometimes there are certain gestures that work well with a particular puppet. I'll also talk to the model makers about its capabilities. I like to find out about the director. It's important to understand a director's way of working. There are huge differences in the way directors pass on information. You need to know if they expect your animation to be exactly as planned, or whether they want you to take things a bit further, whether they like surprises! It's always a good idea to try and find out as much as possible before you start.

Then I will take the puppet through its paces to get used to the movement, check how the silicone folds, squashes and stretches – find out the best place to hold it, the grabbing points, areas that won't get disturbed or show dirt easily. I look for loose bits of clothing that need pinning back, or loose hairs that need stiffening; you don't want to find anything 'boiling'.

Once I'm confident about the puppet, I'll look at the set and check for loose grass or gravel and make sure all the props are well fixed down.

Before we start, I'll plot out the puppet's moves on the set with the lighting crew. I check how the light falls on the puppet's face. Does the light bleach the face out? How do the pupils look when the puppet looks up? Sometimes the way the light falls can show the structure

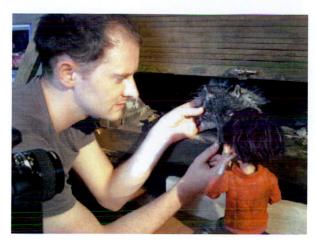

Figure 12.13 Tim Allen animating the wolf in *Peter and the Wolf.* Photo © Tim Allen. Courtesy of Breakthru Films

of the eyeball a bit too clearly. Where do the shadows fall? For marking out moves, I generally make little pencil marks on the floor. Very occasionally I'll use a surface gauge, but it's hardly necessary with a frame grabber. If it's a very complicated or distant shot and it's not absolutely clear, I'll use a pin on a stick – I wouldn't recommend anyone starting out paying \$100 for a surface gauge!

Then, if rigging is needed I'll set that up and test movements to check the rigging for shadows – make sure no rigging shadows cross the puppet. Ideally, I will hide the rig as much as possible, to save on post-production. After that it's down to me to get started.

glossary

black wrap: a heavy-duty black aluminium foil. Many uses, including quick fix flagging of the lens hood or making mini flags for the set. Available from film and lighting suppliers.

camera tape: generally white or yellow – a strong tape for a variety of uses. Traditionally used for taping up a can of film to go to the labs. Useful for putting down marks, as one can mark increments on it with a fine pen. Available from film and lighting suppliers.

compositing: creating new images by combining images from different sources such as live film, 3D imagery, 2D/3D animation, painted backdrops, digital still photographs or text.

f-stops: marked on the aperture ring on your lens barrel. A sequence of numbers from f/2, f/2.8, f/4, f/5.6, f/8, f/11 and f/16 relating to the brightness of the image: each change to a higher number halves the amount of light passing through your lens.

fill light: light used to fill strong black shadows created by the key light. Can be reflected light rather than a lamp itself.

flag: a shaped flat black metal rectangle, can be bought in different sizes, used to cut or control where light falls. 'Flagging' the light simply means blocking it in some way. Large flags are available as black fireproofed material over a rectangular frame. A 'flag' arm can be a small articulated arm attached to a camera mounting, to block lens flare, or a much larger articulated arm used for bigger lamps at a distance.

incident light: the light that falls on a subject.

key light: the main, strongest lamp – either replicating the sun or the moon, or the main source of lighting in an interior.

matte: a mask, blacking off part of the image so that it will not be exposed, placed either in the camera between lens and gate or just on glass in front of the lens, allowing two images (or more) to be superimposed.

reflected light: the light reflected off a subject.

reflector: anything which can reflect light onto your set – white/black polystyrene (styrofoam) white card, aluminium foil on a card, mirrors.

rim light: lamp used to back-light characters, giving separation from the background. Also helps to 'glamorize' a character by adding a glow on the hair.

Scotchlite: made by 3M. Available from lighting/photographic distributors – sticky-backed plastic with a coating of minute glass beads. Used for reflective road signs, etc.

spot meter: a more specialized light meter used for measuring small areas of reflected light, or measuring a distant object. The spot meter should be used standing at the camera position.

chapter 13

post-production

chapter summary

- timecode
- the picture edit
- sound
- titles and credits
- exporting your final film

Rushes are the most terrifying thing on God's earth – exciting but so raw. There are no sound effects. And you have to explain to some executive producer, 'there will be sound here' and you feel you have to explain your way all through the rushes. It's so painful watching it. But the joy of making something move – then you watch it on film and it's not yours any more. You still have the muscle memory – you can remember what was going on in the world when you were shooting it and you can feel your bones aching when you see a particular scene. But you can't do anything about it – it's gone!

Barry Purves

timecode

Once you start putting sound and image together, you need to ensure that you have time-code to match or sync different sources of sound and image together. Until the advent of video recording, sound-to-film synchronization was carried out mechanically and when video arrived an electronic equivalent was needed to take the place of mechanical methods of synchronization. This method is called timecode, and you need to set your time-code at the frame rate selected by the Society of Motion Picture and Television Engineers (SMPTE), depending on which part of the world you are working in. The EBU (European Broadcasting Union) standard of 25 fps is used throughout Europe, Australia and wherever the mains frequency is 50 Hz and the color TV system is PAL or SECAM. For America this is 30 fps, based on the mains frequency of 60 Hz (the TV system is NTSC). The remaining rate of 24 fps is required for film work and is rarely used for audio.

the picture edit

If you have been working with a small budget, you will have edited the film as much as possible in advance with the storyboard, and only need to edit the film in terms of a few frames cut out here and there. However, if you have had a bit more spare time and money you will have given the shots a little overlap at the start and finish, to allow a bit more leeway at the edit stage. This will help achieve smoother edits when cutting on a move.

But there is still the possibility that the film needs cutting more seriously:

When I first worked at Aardman I was working with Dave Sproxton a lot. And that was quite an education because he's not an animator, although he knows it all inside out, how it goes together, the performance, etc. But to cut stuff with him – he's just not precious about the animation. And you learn so much from somebody like that. He'll say 'well that doesn't work, let's lop it off!' and you think 'My God! My work! ...' So you have to get that out the way and then you're not so precious about all those beautiful little bits. They aren't the whole, they may help the story, but they aren't the story ...

Jeff Newitt

Now that post-production is possible on your home computer, you can go through the whole process yourself. I would only point out how the quote from Jeff Newitt above perfectly illustrates the benefits, even if it is somewhat scary, of getting the fresh eye of an editor to work on your film. Simple editing software allows you to import your shots and arrange them as in Figure 13.1 on the right of the scene. You can then drag your shots down onto the timeline below – and the first frame of each selected clip will show up on the viewfinder. You can trim the length of the shot as you like. Software like this is easy to negotiate your way round and has some basic effects and titling you can use. This is an entry-level program; you can achieve more subtle effects and grading with more professional software.

As you put your filmed animation sequences back into your timeline, your storyboard gradually comes to life as you link all these separate sequences to make the film flow. With practice you'll start to feel where the film needs to be cut or mixed between scenes – where you want to fade to black or fade in and out of a scene – and the pace takes shape.

If you are working with an editor rather than on your own, you'll need to make up an edit decision list (EDL), where all the cuts, mixes, fades in or out relate to the timecoded numbers on the film. The editor can then work with you if necessary, making the cuts, digitally cleaning up the film, wiping any rigs, correcting any set shift and color grading. This process can get expensive and it's important to make a decision in advance of how far you are prepared to go with professional post-production. Color grading is a process of matching the colors between the scenes, changing hues, brightness and contrast if necessary. It is quickly dealt with by a professional – but will take time to become familiar with as a beginner. It can be addressed in your editing program; you can see, in the Effects section, that you can make basic adjustments in color, hue and contrast.

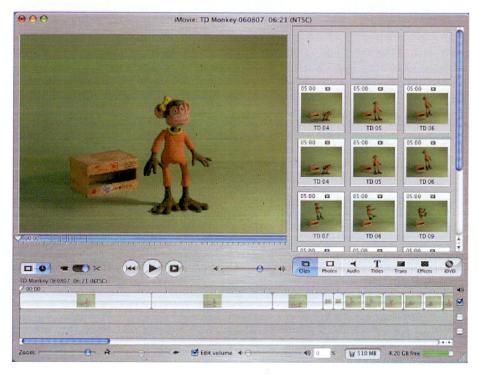

Figure 13.1 Clips imported to editing software.

Figure 13.2 Simple color-grading tools.

sound

When your picture edit is complete, it's time for the soundtrack – this is where sound design really matters. Music, the characters' voices and the layers of sound enhance the mood of the film. You have to build the soundtrack up from nothing – whether it's an interior or an exterior scene, you will need all the atmosphere sounds that make up that scene.

Interiors may have less layers of sound, but it may be important to hear the atmosphere outside – birdsong, traffic, etc. An interior will have a slight echo, as the sound waves reverberate off the walls.

Exterior sounds have no echo – unless you are in a mountain range or a tunnel. But they do have texture: wind; leaves rustling; water; birdsong; outer space (sound?); rain; traffic. James Mather, supervising sound editor on *The Curse of the Were-Rabbit, The Magic Roundabout* and *Harry Potter and the Order of the Phoenix*, explains:

Once the film is delivered, you get given a day per minute to track lay. For a three-minute film you get two to three hours recording Foley and spot effects to picture. The Foleys are the most important stage – it's the bond between the sound effects, the music and the action. It's what makes the characters real. It's quite an art, because you don't necessarily want to create naturalistic sounds, you have to create a world that goes with these strange characters, so you have to look at them and think, 'Is it a rubbery sound? Is it a wooden sound?' And then come up with the effect that works.

Foley artists work to the film and create effects such as footsteps, wings flapping, knuckles cracking, pencils scribbling, sounds that need to be matched in time to an action on the film. The sound editor treats the sounds so that they work for the film, using different recording techniques.

mixing together the layers of sound to make the final soundtrack for the film

If you are doing the sound mix yourself, there is some very basic information to get right about mixing sound. Have the dialog in mono, keeping the sound central (don't pan left or right on the desk). As industry standard you will need some reference tone set at $-18\,\mathrm{dB}$ (1 kHz tone) held for one minute at the front of your soundtrack. If you are recording digitally, remember that digital sound is far less forgiving than analog. Never get up as far as 0 dB with your sound – it will sound horrible!

Once you've finished the recording, either transfer it onto a CD or transfer it to your edit program. It will need a one-frame 'sync pop' (a one-frame burst of tone at 1 k) two seconds or 50 frames before the first frame of visuals, including the titles. Put another sync pop two seconds after the last frame as well. There should be a corresponding 'flash (white) frame' in exactly the same place on the picture. The tone and flash means audio and video can always be aligned.

There are copyright-free music and effects tracks on the internet you can use; if it is the right music that's fine, but the choice of music is very important, it can really lift a film. Other than these 'free' internet sites, you cannot use a music track without the permission of its author – a complex, slow and sometimes extremely expensive procedure. Even 'Happy Birthday to You' is subject to copyright laws. These laws are enforceable as soon as your film is shown to a fee-paying audience. You may think you're only going to show this film within the college environment – but what about festivals, or if it does end up being broadcast? You never know. It would make more sense, if you are at college, to find out if there are any musicians who would play for you, or if you know of a music college, to approach them with a project.

titles and credits

Finally, you need to put on the titles and credits. These can be created with your editing program. Be aware in what environment your film may be screened. Don't make the type too small either for big screen or for TV. If you want rolling credits, work on your instinct for a timing, neither too fast nor too slow. Don't let the credits end up as long as your film. There will be people who have contributed to your film who it is very important to credit; check you have credited all funding agencies, all in-kind support, and that any music is given a title and credit.

exporting your final film

You may need to convert your film into different formats for distribution. For sending files via the internet or uploading to YouTube, you'll need to make it into a viewable file: WMV (Windows Media Video), .AVI (Audio Video Interleave), .MOV Quicktime multimedia file format, or .MPG (compressed) file format. Festivals will require a viewing copy; this could be a DVD, VHS or Mini DV. If your film is selected, they will ask for a screening copy, which could be a Mini DV, a Beta (digi or SP) or HDV; it would be unusual for them to ask to screen a DVD, as they need to edit a program of films together, and DVD is not a very stable format for this purpose.

Don't forget that if you are sending work to the USA or the Far East, you need to produce the finished work in NTSC, which plays back at a different frame rate to the PAL format used in the UK, Europe and India.

chapter 14

getting the job – the business of animation

chapter summary

- know where you stand
- different work, different studios
- commercials
- series
- TV specials and features
- applying for jobs
- your showreel
- starting out as a runner
- festivals
- sending proposals to commissioning editors

My first experiments in animation were in my first year of art school. It was an assigned project, and after my first test shots, I knew this was for me. It seemed to be the perfect mix of art: sculpture, painting, lighting, performance and music. From then on I had a fairly clear path to follow. After two years in art school I moved to California to go to film school. I never had any training in character animation. I just interpreted my film assignments in animation, extremely crude, misinformed, uneducated stop motion. It was fun and I loved it, but the films were total crap. After I graduated I heard they were doing The New Adventures of Gumby in San Francisco. It was perfect, low-end entry-level stop motion. So I moved to San Francisco to beg for a job and, eventually, they let me in. That's where I met a lot of the animators that I have worked with through the years, and that's where I learned how to animate.

Trey Thomas, animator Nightmare Before Christmas, James and the Giant Peach and Corpse Bride

know where you stand

A good animation course will prepare you for the animation industry, so that you know what to expect and know how to present yourself to a potential employer. When the likes of Jeff Newitt and Trey Thomas started out, an animation student was a relatively rare thing. Nowadays, there are hundreds of animation courses. However, there is a great difference between the type of work done at an art college and the sort of work that people make a living with. In some rare cases, a graduate will hit the market with just the right idea at the right time and have their work spotted at a festival or a degree show by a company representative. But for most of us, there is a more circuitous route and it involves developing an understanding of how studios work by looking through websites, watching their programs and reading industry journals. This final chapter looks into some studio work practices, what a commissioning editor looks for in a script, and gives you some tips on how best to present your showreel.

different work, different studios

All studios have different reasons for their existence. Some are set up by animators trying to make their own films, but in order to sustain their work they may need to take on commercials from time to time. Others produce a steady stream of children's TV series. Very generally speaking, the UK animation industry struggles to survive in a market-driven system that means often the only way the general public, other than small children, will get to see good British animation is in a commercial.

The UK does produce more animation than other European countries. In the past, the French have had more luck with government subsidies and their television stations have had to follow a quota system that meant they had to show a majority of French work, but that situation is changing now as funding becomes scarcer. American 2D animation is still the most popular, watched worldwide. However, the animation is kept to a limited style by budgets, and it tends to be dialog or script driven.

Animation special effects is a fast-growing area that demands computer skills in softwares like Maya and Shake, and can often be a route through for a character animator with transferable skills. Post-production houses have a seemingly endless thirst for skilled computer/character animators. The pre-school audience seems to be where model animation makes the biggest impression, especially in the UK. Its tactile, dimensional nature is what makes it so successful in marketing to a younger audience. In the USA, Clokey Productions make Gumby, while in the UK, HOT Animation is the home of the very popular Bob the Builder, Pingu and Rubberdubbers; Cosgrove Hall Films produce a large number of the UK's children's TV programs, including remakes of popular classics such as Rupert Bear, Bill and Ben, and their own creations like Fifi and the Flowertots and Roary the Racing Car, and Aardman who produce Shaun the Sheep, the spin-off from the popular Wallace and Gromit films, and Nickleodeon's Purple and Brown. Aardman were also among the first to develop an internet audience, with Darren Walsh's Angry Kid.

commercials

Commercials are the jam on top for many animation teams. This is what the studios hope will pay the overheads and the wages for what is usually a skeleton staff. If all goes well

they can salt away a little, and it may be used for projects that could expand the studio's repertoire.

With the kind of budgets sometimes available for commercial work, one would expect the benefits to be the high production qualities, innovative ideas and a chance to display one's talents. This is not always the case, however, as the costs of the production can sometimes spiral in the decision-making process – and the results may not be quite the showcase one was expecting.

Loose Moose are a London-based animation company, mainly involved in commercials. Their clients include KP McVities, Kraft Foods, Energizer Batteries and Pepsi Lipton. The commercials they are best known for are Peperami (seen in the UK) and Brisk Tea (for the USA; Figure 14.1). The team consists of two animation directors, Ken Lidster and Ange Palethorpe, two CGI animators, the producer Glenn Holberton, a production assistant and a marketing manager.

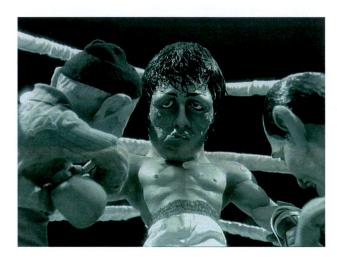

Figure 14.1 Still from Rocky. Courtesy of Loose Moose Productions. © Brisk Tea/JWT

In the first stage of the process, the client will choose an agency with a good track record. The agency will invite various animation companies to pitch for the job, sending round a script and a storyboard. Companies can invest a lot of time, effort and creativity just pitching for a commercial: developing characters and set designs, and filming sometimes quite complex animatics. Ange Palethorpe, describes the process:

When we pitch a job, we cost up all the character designs, and sets, crew and post-production. Once we've got the job, there's generally four to five weeks of going back and forth to the client, checking characters. Then the Plasticine sculpts have to be approved by the client.

The puppets are so expensive; all aspects have to be approved before being made into real puppets. Something like the Brisk Tea ads will take longer as

there are so many characters involved. We usually use Mackinnon & Saunders for puppets and Artem [a London company] for sets.

Based in the West End of London, a large studio space would be prohibitively expensive, so Loose Moose hire the space and the crew as each job comes up. Working in this way, they can rely on the professionalism of a team of experts, but as it's a hired space, they can't afford the luxury of testing time, unless there is a particularly generous budget. So the animators have to be prepared to go in and start 'cold'.

On a commercial, Loose Moose shoot on average about three seconds of animation a day and shoot for about 10–15 days. If there is a chance, they will set up two units for a sevenday shoot.

By contrast, **Aardman Animations** has most of its production on site. Even though they will hire in freelancers, they have a core of staff animators, a camera department, model-making department and administrators. One of Aardman's creative directors, Luis Cook, describes his approach and the relationship between animation company and agency:

As a creative director you need to know exactly what is going on around you, go to exhibitions, watch TV ads, look at hoardings, magazines. It may be art, it may be fashion, you might not like it – but you've got to be aware of it.

When a job comes in I try and make it look as different as I can. Partly because it makes life more interesting for me and hopefully you don't get too stuck in a style. The idea always comes from the script and listening to who your client is – tonally. Which way do they want to go with it? Is it going to be dark, is it going to be serious, is it going to funny, is it going to be brightly colored, is it going to be fast-cutting, or slow? Do you want to make it boring? Do you want to make it exciting? All these things come from the script. Do you want to make it minimal or overloaded with imagery? Sometimes it's really obvious, other times you have to work at it and coax people round.

You can only trust what the agency tell you; the client wants one thing, the agency another – it would be useful sometimes to go straight to the client, but you can't. You have to trust what the agency tells you. You have to remain calm if the agency goes wobbly. If they're coming at you with a terrible idea, say 'Hmm that's interesting. Let me have a think about it and get back to you' to give yourself space!

On a recent commercial this American guy from the agency said to me 'This is a million dollar campaign, get rid of the art!' Culturally, we were coming from different backgrounds; for him my ideas were too abstract. But he was right – it became a very successful campaign and they shifted a lot of product!

series

Series work is often defined by its quick turnaround, lower budget nature. The characters are often refined down to a simple stylized design; the animation is also simplified, for greater

speed and efficiency. It's very often these elements that make this form of animation enduringly popular with children, and the same elements that give the characters marketable appeal. This in turn can make the medium a hot property for the TV companies and licensees.

Dave Sproxton of Aardman comments on the studio's commitment to stop frame:

Given the right approach, stop frame can be made quite economically to great effect. I doubt whether Shaun the Sheep [BBC children's series] would have looked so good or been as entertaining had it been CGI. Aardman are continuing with the stop frame tradition both in features and TV, with several proposals in the pipeline. We also have CGI projects but we're not letting go of our roots.

Series work is also one of the best training grounds for animation. Some of this country's top animators, Steve Box, Loyd Price, Barry Purves, all developed their talent working for several years on programs like CMTB's *Trapdoor* or Cosgrove Hall's *Wind in the Willows* and *Chorlton and the Wheelies*.

Gareth Owen, a producer at Aardman who recently delivered the US *Creature Comforts* series for CBS, describes the process of series production:

When a new series comes in I first need to work out exactly what the company commissioning the series wants – what their company guidelines say. Then I have to decide on the best director for the job. Usually, the writing is a huge process that you need to go through, but with *Creature Comforts*, as it is all recorded live dialog and conversations, there was no script.

Next I need to get an art director and a model-making supervisor on board. We'll have a big pre-production meeting with the DOP, the director, the sparks and myself, and we'll just talk through the first puppets we're going to build. By then we'll have a character designer putting pictures in to overlay the audio. It's always easier to think of a character when you have the visual on screen. We'll try different voices to see how they fit. Once we're happy – then we can start the model builds. The model-making team will consist of a team leader, a handful of sculptors, mould makers and assistant animators who'll be doing the lip sync mouth sets (replacement mouths). The art department will have set and prop builders – the model makers and the set and props team work pretty closely together to ensure everything matches up in scale, things like the time of day are important for the angle of light or any practical lights needed on the set.

To find the rest of the crew we advertise on our website for showreels. For *Creature Comforts*, we had about 200 animation showreels in – some were from students and some from experienced animators. We looked at each one. In some cases, with a beginner, there may be just one shot where you can see they have got the timing and the character. One guy who came onto *Creature Comforts* had only animated one shot, in his bedroom – and it was perfect! He just had that spark and he has carried on through the series, he's an absolute natural. It's not necessarily based on experience – it's based on talent.

We did two-week trials for people who hadn't worked for us before. We give them a line of dialog and a character and throw them in at the deep end. Once they've had a go at

it, a director will go in and help them: act it out for them, give them some advice, find out if there's anything troubling them – really as much guidance as we can give. Then they animate to the same line again, and if there's a marked improvement in their work and we can see they are getting it, then we continue their training, but if it didn't work out, then that's it, I'm afraid.

We needed 30 animators on *Creature Comforts*, but over half of those were our regular Aardman animators and there were another 10 or so who had been trained for the earlier UK series of *Creature Comforts*, some of whom came straight from college – they went through the same process, only they had six weeks of training, where we started with the simple squash and stretch exercises, and took them through the whole range right up to full lip sync and action. They are all now regular animators for Aardman or working on features in the States. That level of training is pretty vital. People who come from a college course haven't had that intense training, they don't get the time on a course for that.

We generally allow two weeks for a model to be made from start to finish – most of the time is spent on making the armature; the actual skinning of the puppet is pretty quick. The sets and props are mainly made in-house, occasionally outsourced if there's anything too complicated that would keep our staff tied up. When the set is ready the base is put on legs in the studio; the rigger will bring the puppet in and place it on the set.

When a puppet comes out of model making we don't see it as a finished character. It takes the animator to put a certain sense of character into a model; they put their own stamp on it. We then take a few days to get everything in place – everything lit, glued down – it all needs to be rock solid in there and hopefully we'll have time to do an overnight test to see if anything shifts or changes through the night.

On a series we run an eight-hour day, with an hour for lunch. The shot will be approved as soon as it's finished. The animator will find the floor manager or production manager, who'll go in and look at the shot, maybe decide if it needs another half second to finish a move, or any other changes. Once the shot's approved we'll put in the DOP and the camera assistant to check the shot technically, make sure there are no flashes, light changes or set shifts, and if there is a rig, they need to do rig removal plates (clear shots of the set, which they will also have done at the start of the shot). Then they will re-board for the next shot.

In between shots, while the DOP and sparks are setting up the next shot, the director, the animator and the camera assistant will go into the LAV unit (Live Action Video) – it's just a rehearsal space. We'll play out the audio and people will get roughly into the position the characters should be in and act out the shot. It really helps the director to direct the animators and be able to clearly say 'I want it like this, or that.' And also to look back at the video and say 'I really like that gesture you did there.' It allows you to put human characteristics into your puppet. When you're saying a line you naturally make body movements that you're unaware of, that you don't register you're doing – all those subliminal things that you would want to put into your animation to bring your characters alive. Nick Park is always good at recognizing those human traits. The other thing it does is give you time to come up with any gags or background interaction between two characters – you might need to give a bit more time in the shot to allow a bit of background action. It's great fun.

Every Friday we have rushes with the whole crew; we'll stop half an hour early, have a beer and watch what we've done that week.

Sound is hugely important and we put a lot of time and effort into making a good sound base.

For Creature Comforts we clean the interviews up as much as possible and make up a track that's relevant to where they are now. We generally spend three days on track laying. We'll send the sound editor a rough cut and notes on exactly what we want. We use a Foley artist quite a lot, and we make our own sounds. All the way through the program we'll have been refining the edit.

We'll be thinking early on about what the music will be like. We'll commission someone who has the right experience. All you can do is show a musician the edit and see what they think – you can't brief them any more than that.

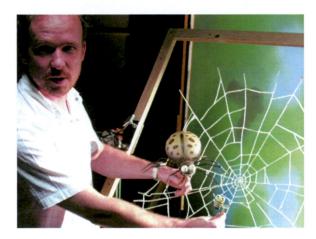

Figure 14.2 Gareth Owen on the set of Creature Comforts. © Aardman Creature Comforts USA Ltd

Finally, we'll go to a post-production house and the DOP will go through it, bringing up the colors in the grade. We'll finish the sound mix and deliver the program to the company with all the paperwork that goes with it. Most tapes sent to broadcasters come back a few days later rejected because of breaking some kind of audio or visual guideline. Pretty much every show we've all worked on a tape will come back with a dead pixel or an audio waveform peaking – one dead pixel broaches the transmission guidelines! It's very simple and quick to correct and deliver back.

TV specials and features

Probably the most challenging task for any animation team is a feature film. A half-hour TV special is a wonderful experience for animators in terms of handling continuity and character development, but making a feature film tests the cohesion of a team in many ways.

A feature film requires a huge crew and soaks up anyone with animation skills for a long period. In recent years there were two films made in the UK at the same time, Corpse Bride and Wallace and Gromit and the Were-Rabbit, with animators from around the world converging in England. More recently, films like Max & Co produced in Switzerland and Coraline in the USA have been the big employers. Lionel I. Orozco, whose US special effects company Stop Motion Works provides services for many stop motion and CGI films, comments:

The growth of online free video hosting sites such as YouTube has increased public awareness. Stop motion is used more frequently in commercials now, for television, the internet and children's TV programming. But I'm not sure that stop motion will gain a foothold in mainstream motion picture work. Searching for a crew for a stop motion feature is more time-consuming than CGI as there is a limited talent pool of artisans and craftspeople in that field. Also, with the expectation of faster production times it's unlikely to be a popular choice for major studios.

Often, a graduate's first experience on a feature is being on a production line making one small part of a puppet, or cleaning up the same puppets over and over again ready for the next scene. This can be dispiriting, especially if you never get to see the rest of the studio. It takes all the company's resources to sustain in the crew a sense of following through a big adventure, and belief in the ultimate goal.

Working on Chicken Run was a much more fast and efficient way of animation. Before I was into refining movement and detail. Chicken Run was about making it work. The puppets were not really designed for refined animation, and yet that was what we were asking of them. A lot of the work was struggling with the puppets. Because clay is not really conducive to refined animation, but they asked an incredible preciseness, they pushed us far beyond anything I've ever done – it was the hardest thing I've ever done I think. As far as subtlety of emotion and subtlety of expression, Nick pushed us far beyond anything I've done before, maybe beyond anything that's ever been done with claymation.

Guionne Leroy

Nick Park of Aardman Animations comments:

Working with a small team is quite easy. I still stayed very much in touch with the Plasticine myself on Wrong Trousers. We [Nick and Steve Box] did roughly half the animation each, but even on Wrong Trousers, I didn't want to let go of Wallace and Gromit, so Steve did all of the penguin. By Close Shave I did let go of it. Doing the animation of Wallace was the main risk: he might get a different shaped face – because we were manipulating his mouth in such a big, radical way it would be easy for the individual animator to put his own stamp on it and take it off in another direction. On A Close Shave we developed pre-made replacement mouths for Wallace. We used it on Chicken Run, where each character had their own set of mouths. It helped keep it all consistent in style.

But each film I had to step back more. I say stepping back – it's not really stepping back; I did do a few scenes of my own in Close Shave – so I did feel I kept

some hand on it – but on Chicken Run I couldn't animate. I never felt I'd lost control. There is a part of it I regret, because I do like doing the animation, I love doing it, but at the same time, to make a film of that size you can't afford to do that, because you have to spend your time going round telling everybody what to do. It is easier to do it yourself than to tell everybody else what to do!

As great as our animators were on Chicken Run, I think by the mere fact that a lot of people are working on it, the style can get homogenized, because everyone's trying to aim at a common thing. It's much harder to keep the edge on the style.

Moving up one notch from being an animator to directing a team of animators can be a difficult transition. Barry Purves reflects on directing *Hamilton Mattress*, a BBC Christmas Special made by Harvest Films:

On Hamilton Mattress I was directing four to five animators. The difficult thing is keeping an overall style and they were four very different animators. You have to allow them their creativity, so that when one makes Hamilton do something extraordinary, you have to let the other animators take elements of that. In trying to get a walk similar, an animator can be so focused on that scene, he may forget how it fits in to the rest of the story. So I try to keep them all on track. When I'm the director and animator, if I see a gesture going wrong, I can work my way out of it. Or if there's a cut point coming up, and I realize I'm just not going to be able to do it in time, then I can find something else to make it work. But directing animators, you are one step removed. It was hard trying to pull it all together, but the rewards are amazing, especially when some of them do something you just wouldn't have thought of.

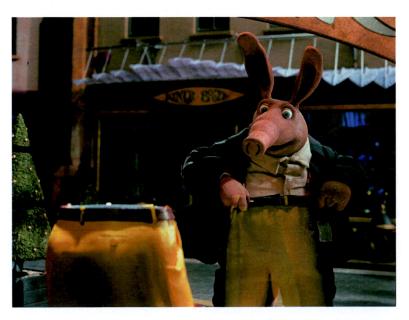

Figure 14.3 Courtesy of Harvest Films. © Hamilton Mattress 2002

applying for jobs

When I got to college [Middlesex Poly] there suddenly was the facility, all I needed, 16 mm gear just hanging around, Steenbecks, dubbing. So I started making films. I was making 3D as soon as I could, using Plasticine. I rang up Film Fair [a London company] and managed to get in there while I was still at college. They were doing Paddington Bear and I got involved making props. The college course was so unstructured that I was able to do two days a week at Film Fair. I then took all the bits I'd done there back to college and ended up with a very good showreel, with finished films rather than tests. In 1985, I finished college and went back to work at Film Fair and within a few months I was co-directing a series.

Jeff Newitt

He makes it sound so easy. These were different times – and Jeff, let's face it, is an exceptional talent.

Getting work with an animation company is more often than not a question of being in the right place at the right time. To improve your chances it's important to know exactly what sort of work companies are doing; there's no point showing them your work only to turn them down when they offer you a chance on a children's series and you would rather work on computer games. Read industry magazines like Campaign, Televisual, Creative Review, Cinefex. Get a copy of the Imagine Animation directory: it's a UK directory with almost every animation company listed in it, as well as TV companies, distributors, festival information. The Animation World Network is another invaluable forum – trawling the internet, looking to see who's hiring and what's in production. It's hard to know what's coming up in advance unless you are part of the inner circle, and that can be very frustrating for the beginner, but going to festivals and events where you may meet other animators is the best way of networking.

Degree shows are important – the better college courses mail out to invite production companies to degree shows, and the companies come if they can. Make sure your college does this.

your showreel

The obvious first step is to send your showreel and CV to a company. If you want to send your work in to try and get a job, it's important to follow a few basic rules, otherwise no one will see your work.

- Label it. This sounds obvious, but we've all seen reels that once had a cardboard case
 and now are a blank CD or DVD. Label the disc itself as well as the case with the title,
 your name, contact number and email address.
- Put your best work at the front. When a company is pushed for time they will expect to see your best work in the first few seconds. This could either be a quick compilation or a 30-second short clip from your best film. There is no point in sending a long tape with examples of all of your work unless your tutor or mentor advises it. But if your piece of work is very long, and the best bit's in the middle, edit! Give the viewer a 30-second trailer. Because if they haven't seen what they want in that time, they'll probably eject it.

- Clearly identify the pieces **you** have worked on and in what capacity. It's no good sending in a clip from something like *Chicken Run* on an animation showreel, when the truth is you were refurbishing parts in the model-making department. Be honest and clear.
- Update your showreel when you have some important new work to show, but don't bombard companies every few weeks with a new CV or showreel.
- If you are sending work to the USA from the UK, remember it must be an NTSC conversion, that's their standard and for tapes coming to the UK from the USA, a PAL conversion is needed.
- If they want you, they'll call you. For the big companies, like Aardman or Cosgrove Hall in the UK or Laikain the USA, you should be prepared to wait for some time for a response. Usually, they will view the work, then if it arouses interest, it'll go further and perhaps be viewed by a director. But the bigger companies get many showreels in every week and can't always get to look at them immediately, especially after graduation time. if you've not heard anything, you could ring after about four weeks and ask for constructive comments. You may have to wait for between two and three months for a response.
- Remember when talking to the receptionist, they have the power to stop you right there that is the first person you must be polite to.
- When you are making up business cards put an image from your film on it. This helps people see immediately what you do and fixes your work in their mind.
- Be reasonable about how you classify yourself 'Joe Bloggs, Animator' sounds better than 'Joe Bloggs, Animator, Designer, Director, Illustrator'. The latter sounds like you don't have particular skills or ambition and will take any old job; this might be true, but it doesn't instill confidence!

starting out as a runner

Being a runner is a good way of getting into a company. A runner is someone who helps a producer or production manager by literally running around, getting last-minute materials, taking messages, making teas and coffees, all sorts of menial but vital tasks. You have to be lucky, but if, once you are in, you show the right qualities – keen, quiet, good humored, enthusiastic but not manic, interested but not nosy, react quickly and ask good questions – you may get asked back. A good runner will invariably get more work, and if you can't get into a company on the strength of your showreel, there are many other entry-level jobs, such as working in model making, that start you very well on your career.

festivals

Try to keep your work seen – festivals are a growing business; there are more and more small festivals looking for different things. If you can attend festivals, they are often very good places for getting to meet people. The big festivals, like Annecy or Ottawa, are the places most animation companies try to get to; look up on the festival website to see if there are any pitching opportunities or chances to meet up with company recruitment officers. See appendix 3 for a calendar of festivals.

The British Council (www.britifilms.com/festivals) lists all the festivals and what the festivals are looking to screen, when their deadlines are. The British Council can also help with travelling expenses if your work is being screened abroad.

Be sure you know what formats are required for viewing, i.e. don't send a DVD if they request VHS viewing copies.

sending proposals to commissioning editors

The job of a commissioning editor is to find the right programs for a TV company. They have to find an idea that they believe in enough to be able to convince their own company, as well as others. So this is what they need to know about your project:

What is it about? Send them two lines that encapsulate the whole idea with a one-page synopsis of the proposal. That is what most commissioning editors want to see at first. They don't want pages and pages of script, or descriptions of merchandising opportunities. The idea is everything – the rest comes later.

2. What will it look like? Send some designs for your characters and some key visuals that display the style of the film. Don't send in original work, as this makes the recipient very nervous! No one wants to be responsible for losing your work. So send in copies.

3. What sort of audience will it attract? Are you aiming this at children or adults? TV companies have very specific age group targets – look at channels to see how the programming changes throughout the day. Is your idea going to appeal to pre-school (1- to 4-year-olds); 5- to 7-year-olds; 8–10, 11, 12? Children change very quickly through these ages. If it is an adult idea, how much animation do you see that is purely for adults? They do have to consider their market, and a really strange and obscure idea may not help them attract viewers.

4. What slots on TV will it fit into? Commissioning editors would all expect anyone approaching them with an idea to know what sort of format they are looking for – to

have an understanding of which slots they can program animation into.

5. **What's the duration?** Give them a story that fits their slots. Some will have slots for five or 10-minute animations. More common is the 26-minute series; in fact, 13 × 26 is a favorite – so can you see your idea developing into 13 episodes?

6. Is there anything similar already on TV or in production? The commissioning editor needs to be aware that this idea is not going to be too like anything else that's coming on air. It sometimes happens that an idea becomes popular, several people seem to come up with the same idea. Don't get paranoid, it doesn't necessarily mean that your work is being ripped off, it just means that you have your finger on the pulse and have created something of the moment – it happens.

Make your presentation look good. Handwriting can be charming but honestly it is better to have your stuff typewritten with a good layout – and no spelling mistakes.

You have to do everything to accommodate people who look at several scripts per day and, however dedicated they are to getting animation on TV, don't have all the time in the world to talk on the phone and to dwell over long scripts. If they are interested from your initial approach, they will invite you for a meeting, and if still interested they would probably draw up some sort of formal development agreement. You should get some legal advice of your own at this stage. The next stage would be for them to commission you to write the script. After that they would start to move on to looking at a production and budgeting – then you may be on your way ...

Even if a commissioner wants your idea they may not be able to fully finance it. The majority of TV channels are not able to fully finance any project and will take a project to other companies for co-financing. They may take it to somewhere like the Cartoon Forum – this is a marketplace for work, set up by Cartoon, the European Association for Animated Film, an organization based in Belgium. It takes place in a different location in Europe each year and is attended by over 250 potential investors, all interested in animation. So it can be a very slow process from script to screen.

Commissioning an idea doesn't necessarily mean they want you to write it. An animator who can write their own material as well as direct and animate is a rare being. It is likely that the producer would bring in a writing team or a script editor to work on your idea.

Be aware that what starts out as a personal project may end up being a very different, very public experience due to the nature of production and the sheer amount of people that become involved. It's like letting your baby grow up – don't be too precious, let it go into the wide world.

Lastly, there is a growing volume of work being done on computer. For all the horror stories I've heard about model animators being dragged kicking and screaming into the world of CGI, there are plenty of other success stories. Many successful model animators have made the transition to work in CGI and can move between the disciplines comfortably. Keep up your computer skills in quiet periods between jobs, train up on new software, always keep on your toes and be aware of what's going on around you. But remember that animation skills are what is important – not software skills. Software will change; animation timing and performance are fundamental to all animation.

The last word goes to Jeff Newitt, who has given me some great quotes to use in this book:

It's always a dress rehearsal – the public think you can hone it and hone it, but you can't – you only get one go. With a play like Hamlet, you know the story, you have the sets and the costumes – and you rehearse it. With animation its just 'You're on! There's the audience and there's the camera. Go!'

Good luck.

bibliography

essential reading reference

The Animator's Survival Kit by Richard Williams, Faber and Faber Ltd, 2001
The Human Figure in Motion by Eadweard Muybridge, Dover Publications, 1989
Animals in Motion by Eadweard Muybridge, Dover Publications, 1957
Timing for Animation by Harold Whitaker and John Halas, Focal Press, 1981
The Illusion of Life by Frank Thomas and Ollie Johnson, Hyperion, 1997
Cracking Animation by Peter Lord and Brian Sibley, Thames & Hudson Ltd, London, 1998
The Art of Stop Motion Animation by Ken Priebe, Thomson Course Technology 2007

definitely worth a look

How to Draw Cartoon Animation, by Preston Blair. Walter Foster Publishing, 1980 Tim Burton's Nightmare Before Christmas: The Film, the Art, the Vision, by Frank Thompson, Disney Press, 2002

Time-Lapse and Stop-Motion Animation using the Bolex H16, by Andrew Alden, www.bolex.co.uk

Film Fantasy Scrapbook, by Ray Harryhausen, Titan Books, 1989

some old yet valuable information

Basic TV Staging, by Gerald Millerson, Focal Press, 1974 Motion Picture Camera Techniques, by David W. Samuelson, Focal Press, 1978

articles

Sight and Sound, no. 11, March 1992, pp. 24–7 The Same Dark Drift by Jonathan Romney On the Brothers Quay

American Cinematographer, vol. 81, no.8, Aug 2000, pp. 56, 62–65 Flying the Coop by John Gainsborough On the making of 'Chicken Run'

Cinefex, no. 82, July 2000, pp. 119–31 Poultry in Motion by Kevin H. Martin On the making of 'Chicken Run'

Cinfefex, no. 56, Nov 1993, pp. 30–53 Animation in the Third Dimension by Mark Cotta Vaz On the making of Tim Burton's 'Nightmare before Christmas' [15:59 26/6/03 n:/4074 SHAW (BH).751/0240516591 Stop Motion/application/4074-Bibliography.3d] Ref: 4074 Auth: Shaw Title: Stop Motion Bibliography Page:

Creative Screenwriting, vol. 6, no. 6, Nov/Dec 1999, pp. 66–68 Writing for the Simpsons

Animation World Magazine, March 2000 Performance and Acting for Animators by Judy Lieff

The Bride Stripped Bare by Robin Rowe. The Editors Guild magazine. Vol. 26, No.4 – July/ August 2005

[15:59 26/6/03 n:/4074 SHAW (BH).751/0240516591 Stop Motion/application/4074-Bibliography.3d] Ref: 4074 Auth: Shaw Title: Stop Motion Bibliography Page:

170 stop motion

appendix 1

software and recording equipment suppliers

frame capture computer software

Mac software

BTV Pro

www.bensoftware.com

Framethief

www.framethief.com

iStop Motion

Boinx Software www.istopmotion.com

Icananimate

www.kudlian.net/products/icananimate

PC software

Stop Motion Pro

admin@stopmotionpro.com

DPS Reality

software/hardware computer film services Romans Business Park, Unit 9 East Street Farnham Surrey GU9 7SX UK t: 00 44(0)1252 718300

e: sales.europe@dps.com

www.dps.com

LunchBox Sync™

Howard Mozeico Animation Toolworks, Inc. t: 01 503-625-6438 f: 01 503-925-0221

e: howardm@animationtoolworks.com www.animationtoolworks.com

sound

Magpie Pro

www.thirdwishsoftware.com/magpie

www.shure.com

microphones and general sound advice

cameras and lenses

Bolex International SA

15 Route de Lausanne CH-1400 Yverdon-les-Bains Switzerland t: 00 41 24 425 60 21 f: 00 41 24 425 68 71 e: sales@bolex.ch www.bolex.ch

sony.com/sony.co.uk canon.co.uk Europe-nikon.com

camera and film equipment hire

Panavision UK

The Metropolitan Centre Bristol Road

Greenford Middlesex UB6 8GD UK

t: + 44-208-839-7333

f: + 44-208-839-7310

http://www.panavision.co.uk/

Lee Filters

Central Way Walworth Industrial Estate Andover Hampshire SP10 5AN UK

t: + 44-1264-366245

f: + 44-1264-355058

www.leefilters.com

lighting

Arri Lighting Rental Ltd

20a Airlinks
Spitfire Way
Heston
Hounslow
Middlesex TW5 9NR
UK
www.arri.com

DHA Lighting Ltd

284–302 Waterloo Road London SE1 8RQ UK

t: 020 7771 2900 f: 020 7771 2901 ISDN: 020 7401 9202

e: sales@dhalighting.co.uk

Stage Electrics Lighting Hire

Customer Service Team Third Way Avonmouth Bristol BS11 9YL UK

t: 0117 938 4000 f: 0117 916 2828

e: hire@stage-electrics.co.uk e: sales@stage-electrics.co.uk

appendix 2

manufacturers and outlets

modelling clays

Art Studio Clay Co.

t: 00 1 800 323 0212 stockists of Ultracal

New Clay Products Ltd

1 Battle Road
Heathfield Industrial Estate
Newton Abbott
TQ12 6RY
UK
t: 01626 835700
suppliers of modelling clays, including
Newplast & Harbutt's Plasticine

Van Aken Plastilina

Van Aken International 9157 Rochester Court Rancho Cucamonga CA 91729 USA t: 909 850616 f: 909 980 2333

wire

Wires.co.uk 18 Rayen Road

South Woodford London E18 1HW UK t: 020 8505 0002 f: 020 8559 1114 e: dan@wires.co.uk www.wires.co.uk

Woolton Wire

4 Longworth Way
Liverpool L25 6JJ
UK
t: 0151 428 5097
f: 0151 421 0907
specialist suppliers of aluminium armature
wire for sculpture and model making
for small amounts of aluminium wire, try
Bonsai tree nurseries
Suppliers of wire in the USA:
www.mcmaster.com

sculpting tools etc.

Alec Tiranti Ltd

High Street Theale Reading RG7 5AR UK www.tiranti.co.uk

Bath Potters Supplies

Unit 18 Fourth Avenue Westfield Trading Estate Radstock Bath BA3 4XE UK t: 01761 411077

Burman Industries

14141 Covello Street, Suite 10c Van Nuys CA 91405 USA t: 00 1 818 782 9833 f: 00 1 818 782 2863

instruction tapes on mould making, sculpting and painting

Hewlett Hind

Shrewton House Shrewton Salisbury SP3 4HJ UK t: 01980 620233

moulding materials

Alchemie

Warwick Road Kineton Warwick CV35 0HU UK t: 01926 641600 suppliers of silicones and resin

Bentley Chemicals

Rowland Way Hoo Farm Industrial Estate Kidderminster Worcestershire DY11 7RA UK t: 01562 515121 suppliers of silicones, resins and various modelling materials

Jacobson's Chemicals

Unit 4 Newman Lane Industrial Estate Alton Hampshire GU34 2QR UK t: 01420 86934 supply specialist silicones for moulding and casting, Alginate, latex, Plastiline, Sculpey, resin and most modelling materials

MCMC (formally Matrix Mouldings)

Unit E **Paintworks** 277 Bath Road Bristol BS4 3EH UK

t: 0117 9715145 (freephone number: 0800 0744788) supply a variety of resin, silicone and fiberalass materials

Mouldlife

Tollgate Workshop Bury Road Kentford Suffolk CB8 7PY UK t: 01638 750679 suppliers of silicones and moulding materials

Sherman Laboratories

17 Tomswood Road Chigwell Essex 1G7 5QP UK t: 0208 5591942 supplies good foam latex kits

South Western Industrial Plasters

63 Netherstreet Bromham Chippenham SN15 2DP t: 01380 850616

suppliers of plasters, silicones, latex, resin and wet clay. Also supply modelling tools and equipment

Thomas & Vines Ltd

Units 5 and 6 Sutherland Court Moor Park Industrial Centre Tolpits Lane Watford Herts WD1 8SP UK t: 01923 775111 www.flocking.co.uk

Burman Industries

14141 Covello Street, Suite 10c Van Nuvs CA 91405

USA

t: 00 1 818 782 9833 f: 00 1 818 782 2863

The Monster Makers

7305 Detroit Ave
Cleveland
OH 44102
USA
t: 216-651-SPFX (7739)
f: 216-631-4FAX (4329)
e: sales@monstermakers.com
http://www.monstermakers.com
sole suppliers of McLaughlin Foam Latex

GM Foam, Inc

14956 Delano St Van Nuys CA 91411 USA t: 00 1 818 908 1087 f: 00 1 818 908 1262 www.Gmfoam.com

inks and paints

Paint Specialities Lab

www.graphiclynx.com/pslab

Sun Chemical Gibbon Inks and Coatings

25 Deer Park Road Wimbledon London SW19 3UE UK

t: 020 8540 8531 f: 020 8542 5256

designers and model makers

Mackinnon & Saunders Ltd

148 Seamons Road Altrincham Cheshire UK t: 0161 929 4441 f: 0161 929 1441

e: info@mackinnonandsaunders.com www.mackinnonandsaunders.com

ScaryCat Studio

Gary Jackson and Cat Russ Unit 6.1 The Paintworks 275 Bath Road Bristol BS4 3EH UK t: 0117 9721155 e: mail@scarycatstudio.com

www.scarycatstudio.com

Germany

Jürgen Kling Animation und Puppenbau

Muhlenstrasse 8a D 63571 Geinhausen Germany t: + 49 (0)6051 609296 e: jkling@weirdoughmation.de www.juergenkling.de

model-making supplies

EMA Model Supplies

Unit 2 Shepperton Business Park Govett Avenue Shepperton TW17 8BA UK

t: 01932 228 228 f: 01932 253766 e: emashep@aol.com

armatures/ball-andsocket joints

UK

Gryphyn

716 Halifax Rd Eastwood Todmorden Lancashire OL14 6DP UK t: 01706 818863

e: edawe@easynet.co.uk

John Wright Modelmaking

Studio 1 Centrespace 6 Leonard's Lane Bristol BS1 1EA UK

t: 0117 9272854

e: mail@jwmm.co.uk www.jwmm.co.uk

models props, armatures, set building

USA

Sherline Products, Inc

San Marcos
California
USA
t: 00 1 800 541 0735
manufactures miniature lathes and mill column attachments

Stop Motion Works

e: smw@stopmotionworks.com www.stopmotionworks.com

Armaverse Ltd

906 E. Walnut St. Lebanon IN 46052 USA

t: 1-866-836-1010

e: info@armaverse.com www.armaverse.com

magnets

Magnet Applications

North Bridge Road Berkhampstead Hertfordshire HP4 1EH UK

t: 01442 875081

e: tracie_heffernan@magnetuk.com

Magnet Sales and Service Ltd

Unit 31 Blackworth Industrial Estate Highworth SN6 7NA UK

t: 01793 862100 f: 01793 862101

e: sales@magnetsales.co.uk

rigging

Climpex

S Murray & Co Holborn House Old Woking Surrey GU22 9LB UK

t: 01483 740099

f: 01483 755111

e: sales@smurray.co.uk

Berkey System

16945 Cottage Grove Avenue Wayzata MN 55391 USA

t: 952 476 6413 f: 952 476 0821

e: bberkey@berkeysystem.com

health and safety

Nederman Ltd

PO Box 503
91 Walton Summit
Bamber Bridge
Preston
Lancashire PR5 8AF
UK
www.nederman.co.uk
supply health and safety equipment

appendix 3

calendar of animation festivals and film festivals incorporating animation

Sources:

British Council: www.britfilms.com

Animation World Network: http://events.awn.com/

ASIFA, International Animated Film Association: www.asifa.net Please note: dates of festivals and film entry deadlines may change

january

Taiwan/Taipei

Golden Lion International Student Film Festival

Deadline: November

Awards: Golden Lion award (US \$5000), Silver Lion award (US \$3000), Bronze Lion

award (US \$2000), Special Jury award (US \$5000), Audience award

Contact: Golden Lion International Student Film Festival, Motion Picture Dept., NTUA, 59,

Da Kuan Rd., Sec. 1, Pan Chiao, Taipei County 220, Taiwan

t: (886 2) 2272 2181 ext. 358

f: (886 2) 2968 7563 e: d22@mail.ntua.edu.tw www.ntua.edu.tw/~alion

february

Spain/Lleida

ANIMAC - International Animation Film Festival

Deadline: November **Awards:** Non-competitive

Contact: International Animation Film Festival (ANIMAC), C/Major, 31, 25007 Lleida.

Spain

t: (34 973) 700 325 f: (34 973) 700 325 e: animac@animac.info

UK/Middlesborough

Animex Student Animation Awards

Deadline: October

Contact: University of Teeside, Middlesborough, Tees Valley, TS1 3BA, UK

t: 01642 342631 f: 01642 342691

e: chris@animex.net (Chris Williams, festival director)

www.animex.net

UK/Exeter

Animated Exeter

Deadline: November

Contact: Liz Harkman, Arts Events & Festivals Officer, Exeter City Council, Civic Centre,

Paris Street, Exeter EX1 1JJ, UK

t: 01392 265208 f: 01392 265366

e: elizabeth.harkman@exeter.gov.uk animatedexeter@exeter.gov.uk www.animatedexeter.co.uk

february/march

Belgium

Anima – Brussels Cartoon and Animation Film Festival

Deadline: October

Contact: Folioscope/Anima, Avenue de Stalingrad, 52, B-1000 Brussels, Belgium

t: (32 2) 534 4125 f: (32 2) 534 2279 e: info@folioscope.be

www.awn.com/folioscope/festival

USA/Miami

Miami International Film Festival

Deadline: November

Awards: Best Feature, Best Documentary, Best Short Film and Audience Award

Contact: Miami International Film Festival, c/o Miami Dade College, 25 NE 2nd Street,

Room 5501, Miami, FL 33132, USA

t: (1 305) 237 3456 f: (1 305) 348 7055

e: info@miamifilmfestival.com www.miamifilmfestival.com

march

Finland/Tampere

Tampere International Short Film Festival

Deadline: December

Awards: International jury to award Grand Prix, a 'Kiss' trophy, for best film in the competition; three prizes for the best film in each category; one special prize; diplomas of merit and cash prizes awarded by the festival organizers

Contact: Tampere Film Festival, PO Box 305, 33101 Tampere, Finland

t: (358 3) 213 0034 (film department)

f: (358 3) 223 0121

e: filmdept@tamperefilmfestival.fi www.tamperefilmfestival.fi

Turkey/Ankara

Ankara International Film Festival

Deadline: January

Awards: Various awards, contact festival for more information

Contact: Ankara International Film Festival, Farabi sok. No. 29, 1 Cankaya, Ankara,

Turkey

t: (90 312) 468 7745 f: (90 312) 467 7830

e: festival@filmfestankara.org.tr www.filmfestankara.org.tr

UK/Belfast

Belfast Film Festival

Deadline: August

Awards: First prize – £5000; Second prize – £3000; Third prize – £2000 **Contact:** Belfast Film Festival, Unit 18, North Street Arcade, Belfast BT1 1PB, UK

t: (44 28) 9032 5913 f: (44 28) 9032 5911 e: info@belfastfilmfestival.org www.belfastfilmfestival.org

april

Italy/Positano

Cartoons on the Bay - International Festival and Conference on Television

Animation

Deadline: Janua

Deadline: January **Awards:** Various

Contact: Cartoons on the Bay, International Festival and Conference on Television

Animation, via U. Novaro, 18, 00195 Rome, Italy

t: (39 06) 37 498 315/423 f: (39 06) 37 515 631 e: cartoonsbay@raitrade.it www.cartoonsbay.com

Norway/Oslo

Oslo Animation Film Festival

Deadline: January

Awards: Best film, Best debut, Best use of animation in commercial, Jury Special prize,

Audience prize

Contact: Oslo Animation Film Festival, PB 867 Sentrum, 0104 Oslo, Norway

t: (47 23) 6930 0934

Germany/Dresden

Filmfest Dresden - International Festival for Animation and Short Films

Deadline: January

Awards: International Competition with awards totalling €22 000; National Competition

with awards totalling €15000

Contact: Filmfest Dresden, Alaunstr. 62, 01099 Dresden, Germany

t: (49 351) 82947-0 f: (49 351) 82947-19 e: info@filmfest-dresden.de

USA/Philadelphia

Philadelphia Film Festival

Deadline: January

Awards: Jury and audience awards, festival awards in several categories, including artistic achievement to directors and actors

Contact: Philadelphia Film Festival, c/o Philadelphia Film Society, 234 Market St, Fifth

Floor, Philadelphia, PA 19147, USA t: (1 215) 733 0608, ext. 237

f: (1 215) 733 0637 e: rmurray@tlavideo.com www.phillyfests.com

USA/San Diego

San Diego International Film Festival

Deadline: February

Awards: Competitive for various categories

Contact: San Diego Film Festival, 7974 Mission Bonita Drive, San Diego, CA 92120, USA

t: 619-582-2368 f: 619-286-8324 e: info@sdff.org www.sdiff.com

april/may

USA/San Francisco

San Francisco International Film Festival

Deadline: November

Categories: Narrative features, documentaries, shorts, animation

Awards: Golden Gate Awards for documentaries and shorts, cash prizes for various

categories

Contact: San Francisco Film Society, 39 Mesa Street, Suite 110, The Presidio, San

Francisco, CA 94129, USA

t: (1 415) 561 5011/561 5014

f: (1 415) 561 5099

e: gga@sffs.org www.sffs.org

may

Czech Republic/Zlin

International Film Festival for Children and Youth

Deadline: March

Awards: Various, including a 'Golden Slipper' for best film

Contact: Filmfest, s.r.o., Filmova 174, 761 79 Zlin, Czech Republic

t: (420 577) 592 275 f: (420 577) 592 442 e: festival@zlinfest.cz www.in-zlin.cz

www.in-ziin.cz

Germany/Stuttgart

Stuttgart International Animated Film Festival – Trickfilm Festival

(biennial; even years) **Deadline:** December

Awards: Prizes to the value of €54500. State Capital of Stuttgart prize (€7500), State of Baden-Wuertemberg prize (€7500), international prize for best film (€15000), Television audience prize (€12000). Further prizes

Contact: Stuttgart International Festival of Animated Film, Breitscheidstrasse 4, D-70174 Stuttgart, Germany

t: 49 711 92 54 61 15

f: 49 711 92 54 61 50

e: bauer@festival-gmbh.de (Andrea Bauer)

www.itfs.de

may/june

France/Annecy

Festival International du Film d'Animation

(plus film market) **Deadline:** January

Awards: Grand Prize for best animated film, two special distinction prizes and a special distinction prize for best computer-animated film. Also prizes for fiction films (shorts and feature films), for commissioned and television films, and for internet animation

Contact: Festival International du Film d'Animation, 6 Ave des Iles, BP 399, 74013

Annecy Cedex, France t: (33 4) 5010 0900 f: (33 4) 5010 0970 e: info@annecy.org www.annecy.org

june

Australia/Melbourne

Melbourne International Animation Festival

Deadline: January

Contact: The Melbourne Animation Festival, PO Box 1024, Collingwood, Melbourne,

Victoria 3066, Australia t: (61 3) 9375 1490 f: (61 3) 9376 9995 e: info@miaf.net

USA/New York

Brooklyn International Film Festival

Deadline: March

Awards: Grand Chameleon award for the best film of the year, Chameleon Statuette

award to the best film in each category

Contact: Brooklyn International Film Festival, 180 South 4th Street, Suite 2 South,

Brooklyn, NY 11211, USA t: (1 718) 388 4306/486 8181

f: (1718) 599 5039

e: 2008wbff.org (general enquiries) www.brooklynfilmfestival.org

Russia/St Petersburg

Message To Man – St Petersburg International Film Festival

Deadline: April

Awards: Grand Prix: Golden Centaur plus US \$5000. Four other cash awards of US \$2000 each for best feature documentary, best short documentary, best short, best animation. Also cash awards for best debut films

Contact: Message to Man Film Festival, 12 Karavannaya Street, 191011 St Petersburg, Russia

t: (7 812) 972 1264/7 812 570 6151

f: 7 812 570 6116

e: info@message-to-man.spb.ru www.message-to-man.spb.ru

Croatia/Zagreb

Zagreb World Festival of Animated Films

(biennial; even years) **Deadline:** February

Awards: Money award for the Grand Prize and for the first film. Awards for three best

student films

Contact: World Festival of Animated Films, Animafest, Kneza Mislava 18, 10000 Zagreb,

Croatia

t: (385 1) 450 1190 f: (385 1) 450 1193 e: info@animafest.hr www.animafest.hr

july

Brazil/Rio de Janeiro

Anima Mundi – International Animation Festival of Brazil

Deadline: March

Awards: Audience award (trophy and cash) and professional jury award (trophy and cash)

Contact: Anima Mundi, c/o Iman Imagens Animadas Ltda, Rua Elvira Machado 7, casa

5, 22280-060 RJ Botafogo, Rio de Janeiro, Brazil

t: (55 21) 2543 7499 f: (55 21) 2543 8860 e: info@animamundi.com.br www.animamundi.com.br

Ireland/Galway

Galway Film Fleadh

Deadline: April

Awards: Audience award, best first feature, best Irish short

Contact: Galway Film Fleadh, Cluain Mhuire, Monivea Road, Galway, Republic of

Ireland

t: (353 91) 751 655

f: (353 91) 735 831

e: info@galwayfilmfleadh.com www.galwayfilmfleadh.com

Tanzania/Zanzibar

Festival of The Dhow Countries

Deadline: May

Awards: Golden Dhow and Silver Dhow

Administrative address: Festival of The Dhow Countries, Box 3032, Zanzibar,

Tanzania

t: (255 4) 747 411 499 f: (255 4) 747 419 955

e: ziff@ziff.or.tz www.ziff.or.tz

august

Japan/Hiroshima

International Animation Festival

(biennial; even years) **Deadline:** April

Awards: Grand Prix (¥1 million), Hiroshima prize (¥1 million), debut prize (¥500000), Renzo Kinoshita Prize (¥250000), Special International Jury Prize(s), Prize(s) for outstanding works

Contact: Hiroshima Festival Office, 4–17 Kako-machi, Naka-ku, Hiroshima 730–0812,

Japan

t: (81 82) 245 0245 f: (81 82) 245 0246

e: hiroanim@urban.ne.jp

www.urban.ne.jp/home/hiroanim

UK/Edinburgh

Edinburgh International Film Festival

Deadline: April (shorts, features) June (animation, Mirrorball)

Awards: Awards include: McLaren award for new British animation, Michael Powell

award for best new British feature

Contact: Edinburgh International Film Festival, Filmhouse, 88 Lothian Road, Edinburgh, EH3 9BZ, UK

t: (44 131) 228 4051

f: (44 131) 229 5501 e: info@edfilmfest.org.uk

www.edfilmfest.org.uk

USA/Palm Springs

Palm Springs International Festival of Short Films

Deadline: May

Awards: Cash and merit awards in all categories

Contact: Palm Springs International Film Festival, 1700 East Tahquitz Canyon Way, Suite 3,

Palm Springs, CA 92262, USA

t: (1 760) 322 2930 f: (1 760) 322 4087 e: info@psfilmfest.org www.psfilmfest.org

USA/Los Angeles

World Animation Celebration

Deadline: June

Awards: Competitive. Prizes in various categories

Contact: World Animation Celebration, 30101 Agoura Court, Suite 110, Agoura Hills,

CA 91301, USA t: (1 818) 575 9615 f: (1 818) 575 9620 e: info@wacfest.com **Director:** Dan Bolton

www.wacfest.com/mission.html

september

USA/New York

New York Animation Festival

Deadline: May

Awards: Competitive

Contact: New York Animation Festival, PO Box 1513, New York, NY 10009, USA

t: (1 212) 479 7742 e: info@nyaf.org www.nyaf.com

september/october

Ukraine/Kiev

KROK International Animation Festival

Deadline: May **Awards:** Competitive

Administrative address: KROK International Animation Festival, Saksaganskogo St. 6,

01033 Kiev, Ukraine

t: (380 44) 227 5280/227 6629

f: (380 44) 227 3130 e: krokfestival@ukr.net www.animator.ru/krok

october

Canada/Ottawa

Ottawa International Student Animation Festival

Deadline: June **Awards:** Competitive

Contact: Ottawa International Student Animation Festival, c/o Canadian Film Institute, 2

Daly Avenue, Ottawa, Ontario K1N 6E2, Canada

t: (1 613) 232 8769 f: (1 613) 232 6315 e: info@animationfestival.ca www.awn.com/ottawa

Ottawa International Animation Festival

(biennial; even years) **Deadline:** July

Awards: Competitive. Various awards in different categories

Contact: Ottawa International Animation Festival, c/o Canadian Film Institute, 2 Daly

Avenue, Ottawa, Ontario K1N 6E2, Canada

t: (1 613) 232 8769 f: (1 613) 232 6315 e: info@animationfestival.ca www.awn.com/ottawa

France/Bourg en Bresse

Festival of Animation for Young People

(biennial; even years) **Deadline:** July

Awards: Main prize in each category from an international jury and an official young

people's jury

Festival and administrative address: Festival du Film d'Animation pour la Jeunesse, Maison des Sociétés, Immeuble Chambard, Boulevard Joliot Curie, 01000 Bourg en Bresse, France

t: (33 4) 7423 6039 f: (33 4) 7424 8280

e: festival-bourg@wanadoo.fr

Australia/Brisbane

Brisbane International Animation Festival

Deadline: August

Awards: Various awards. Contact festival for further details

Contact: Griffith University 5th Brisbane International Animation Festival, SouthBank

Cineplex, 167 Grey St, South Brisbane, Q 4101, Australia

t: 61 7 3846 6133 f: 61 7 3844 5473 e: info@biaf.com.au www.biaf.com.au

Germany/Wiesbaden

Wiesbaden International Weekend of Animation

Deadline: Contact festival for details

Contact: Wiesbaden International Weekend of Animation, Freunde der Filme im Schloss,

Klopstockstr. 12, D-65187 Wiesbaden, Germany

t: (49 611) 840 562 f: (49 611) 807 985 e: info@filme-im-schloss.de www.filme-im-schloss.de

Germany/Leipzig

Leipzig International Festival for Documentary and Animated Films

Deadline: August, by dialog script in German, Russian, English, French or Spanish

Awards: Several cash prizes in various categories

Contact: Dokfestival Leipzig, Große Fleischergasse 11, 04109 Leipzig, Germany

t: 49 (0)341 30864-0 f: (49 341) 980 6141? e: info@dokfestival-leipzig.de www.dokfestival-leipzig.de

Slovakia/Bratislava

Biennial Animation Festival - Bratislava

(biennial; odd years) **Deadline:** June

Awards: Various awards

Administrative address: Bibiana, International House of Art for Children, Bab

Secretariat, Panskà Ul.41, 815 39 Bratislava, Slovak Republic

t: (421 2) 544 13 314 f: 421 2 – 5443 3550 e: bab@bibiana.sk

www.bibiana.sk/bab_e.htm

South Africa/Durban

The Durban International Film Festival

Deadline: March

Awards: Various awards

Administrative address: The Durban International Film Festival, Centre for Creative

Arts, University of KwaZulu-Natal, Durban 4041, South Africa

t: (27 31) 260 2506

f: (27 31) 260 3074 e: diff@nu.ac.za

www.cca.ukzn.ac.za

Sweden/Uppsala

Uppsala International Short Film Festival

Deadline: July

Awards: Uppsala Grand Prix, Special Prizes of the Jury, Audience Award

Contact: Uppsala International Short Film Festival, Box 1746, SE-751 47 Uppsala,

Sweden

t: (46 18) 120 025 f: (46 18) 121 350

e: info@shortfilmfestival.com www.shortfilmfestival.com

UK/Norwich

AURORA

(biennial; odd years) **Deadline:** July

Awards: Best International Animation, Best International Student Animation, Best Independent Animation, Best Commercial Animation, Best Animated Pop Promo, Best Experimental Animation, Best UK Student Animation and The Cinewomen Award for the best animation by a female director in any category

Contact: AURORA, Francis House, Redwell Street, Norwich NR2 4SN, UK

t: 44 (0) 1603 756231 f: 44 (0) 1603 615728 e: info@aurora.org.uk www.aurora.org.uk

UK/Leeds

Leeds International Film Festival

Deadline: July

Awards: Competitive

Contact: Leeds International Film Festival, Film Festivals Office, P.O. Box 596, Leeds LS2

8YQ, UK

t: (44 113) 247 8398 f: (44 113) 247 8494 e: filmfestival@leeds.gov.uk www.leedsfilm.com

november

UK/Bristol

Encounters Short Film Festival

Deadline: May

Awards: Contact festival for details

Contact: Animated Encounters, Watershed Media Centre, 1 Canon Road, Harbourside,

Bristol BS1 5TX, UK t: (44 117) 927 5102 f: (44 117) 930 9967

e: info@animated-encounters.org.uk www.encounters-festival.org.uk/

Netherlands/Utrecht

Holland Animation Film Festival

Deadline: June

Awards: Grand Prix for best film or video. Prizes in each category

Contact: Holland Animation Film Festival, Hoogt 4, 3512 GW Utrecht, Netherlands

t: (31 30) 2331733 f: (31 30) 2331079 e: info@haff.nl www.haff.nl

Portugal/Espinho

Cinanima Espinho International Animation Film Festival

Deadline: July

Awards: A single award in each of the categories

Festival and administrative address: Organizing Committee, Cinanima, Rua 62,

251, Apartado 743, 4500-901 Espinho Codex, Portugal

t: (351 22) 733 1350/1 f: (351 22) 733 1358

e: cinanima@mail.telepac.pt

www.cinanima.pt

Slovenia/Ljubljana

Ljubljana International Film Festival

Deadline: September

Awards: Kingfisher Award (€5000) – perspective section

Contact: Ljubljana International Film Festival, Cankarjev Dom, Presernova 10, 1000

Ljubljana, Slovenia t: 386 | 241 7100 f: 386 | 241 7295 e: cankarjev.dom@cd-cc.si

www.cd-cc.si

South Africa/Johannesburg

South African International Film Festival

Deadline: July

Awards: Non-competitive, except for a short films competition for Southern African

filmmakers

Contact: South African International Film Festival, PO Box 32362, Bloemfontein 2017,

South Africa

t: (27 11) 403 2541/403 3436

f: (27 11) 403 1025

Spain/Barcelona

L'Alternativa - Barcelona Independent Film Festival

Deadline: July

Awards: One in each major category

Contact: L'Alternativa – Barcelona Independent Film Festival, Centre de Culture

Contemporanea de Barcelona, C/Montalegre 5, 08001 Barcelona, Spain

t: (34 93) 306 4100 f: 34 93 302 24 23 e: alternativa@cccb.org http://alternativa.cccb.org

Spain/Bilbao

Bilbao International Festival of Documentary and Short Films

Deadline: September

Awards: Grand Prix €6000; Gold Mikeldi €3000; Silver Mikeldi €1800

Contact: Ma Angeles Olea, Festival of Documentary and Short Film, Colón de Larreátegui

37-4 Dcha, 48009 Bilbao, Spain

t: (34 94) 4248698 f: (34 94) 4245624

UK/Bradford

Bradford Animation Festival (BAF!)

Deadline: July

Awards: Competitive

Contact: National Museum of Photography, Film & Television, Bradford BD1 1NQ, UK

t: (44 1274) 203 349 f: (44 1274) 203 387 e: tom.woolley@nmsi.ac.uk

www.baf.org.uk

december

USA/Anchorage

Anchorage Film Festival

Deadline: September

Awards: Various cash prizes, contact festival for further details

Contact: Anchorage Film Festival, 1410 Rudakof Circle, Anchorage, AK 99508, USA

t: (1 907) 338 3690 f: (1 907) 338 3857

e: filmsak@alaska.net

www.anchoragefilmfestival.com

appendix 4

animation courses that include or specialize in stop motion, and related organizations and websites

This list is not comprehensive, but the organizations and websites I have included in this appendix will help any further searches. Courses marked with ETNA are members of the European Training Network for Animation.

Australia

Victorian College of the Arts

234 St Kilda Road Southbank Victoria 3006

Contact: Michelle van Kampen

t: 61 3 9685 9000 (film and television)

t: 61 3 9685 9300 (general enquiries) f: 61 3 9682 1841 (general enquiries)

e: m.vankampen@vca.unimelb.edu.au

www.vca.unimelb.edu.au

A one-year Graduate Diploma course open to mature age students with previous experience or degree-level education in animation-, art- and communication-related disciplines. School of Film and Television

Belgium

La Cambre

Hogeschool, section Animation 21 Abbaye de La Cambre B-1000 Brussels t: 32 2 626 17 80 f: +32 2 640 96 93 e: lacambre@lacambre.be www.lacambre.be

Canada

Cégep du Vieux Montreal

Département d'Animation

255, rue Ontario Est

Montréal, Quebec H2X 1X6

t: 514 982 3437 (management of communications)

f: 514 982 3448

f: 514 982 3400 (director general)

e: directiongenerale@cvm.qc.ca

www.cvm.qc.ca/

Coordinator: Pierre Grenier (Director General: Jacques Roussil; General Manager: Jean-

Denis Asselin)

Traditional animation to back up computer animation training

Sheridan College

Centre for Animation and Emerging Technology

1430 Trafalgar Road

Oakville

Ontario L6H 2L1

t: 905 845 9430

e: infosheridan@sheridanc.on.ca

www.sheridanc.on.ca/learning/schools.html

http://www1.sheridaninstitute.ca/

Vancouver Institute of Media Arts (VanArts)

Vancouver Institute of Media Arts

626 West Pender St. Suite 910

Vancouver, BC

V6B 1V9

t: 604-682-2787 or 1-800-396-2787

f: 604-648-2789

e: info@vanarts.com (general info)

www.vanarts.com

Admissions Manager/Animation Instructor: Ken Priebe

Part-time courses in stop motion

Denmark

The Animation Workshop (ETNA)

Kasernevej 5 8800 Viborg

t: 87 25 54 00

f: 87 25 54 11

e: info@animwork.dk (general enguiries)

Contacts: Morten Thorning and Søren Fleng

www.animwork.dk/ Storyboard and layout for series and feature films (twice 2 weeks) Character animation (twice 14 weeks and once 2 weeks) Will run stop motion classes when there is demand

France

EMCA, L'Ecole des Métiers du Cinema d'Animation (ETNA)

1, Rue de la Charente 1600 Angoulême t: 33 (5) 45 93 60 70 f: 33 (5) 45 93 60 80 e: emca@angouleme.cci.fr www.angouleme-emca.fr/

Contacts: Loic Le Guen and Christian Arnau

La Poudrière, Ecole du Film d'Animation (ETNA)

12, rue Jean Bertin F-26000 Valence t: 33 (4) 75 82 08 08 f: 33 (4) 75 87 08 07 e: contact@poudriere.eu

Contact: Isabelle Elzière-Delalle

Directing animation film: creative and artistic aspects (two-year course)

Spain

Centro Integral de Cursos Especializados (CICE)

Alcalá 155 1º planta ES-28009 Madrid t: 34 (91) 401 07 02

e: cice@tsai.es www.cicesa.com

www.cicesa.com/diseno/formacion/c_cortometrajes.html

Contact: Marco Antonio Fernandez Doldan

Computer animation with traditional training in stop motion

Fak d'Art (ETNA)

Muntaner 401, entlo 08006 Barcelona t: 34 (93) 201 08 55 f: 34 (93) 200 72 39 e: fbengyent@fda.es?

Contacts: Fransisco Benavent and Jordi Martorell

New technologies applied to traditional animation: pre-production (four months), post-production (four months)

UK

Arts Institute at Bournemouth

Wallisdown

Poole

Dorset BH12 5HH

t: 44 (0) 1202 533 011

f: 44 (0) 1202 537 729

e: ourseoffice@aib.ac.uk

www.arts-inst-bournemouth.ac.uk

BA (Hons) Film and Animation Production. Three-year course enabling students to develop specialization and skills necessary for their chosen career

MA Animation

plus a Saturday Art School for children

Central Saint Martins College of Art and Design

University of the Arts London

Short Course Office

10 Back Hill

Clerkenwell

London EC1R 5EN

t: 020 7514 7015

f: 020 7514 7016

e: shortcourse@csm.arts.ac.uk

www.csm.arts.ac.uk

Short course in Stop Motion Animation

Cornwall College

Trevenson Road

Pool

Redruth

Cornwall TR15 3RD

t: 01209 617 649

f: 01209 616 168

e: stephen.howard@cornwall.ac.uk

www.cornwall.ac.uk

Foundation Degree (FdA) in Animation

Edinburgh College of Art

Lauriston Place

Edinburgh EH3 9DF

t: 44 (0) 131 221 6000

e: d.holwill@eca.ac.uk

www.eca.ac.uk

BA (Hons) Visual Communication – Animation

Glamorgan Centre for Art and Design Technology

Glyntaff Road Glyntaff Pontypridd, RTC South Wales CF37 4AT t: 44 (0) 1443 663309 f: 44 (0) 1443 663313 www.gcadt.ac.uk/ HND and BA (Hons) Animation

London College of Communication

University of the Arts London
Elephant and Castle
London SE1 6SB
t: 020 7514 6892
e: t.shore@lcc.arts.ac.uk
www.lcc.arts.ac.uk
Introduction to Animation (short course)
Foundation Degree in Animation
BA (Hons) Animation (Top up)
MA Postgraduate Diploma (Animation)

National Film and Television School

Beaconsfield Studios Station Road Beaconsfield Bucks HP9 1LG t: 01494 731425 f: 01494 674042 e: info@nfts.co.uk www.nftsfilm-tv.ac.uk MA Animation Direction

Norwich School of Art and Design

Francis House
3–7 Redwell Street
Norwich
Norfolk NR2 4SN
t: 01603 610561
f: 01603 615728
e: info@nsad.ac.uk
www.nsad.ac.uk
MA Animation and Sound Design

Plymouth College of Art and Design

Tavistock Place Plymouth PL4 8AT t: 01752 203434

f: 01752 203444

e: enquiries@pcad.ac.uk

www.pcad.ac.uk

Foundation Degree in Animation and Creative Media

Ravensbourne College of Design and Communication

Walden Road

Chislehurst

Kent BR7 5SN

t: 020 8289 4900

f: 020 8325 8320

e: info@rave.ac.uk

www.ravensbourne.ac.uk

BA (Hons) Animation Level 3 only

The Royal College of Art

Kensington Gore

London SW7 2EU

t: 44 (0)20 7590 4444

f: 44 (0)20 7590 4500

e: admissions@rca.ac.uk

www.rca.ac.uk

MA Animation

Sheffield Hallam University

Faculty of Arts, Computing, Engineering and Sciences

City Campus

Howard Street

Sheffield S1 W1B

t: 0114 225 5555

f: 0114 225 4449

e: aces-info@shu.ac.uk

www.shu.ac.uk/art/media

BA (Hons) Animation

MA Animation

University College for the Creative Arts

Falkner Road

The Hart

Farnham

Surrey GU9 7DS

t: 01252 722 441

f: 01252 892 817

e: rnoake@surrart.ac.uk www.surrart.ac.uk BA (Hons) Animation

University of Gloucestershire

Faculty of Media, Art and Communications
Pittville Studios
Albert Road
Cheltenham GL52 3JG
t: 01242 532208
f: 01242 532207
e: aberry@glos.ac.uk
www.glos.ac.uk/mac
BA (Hons) Animation and Interactive Media

University of Lincoln

Hull School of Art and Design Department of Animation 42 High Street Hull HU1 1PS t: 01482 311 327 f: 01482 311 330 e: asugden@lincoln.ac.uk www.lincoln.ac.uk/ BA (Hons) Animation

The University of the West of England

Bower Ashton Campus
Kennel Lodge Road
Bristol BS3 2JT
t: 0117 965 6261
f: 0117 344 4820?
www.uwe.ac.uk
The Bristol Animation Courses (ETNA) – three-month courses for graduates
BA (Hons) Animation
MA Animation

University of Wales College, Newport

School of Art, Media and Design Caerleon Campus PO Box 179 Newport South Wales t: 01633 432182 e: james.manning@newport.ac.uk uic@newport.ac.uk www3.newport.ac.uk BA (Hons) Animation MA Animation

University of Westminster

School of Media, Arts and Design Harrow Campus Watford Road Northwick Park Harrow HA1 3TP t: 020 7911 5903 f: 020 7911 5955 e: harrow-admissions@wmin.ac.uk www.wmin.ac.uk/harrow BA (Hons) Animation

University of Wolverhampton

School of Art and Design Molineaux Street Wolverhampton WV1 1SB t: 01902 322 260 f: 01902 321 944 e: C.H.Slim@wlv.ac.uk www.wlv.ac.uk BA (Hons) Animation

USA

California Institute of the Arts

School of Film/Video
24 700 McBean Parkway
Valencia, CA 91355-2397
t: 661 255 1050
f: 661 253 7824
e: admiss@calarts.edu
www.calarts.edu
Program in Experimental Animation. BFA, MFA

The Douglas Education Center

Douglas Education Center 130 Seventh Street Monessen, PA 15062 t: 724-684-3684 f: 1-800-413-6013 e: swalters@douglas-school.com (admissions) dec@douglas-school.com (general)

www.douglas-school.com

Rick Catizone's Art of Animation Diploma Program

Sixteen-month program designed to provide students with the skills necessary for a career in animation

Art Institute of Pittsburgh

420 Boulevard of the Allies Pittsburgh, PA 15219 t: 800 275 2470

f: 412 263 6667

e: admissions-aip@aii.edu

www.aip.aii.edu

Rhode Island School of Design

2 College St

Providence, RI 02903-2791

t: 401 454 6100

f: 401 454 6356?

e: admissions@risd.edu

www.risd.edu

Film, animation, video

Rochester Institute of Technology

School of Film and Animation

Frank E. Gannett Building

70 Lomb Memorial Drive Rochester, NY 14623-5604

t: 585-475-6127 (Stephanie Maxwell Animation Chair)

f: 716 475 7575

e: sampph@rit.edu

www.rit.edu/~animate

http://cias.rit.edu/~sofa/

Thirty-week program of stop motion skills

training - key organizations

UK

Organizations offering training in filmmaking and related areas in the UK. Apart from courses in full-time education, many organizations offer professional, vocational training for freelancers.

Skillset

Skillset is the national training organization for broadcast, film, video and multimedia. The site includes careers advice for those wishing to get in to the industry and those already

working. The site gives information about individual training courses and their scheme to fund 60% of vocational training on certain other courses. The Film Council gives training funds to organizations to run courses, including through Skillset, but not to individuals needing funding.

www.skillset.org

BECTU (Broadcasting, Entertainment, Cinematograph and Theatre Union)

This is the national training organization for broadcast, film, video and multimedia. The skills base part of the site includes subsidized careers advice for those wishing to get in to the industry and those already working. The site also gives information about individual training courses and their scheme to fund 60% of vocational training on certain other courses.

www.bectu.org.uk

Metier

Metier are the national training organization for the arts and entertainment industries, including performance art, visual art, literary art, arts development and teaching, technical support and production design, arts management administration and support roles.

www.metier.org.uk

Europe

ETNA

The European Training Network for Animation includes eight European professional animation training centers, as well as around 40 European animation studios. The goals of this network are to perfect European animation training, to encourage and better the links between animation training and industry requirements and developments, and to facilitate the mobility of European professionals throughout Europe.

www.cartoon-media.be

other useful organizations

Cartoon

European Association of Animation Film. Incorporates Cartoon Forum, Cartoon Masters, Cartoon d'Or, Cartoon Movie, Jobs and News

Marc Vandeweyer and Corinne Jenart (General Managers)

314, Boulevard Lambermont

1030 Brussels

Belaium

t: 32 2 245 12 00

f: 32 2 245 46 89

e: forum@cartoon.skynet.be

www.cartoon-media.be

ASIFA

International Animated Film Association/Association Internationale du Film d'Animation ASIFA was formed in 1960 by an international group of animators to coordinate, further the interests and increase worldwide visibility of animation. The Association is founded in the firm belief that the art of animation can be enriched and greatly developed through close international cooperation and the free exchange of ideas, experience and information between all who are concerned with animation. ASIFA's membership includes over 1500 animation professionals and fans in more than 50 countries.

http://asifa.net

Animation World Network

A website resource with jobs, directories, articles.

www.awn.com

Stopmotionanimation.com

Animator Anthony Scott's iwebsite for discussions on any subject to do with stop motion animation.

index

A Grand Day Out 121	Back lights 177
A Midsummer Night's Dream 2	Background
Aardman animations 203	forced perspective 111
Achilles 130, 169	lighting 177
Acting, stillness 175	Balance, posing 128
Actions in movement 134-8	Ball-and-socket armatures 78-82
Adam 166	rig arms 82
Adventures of Mark Twain 121	rigging points 80–2
Allen, Tim 192-3	Ball movement and animation 26
Aluminium milled lampshades 109	Base, sets 105–6
American clay 152	Bending of characters 53
Analog video cameras 9	Berkey Systems rigging 112
Angle of shots 39	Bibliography 213-14
Animals in Motion 126	Bill and Ben 201
Animals movement 143-4	Birds
Animated Conversations 114	flight 145–6
Animatics, editing 47–50	movement 145-6
Animation	Black wrap lighting 178
balls 26	Blackton, James Stuart 54
bouncing ball 38–9	Blinking, comedy 172–3
courses 201	Blocking out shots 183
familiar objects 21–2	Bob the Builder 46–7, 118, 122, 201
festivals calendar 221–34	Boots for puppets 71
moving coin 24–5	Borthwick, Dave 3
software 12–15, 22–5	Bouncing ball
special effects 201	animation 38-9
stop motion courses 235-45	movement 29-30
studios 201	Box, Steve 174
Anticipation of movement 134-8	Breakdown of sound 117–19
Anti-flare spray for buildings 107	Breaking up of movement 138–9
Applications for jobs 209	Brisk Tea commercial 48–9, 116
Armatures	Bruce, Barry 12
ball-and-socket 78–82	Buildings in sets 107–8
computer Aided design 81	
drawings 65, 79	CAD (computer aided design) 50, 81, 103
mechanical man 81	Caine, Michael 172
puppets 59–67, 72	Calendar of animation festivals 221–34
ASA ratings for lighting 178	Cameras 9-10
ASIFA (International Animated Film	angles 40
Association) 245	moves 42, 181-2
Aspect ratios 23, 39–40	position 181
Avery Tex 6 170	set up 181–4

Cameras (continued)	Curing, casting 92
shake 189	Curse of the Were-Rabbit 152
tape 182	
Canhead 7, 174	Dale, Phil 11, 18
Cannon firing ball movement 30	Darkness, Light, Darkness 3
Caricature 5–7	Depth of field 179-80
Cartoons organization 244	Dialog 49, 116-17
Casting 88–93	Digging a hole movement 137
coloring 93	Digital stills 10–11
curing 92	shooting 183
gelling times 92 silicone 93	Digital video (DV) 9–10, 183
CGI see computer generated imaging	Diopter lenses 12
Chaplin, Charlie 136	Director of photography (DOP) 103, 205,
Characters	206
animation 166-9	Disney Studios 1, 5
design 51-4	Dodgem cars collision 33–4
subtlety of animation 173–5	'Doggy movements' 22
two or more in comedy 173	DOP see director of photography
Checks in production 191-2	Dope sheets 30–1
Chew Chew Land 54	Double frames 27–9
Chicken Run 1, 7, 147–8, 152, 173	Dragonslayer 4
Chroma keys 187–8	Drawings 65 70
Clark, Blair 78, 83	armatures 65, 79 movement 126-7
Claymation 12	plans 38
Clays for modelling 54–6	puppets 58-9
Climpex 112	Drilling, Teresa 147–68
Clokey, Art 55	characters 150
Clothes for puppets 73	extreme downward position 153-4
Coloring, casting 93	final position 162–8
Comedy 169–73	first position 150-3
Comic timing see comedy	models 148-50
Commercials 201–3	monkey jump 164-5
Commissioning editors, proposals 211–12 Compact point and shoot cameras 11	plasticine 155, 160
Compositing 187	slowing down movement 158–62
Composition 39	upward movement 154–8
Computer aided design (CAD) 50, 81, 103	Vinton's style 154
Computer generated imaging (CGI) 4	Dudok de Wit, Michael 167
Continuity, shots 39, 40–1	Durable clothing for puppets 65–7
Cook, Luis 52, 203	Duracell bunny character 95–100
Cool Edit software 19	DV see digital video
Copyright 124	
Cornford, Nigel 94	EBU (European Broadcasting Union) 195
Corpse Bride 11, 78, 192, 207	Edit decision list (EDL) 196
Costumes/dressing of models 93-5	Editing
Courses in animation 201	animatics 47-50
Creature comforts 114, 147, 162, 174, 192,	pictures 196–7
204–5, 206	sound 18-19, 197-8
Credits .199	sound packages 18–19
Crossing the line rules 41–2	story reels 47–50

Editors 37-8		Foam
films 191		latex casting 88-92
proposals 211–12		urethane 107
EDL see edit decision list		Foamcore in sets 103
Effects copyright 124		Focusing 42-3
El Nombre 192		Fog/mist effects 191
Electricity, health and safety 17–18		Follow-through movement 138
Engle Benjy 187		AND THE PROPERTY OF THE PROPER
Enjy Benjy 192		Forced perspective 110–11
Epoxy resin moulds 87		Four-legged animals movement 143
Equity (UK actors union) 115		Frame grabbers 12–15
Establishing shots 39		Frame toggling 13
European Broadcasting Union (EBU)	195	Friction heads, tripods 15
EV see exposure values		Frog puppets 103-4
Exporting films 199		
Exposure values (EVs) 178		G-clamps 112
Exterior sets 109-10		'Gaffer' gloves 110
Extreme downward position 152–3		Golezsowski, Richard 170, 188
Eyelids 172		Geared heads 15–16
Eyelines 172		Gelling times in casting 92
Eyes for puppets 69–70		
Eyes for puppers 69-70		
F (: .: 170 170		Glossary
F-stops for lighting 178, 179		equipment 19-20
Falling leaf/feather movement 31		model making 100-1
Fantasia 27		production 193-4
Fast-cast resin 87		sets 113
Fast walk movement 140		Gobos lighting effects 110
Father and Daughter 167		Green screen/blue screen 187-8
Features for television 206-8		GRP see glass-reinforced plastic
Feet		Gumby 55, 201
armatures for puppets 72		Gumby (character) 55
movement 137-8		Gutmann, Otmar 6
puppets 70-2		Samann, Simar S
Festivals 210–11		Hair for puppets 68-9
Fibreglass resin 87		Halogen lamps 16
Fill lights 177		Hamilton Mattress 208
Films		Hammering movement 135–7
exporting 199		·Hand-drills 18
festivals with animation, calendar	221–34	Hands
grammar 38–9		movement 137-8
Filters, polarizing 188		puppets 70
Final checks in production 191-2		Hard moulds 83, 86-8
Final Cut Pro software 18		Harryhausen, Ray 4, 51
Final position settlement 162-8		HDV see high definition video
Fire effects 189		Heads
First position for models 150-3		puppets 67–8
Fixing of characters 53		tripods 15
Flight of birds 145–6		· ·
		Health and safety blow torches 79
Flocking in sets 107		
Fluid heads for tripods 15		casting 88
Flushed Away 7		electricity 17–18

Health and safety (continued)	Lite drawing 12/
flocking 107	Lifting of heavy boxes 132
latex 88	Light
lighting 180	measurement 178
lights 110	meters 179
magnets 105	Lighting 16-18, 177-80
plastics 63	depth of field 179–80
polyurethane resins 87–8, 107	f-stops 178, 179
Ultracal 87	health and safety 180
urethane foam 107	interior sets 108–9, 110
Heavy boxes lifting 132	shutter speeds 179
High definition video (HDV) cameras 10	Line of action, posing 128-9
Hilligoss, Nick 103-4, 106	Lip sync 119–24
Hips movement 140	Liquitex 93
Hittle, Tim 7, 21, 174, 176	Live Action Video (LAV) unit 205
HMI (Hydrargyrum Medium arc Iodide)	Live overlays 13
bulbs 17	Lizard movement 143-4
Home on the Range 6	Look of sets 102–3
Hot glue gun 18	Loose Moose 124, 202
Human puppets 103–4	Lord, Pete
	Adam 166
Humanoid joints 80	
11 25 0	character animation 168
Ideas 35-8	illusion of speed 142
Interior sets 108–9	lip sync 121
International Animated Film Association	Morph 125
(ASIFA) 245	planning 32, 34
iStopMotion software 23–4	timing 129–30
	Lost World 4
Jackson, Gary 74, 95	Lunchbox Sync animation system 15
Jason and the Argonauts 4	,
Jobs applications 209	Mackinnon, lan 76–7
Johnston, Ollie 1	Mackinnon & Saunders (model makers) 76–8,
JPEG files 11	112
Jurassic Park 4	moulds 83
Jurassic Fark 4	
V00	puppets 109
K&S square brass tubing 67, 70, 97, 152,	replacement heads 120
158	Wind in the Willows 122
Key lights 177	Magnets for sets 105
	Manufacturers 217–20
Lampshades, aluminium milled 109	Maquettes 77–8
Landscapes, sets 106–7	see also sculpts
Lasseter, John 2	Match moving 182
Latex	Materials
care 93	glossary 113
	puppets 58
•	
mixing 91–2	Mather, James 198
LAV (live action video) unit 205	Max & Co 1
Laws of motion (Newton) 26, 170-2	MDF for sets 103
LED (Light Emitting Diode) lighting 18	Measurement of light 178
Lenses 12	Mechanical man armatures 81
Leroy, Guionne 1, 5, 124, 167, 175, 207	Meters for light 179

Mighty Joe Young 4	pace 136–7
Milliput hair 68–9	reaction 134–8
Mini digital video recorders 10	relaxed walk 143
Mini-spots lighting 16	rhythm 136–7
Miracle Maker 106	rigging 139-40
Mixing	running 140–2
latex 91-2	snap 138
sound 198	speed 142-3
Models	tennis ball 134–5
clays 54–6	timing 129–30
costume/dressing 93-5	walking 139–40
Drilling, Teresa 148–50	weight 131–4
glossary 100–1	Moving coin animation 24–5
Mackinnon & Saunders 76–8, 112	Moving parts for characters 53
plasticine 55–6	Music copyright 124
posing 65, 128-9	Muybridge, Eadweard 126
Monkey jump 164–5	My Baby Just Cares for Me 120
Monsters inc. 2	
Moon in exterior sets 109-10	Nature 5–7
More than one character in comedy 173	Neighbours 4
Morph 6, 34, 55, 125	Neodymium magnets 105
Motion	Newitt, Jeff
blur effects 191	caricature 6–7
control 16, 182	character animation 167, 173
Motivation 40	equipment 8
Moulds 83–8	illusion of speed 142
hard 86–8	movement 125
plaster 87	nature 6–7
plasticine press 88	pictures editing 196
resin 87-9	timing 130–1
seams 85-6	walking and running 139
silicone 88	Newplast modelling clay 152
textures 84	Newton's laws of motion 26, 170-2
undercuts 84–5	Nightmare before Christmas 78, 105, 190
Mouth	
movements 119	Olympus E330 camera 10
shapes 123	Onion skinning 14
Movement 25-7	Orozco, Lionel I. 207
action 134–8	Out of the Inkwell 5
animals 143-4	Overlapping action 138
anticipation 134–8	Owen, Gareth 204
birds 145-6	
breaking up 138-9	Pace in movement 136-7
digging a hole 137	Palethorpe, Ange 124, 202–3
fast walk 140	Panning of cameras 42, 181
feet 137–8	PAR (Parabolic Aluminized Reflector) lights 17
follow-through 138	Park, Nick
hammering 135-7	Creature Comforts 174
hands 137–8	facial animation 121
hips 140	modelling clays 54
mechanics 125-7	models 51

Park, Nick (continued)	hair 68–9
planning 34	hands 70
scripts 37	heads 67–8
sound 114-15	human 103-4
TV features 207–8	K&S square brass tubing 97
Wallace and Gromit 6	materials 58, 75
Perception video recorder (PVR) 13	plasticine 57–64
Persistence of vision 170-2	posing 128-9
Perspective, forced 110-11	shoes 71
Peter and the Wolf 192	snipping foam 72–3
Photofloods lighting 16	tools 58
Pictures, editing 196–7	wire 57-64
Pingu 6, 201	Purves, Barry
Pixels 10	character animation 166-8
Plan drawings 38	Hamilton Mattress 208
Planning	posing 129
animation 32–4	rushes 195
shots 38-43	timing 130
Plaster moulds 87	walking 142
Plasticine	PVR see perception video recorder
Drilling, Teresa 155, 160	
flour sack 168	Rain effects 189
heads for puppets 68	RAW image format 11
models 55-6	Reaction in movement 134-8
press moulds 88	Recording
puppets 57-64	dialog 116–17
Plastiline 71, 83, 95	equipment suppliers 215–6
Plastizote 149	sound 19
Polarizing filters 188	Red Hot Riding Hood 170
Polo advertisements 52	Reflectors 177
Posing	Relaxed walk movement 143
models 128-9	Replacement heads for lip sync 120
puppets 128–9	Resin moulds 87–9
Possum's Rest 107	Reverse angle shots 42
Pre-production of sound 115-16	Rex the Runt 170, 188
Prime lenses 12	Rhythm of movement 136–7
Pro Tools software 19	Rig arms for ball-and-socket armatures 82
Production glossary 193-4	Rigging
Proposals for commissioning editors 211–12	ball-and-socket armatures 80–2
Props 111-12	movement 139-40
Puppeteering 2	sets 112–13
Puppets 57–75	Rigoletto 94
armatures 59-67	Rigs for shooting 184-88
clothes 73	Robustness, characters 53
drawings 58-9	Rocky (Brisk Tea commercial) 48–9, 116
durable clothing 65–7	Rotten Ralph 122, 192
eyes 69	Rubberdubbers 201
feet 70–2	Runners, jobs 210
feet armatures 72	Running movement 139, 140–2
frog 103-4	Rupert Bear 201

SLR (single lens reflex) cameras 11 Smoke effects 191 SAAPTE are Society of Adabian Bistons and
SMPTE see Society of Motion Picture and Television Engineers
Snap, movement 138
Snipping foam, puppets 72–3 Snow effects 189
Snow White 5
Society of Motion Picture and Television
Engineers (SMPTE) 195
Soft moulds 83, 88
Software, animation 22–5
suppliers 215–16
Sound 114–24
breakdown 117–19
editing 197–8
mixing 198
pre-production 115–16
recording 19
Special effects 188-91, 201
Speeds, movement 142-3
panning/tracking 182
Sproxton, Dave 204
Squashing 29-30
Star Wars 4
Starewitch, Ladislaw 5, 186
Staying upright, characters 53
Sticky wax for interior sets 108
Stillness in acting 175
Stop motion animation courses 235–45
Stop Motion Pro software 13-14
Story reels editing 47–50
Storyboards 43–7
Stretching 29–30
Studios, animation 201
Subtlety
character animation 176–8 characters 53
Sun in exterior sets 109–10
Suppliers 215–16
Sutcliffe, Stuart 84
Svankmajer, Jan 3
ovankinajai, jan
Talcum powder for modelling 57
Television (TV) features 206-8
Templeton, Suzie 192
Tennis ball movement 134–5
Textures, moulds 84
The Adventures of Mark Twain 154
The Cameraman's Revenge 5

The Frogs Who Wanted a King 5 The Great Cognito 121 The Human Figure in Motion 126 The Illusion of Life 1 The Mascot 5 The Monk and the Fish 167 The Periwig Maker 11, 52 The Pied Piper 51 The Potato Hunter 7 The Secret Adventures of Tom Thumb 3 The Street of Crocodiles 3 The Tale of the Fox 5 The Wind in the Willows 122 The Wrong Trousers 121, 174 This Unnameable Little Broom 3 Thomas, Frank 1 Thomas, Trey 56, 200, 201 Thunder Pig 124 Tilt, cameras 181 Tilting 42 Timecodes 195 Timing 27-9 Timing of movement 129-30 Tippett, Phil 4 Titles 199 Toolkit 18 Tools for puppets 58 Toy Story 1, 2 Track, cameras 181 Tracker beds 16 Tracking 42 Training organizations 243-4 Trainspotter 36 Trapdoor 204 Treatments 35, 38 Tripods 15-16 Trnka, Jiri 2 Tulips will Grow 6 Tungsten lighting

TV (television) features 206-8 Two or more characters, comedy 173 Ultracal moulding compound 87 Undercuts in moulds 84-5 Upward movement 154-8 Urethane foam 107 Ventilation for casting 88 Vinton's sculpting style 154 Vision, persistence 170-2 Visualizations 46-7 Voice over scripts 115-16 Voice techniques 117 Walk birds 145 lizards 143-4 movement 139-40 Walker, Christine 105-6 Wallace and Gromit 6, 37-8, 53, 114, 207 Water effects 193 Wax for interior sets 108 Webcams 12 Websites for animation related organizations 235-45 Weight, sense of 133-4 White balance for video 182 Who Framed Roger Rabbit? 6 Wind effects 191 Wind in the Willows 204 199 Windows Media Video (WMV) files Wire for puppets 57–64 WMV (Windows Media Video) files

X-sheets 30-1

Zoom cameras 181 lenses 12

Media